M000105402

CLEVELAND
THEN & NOW

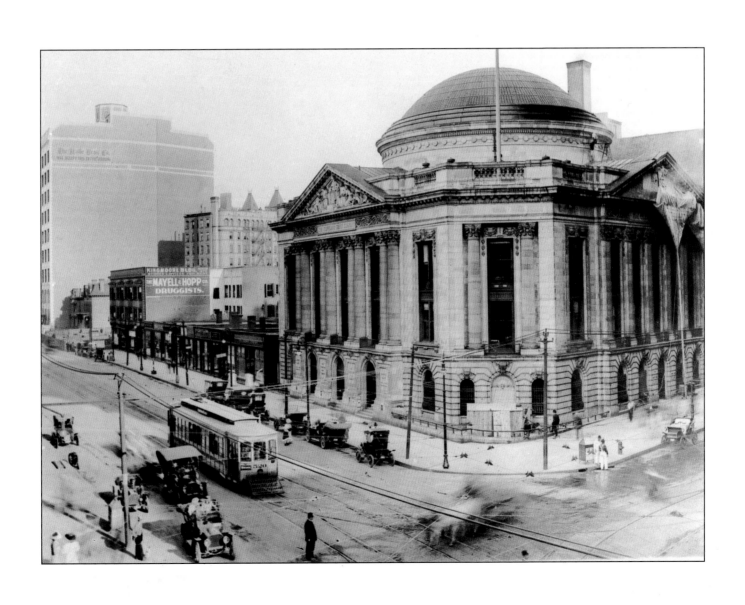

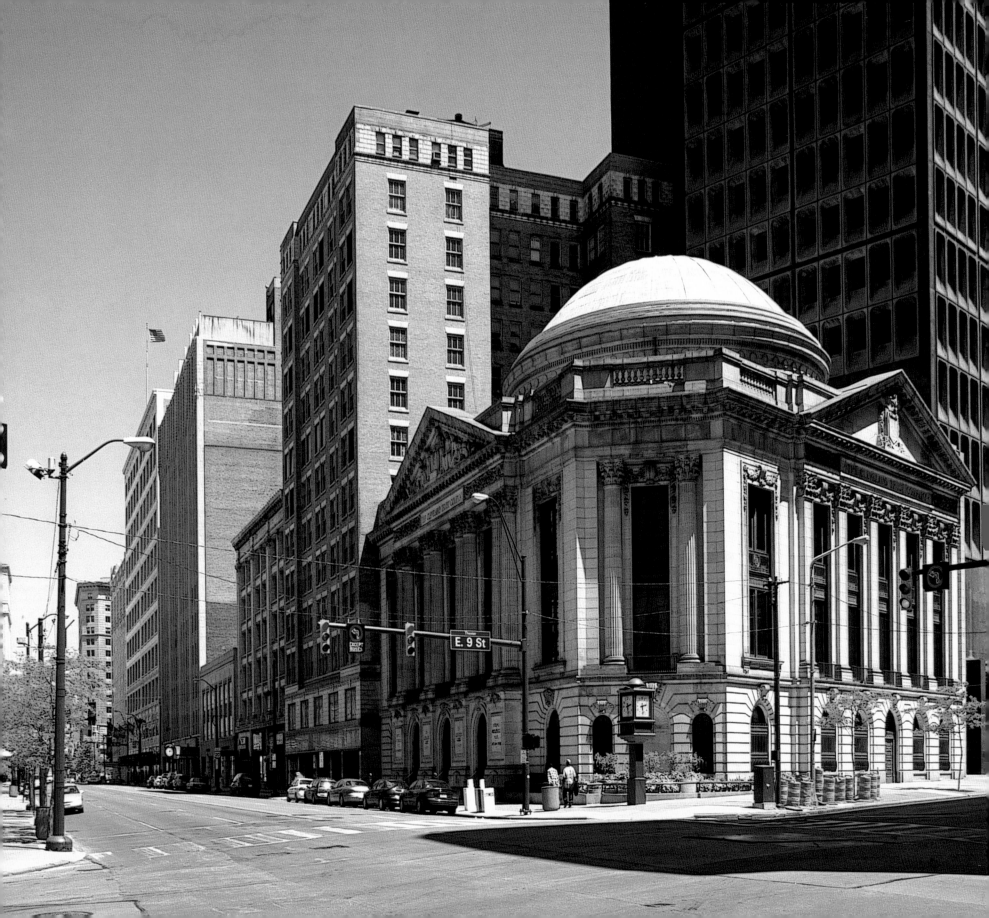

CLEVELAND THEN & NOW

JOHN J. GRABOWSKI AND DIANE EWART GRABOWSKI

THUNDER BAY
P·R·E·S·S

San Diego, California

Thunder Bay Press
An imprint of the Advantage Publishers Group
5880 Oberlin Drive, San Diego, CA 92121-4794
www.thunderbaybooks.com

Produced by PRC Publishing
The Chrysalis Building
Bramley Road, London W10 6SP, United Kingdom

An imprint of Chrysalis Books Group plc

© 2002 PRC Publishing

Copyright under International, Pan American, and Universal Copyright Conventions.
All rights reserved. No part of this book may be reproduced or transmitted in any form
or by any means, electronic or mechanical, including photocopying, recording, or by any
information storage-and-retrieval system, without written permission from the copyright
holder. Brief passages (not to exceed 1,000 words) may be quoted for reviews.

All notations of errors or omissions should be addressed to Thunder Bay Press,
Editorial Department, at the above address. All other correspondence (author inquiries,
permissions) concerning the content of this book should be addressed to
PRC Publishing Limited, The Chrysalis Building, Bramley Road, London W10 6SP,
United Kingdom. A member of the Chrysalis Group plc.

Library of Congress Cataloging-in-Publication Data.

Grabowski, John J.
Cleveland then & now / John Grabowski and Diane Ewart Grabowski.
p. cm.
ISBN 1-57145-879-4
1. Cleveland (Ohio)-Pictorial works. 2. Cleveland (Ohio)-History-Pictorial works.
I. Title: Cleveland then and now. II. Grabowski, Diane Ewart. III. Title.

F499.C643 G73 2002
977.1'32'00222-dc21 2002032262

PRINTED IN CHINA

4 5 6 7 8 08 07 06 05 04

ACKNOWLEDGMENTS:

Thanks to the Western Reserve Historical Society Library reference staff for their
assistance with the Cleveland "then" photographs. Thanks to Richard Palmer for
his excellent photographic work, "then" and "now." And thanks to Simon Clay
for capturing Cleveland "now" photographically.

PHOTO CREDITS:

The publisher wishes to thank The Western Reserve Historical Society for kindly
providing the "then" photographs for this book.

Thanks to Simon Clay for taking all the "now" photographs in this book, with the
exception of the photographs on the following pages:

Pages 85, 99, and 143, courtesy of Richard Palmer.

Pages 1 and 2 show Euclid Avenue at East Ninth Street, in the early 1900s with the
Cleveland Trust Company Building (photo: The Western Reserve Historical
Society), and the same building today, currently owned by KeyCorp (photo: Simon
Clay). See pages 58 and 59 for further details.

For cover photo captions and credits, please see jacket.

DEDICATION:

To the memory of Werner D. Mueller.

INTRODUCTION

Cleveland: the Comeback City. During the 1980s, this promotional phrase caught on as a way of describing the city and proclaiming faith in its future. Beyond this, the name had two implications. Clearly, it admitted that Cleveland had experienced problems; there can be no comeback without an earlier setback. More importantly, it acknowledged that the city had at one time been successful and that its heritage was special.

In a sense, Clevelanders have a heritage of three separate, superimposed identities to draw upon. The city's origins date to 1796. In that year Moses Cleaveland, a representative of the Connecticut Land Company, arrived at the head of an expedition sent to survey the company's holdings: the entire northeastern corner of what would become Ohio. Known as the Western Reserve, the area was used by Native Americans as a hunting ground and a buffer zone between the warring Iroquois and Algonkian groups. Sailing along the southern coast of Lake Erie, Cleaveland stopped at the mouth of the Cuyahoga River. He chose this site as the main port and future "capital" of the Western Reserve.

Cleaveland and his surveyors planned the settlement along the familiar lines of a New England town, with a central commons surrounded by neat rectangular building plots. Named for Cleaveland despite his own wishes (the *a* in the first syllable was later dropped), the settlement got off to a slow start because of its isolation and the malaria-bearing mosquitoes that bred in the flatlands beside the river. Nonetheless, new inhabitants, mostly from New England or New York, arrived in slowly increasing numbers. For a few brief decades, Cleveland did indeed have the look and feel of a New England village transported to the frontier.

The construction in 1825–32 of the Ohio & Erie Canal proved to be a turning point in the town's destiny. The canal linked the Cuyahoga with the Ohio River, making Cleveland a transportation hub between the Mississippi and Great Lakes waterways. Along with the dredging of the river mouth and harbor and the increasing use of steam-powered vessels on Lake Erie, the canal transformed the backwoods village into a busy port. By the eve of the Civil War, the population was 43,417. No longer part of New England, Cleveland was a small city in which transplanted northeasterners, primarily Protestants of British ancestry, formed the civic leadership, while immigrants, mainly Irish Catholics and Germans, provided the labor and skills needed on its docks, and in its stores and workshops.

This new commercial prosperity created the economic base for another transformation. By the turn of the twentieth century, Cleveland had taken on its third and most lasting identity, that of an industrial city of steel mills and factory workers. The smokestack, rather than the skyscraper, symbolized the city's coming of age as an economic power to be reckoned with. Industrial wealth built mansions—notably along Euclid Avenue, which people began to compare with the great boulevards of Europe—and also founded cultural institutions, many of which were clustered in University Circle, four miles to the east of the central city.

Cleveland's boundaries expanded as immigrant neighborhoods grew up around the factories, many of which were built along transportation corridors in outlying areas. Between 1880 and 1924 tens of thousands of immigrants, mostly from central and eastern Europe, arrived in the city. By 1920 Cleveland had become a polyglot city of 796,841 people, with two thirds of its population foreign-born or the children of immigrants. During World War I, African American migrants from the South also began arriving in great numbers. They joined an existing black community that had roots going back nearly to the city's founding. Although the industrial economy was shattered by the Depression, it recovered during World War II and reached new heights in the years immediately after, a period when civic boosters touted the city as "the best location in the nation."

Twenty years later, local wits were calling Cleveland "the mistake on the lake," following a run of problems in the 1960s and 1970s. The most serious of these was a decline in industrial production, as the massive, aging mills of the Great Lakes region lost out to lower-cost producers in the South and overseas. Cleveland's industrial heritage seemed a liability rather than an asset. Factories sat empty and rusting, while steelworkers collected unemployment and tried to find new jobs. Clevelanders struggled to create a new civic identity, one that would mesh with America's new economic realities.

This was made both easier and harder by the fact that Cleveland had a history of being a runner-up. Positioned to become the commercial hub between the interior and the eastern seaboard, it lost out to Chicago as the American West opened up. After a very brief spell as "the leading automobile manufacturing city in the universe" (as one local newspaper put it), Cleveland was eclipsed by Detroit and for the most part had to be content supplying parts and steel to its northern neighbor's industrial empire. A legacy of industrial wealth has endowed the city with world-class cultural institutions like the Cleveland Museum of Art and the Cleveland Orchestra, plus a number of smaller gems, but in no way can it compete with the scope of arts and culture in a city like New York. Cleveland is not the "Big Apple" or "Motown" or even the "Second City."

However, being famous for one particular thing has its downside, as exemplified by the case of Detroit. Cleveland has a certain amount of flexibility in shaping its new identity, one still very much in the making at the start of the twenty-first century. The service sector will undoubtedly be central to its future. Nationally recognized law firms and financial institutions, established to support the city's industries and businesses, prosper in the emerging economic environment. New buildings dedicated to sports and entertainment, like the Rock and Roll Hall of Fame and the stadiums and arenas of the Cleveland Indians, Browns, and Cavaliers, give the city a high-profile image and attract large numbers of visitors. Major educational and medical institutions like Case Western Reserve University, University Hospitals of Cleveland, and the Cleveland Clinic Foundation give the city a well-deserved international reputation as a research center, particularly in the critical medical-biotechnology area. Students, physicians, and researchers come from all corners of the world to work and study in these institutions, enhancing Cleveland's reputation as one of the nation's most diverse communities.

These changes in identity have been accompanied by substantial changes in the city's landscape. One often has to look hard to find the past amid the present. In selecting the "then" photographs for this book, we did not search for images of sites that have remained largely intact. Rather, we selected pictures that help tell the story of the city and its people. Today, some of the sites bear no resemblance to what can be seen in the older photographs—entire neighborhoods have disappeared, major intersections have been altered to suit the automotive lifestyle, and grand old buildings have been replaced by newer and perhaps grander buildings.

Yet, traces of Cleveland's old identities live on. Public Square, in the center of downtown, preserves the outlines of the New England–style town commons. The canal, now part of a national recreation area, survives from the commercial era. Railroads and bridges, so much a part of Cleveland's industrial past, still figure largely in the current landscape, as do churches and synagogues built by those who came to work in the industrial city. The paired images in *Cleveland Then and Now* capture these legacies, both spectacular and mundane. They also testify to the enormous amount of change that has taken place in one community in little over two hundred years—change that is, itself, the essence of history.

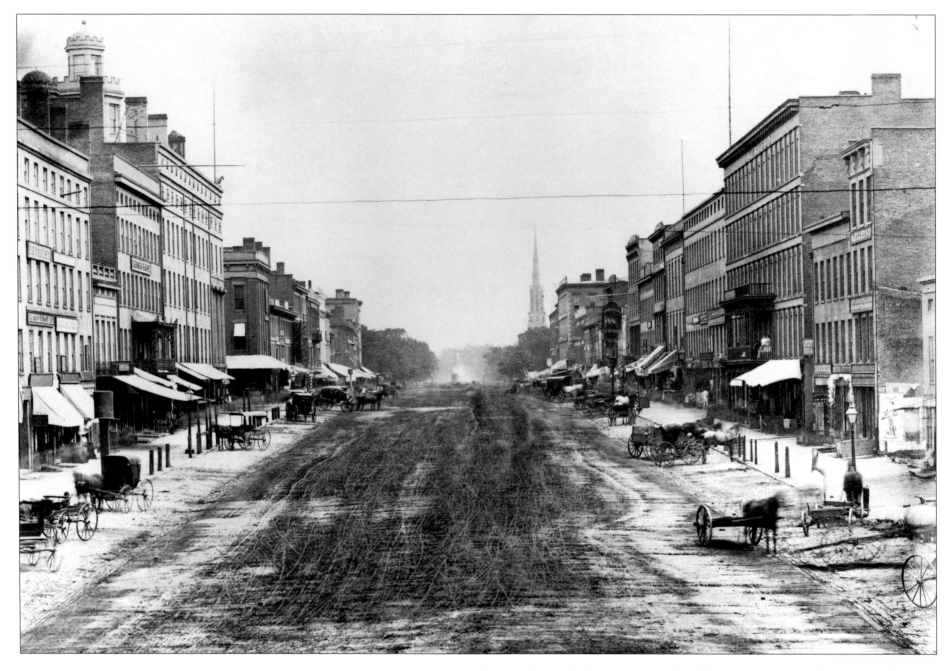

Superior Street looking east toward Public Square, 1860. This is one of the earliest surviving photographs of Cleveland. The city's founder, Moses Cleaveland, and his surveyors had planned a town centered on a commons, which became known as Public Square. They allotted Superior, the main east-west street, a generous 132-foot right-of-way. Superior ran from the Cuyahoga River on the west to the town's edge at Erie Street on the east. At Public Square, it intersected with Ontario Street, cutting the Square into quadrants.

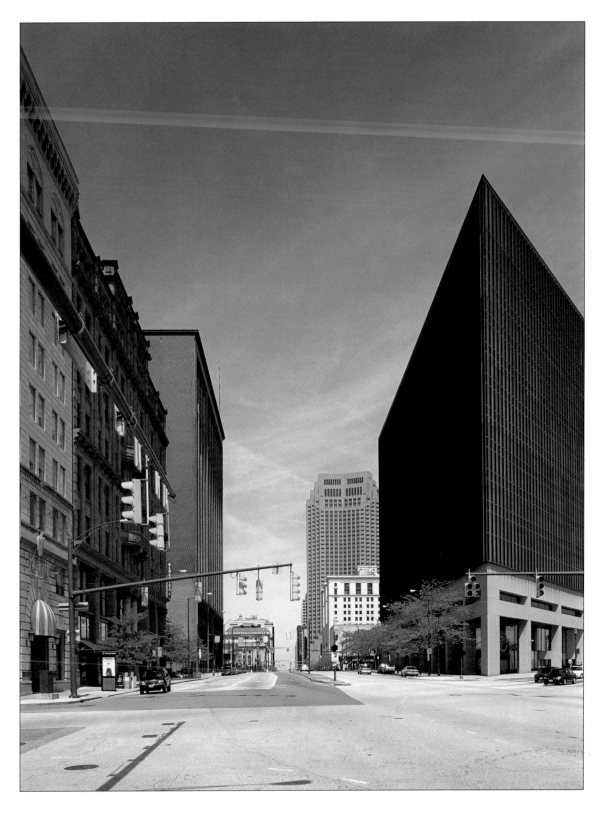

Today the downtown portion of Superior Avenue remains a major thoroughfare, although no longer the city's "main street." A mixture of old and new buildings, including the Perry-Payne and Rockefeller Buildings to the left and the Frank J. Lausche State Office Building on the right, line Superior between West Ninth and Public Square.

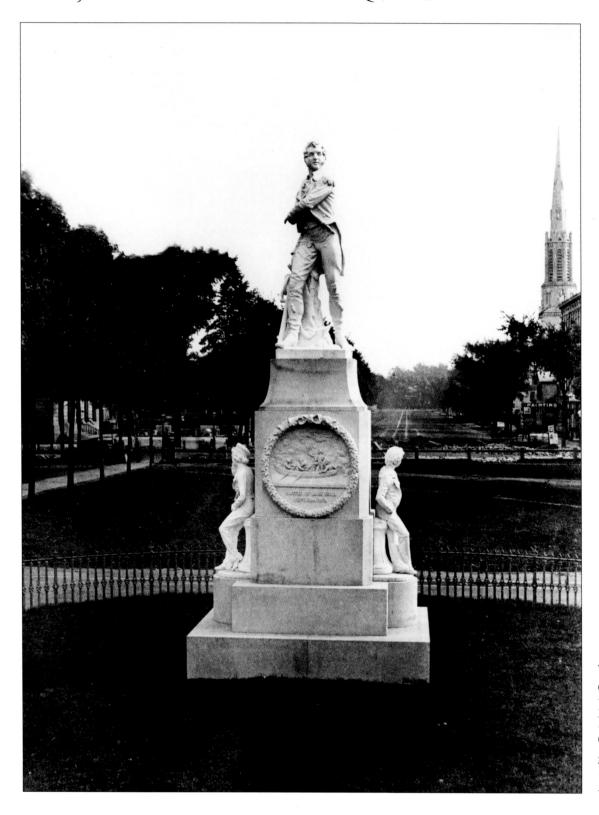

The Perry Monument commemorated U.S. Navy Commodore Oliver Hazard Perry's victory in the Battle of Lake Erie during the War of 1812. Defeat of the British helped make Lake Erie safe for American shipping, giving Cleveland's fortunes a considerable boost. The city's grateful residents dedicated a monument to the naval hero in 1860. It was placed in the center of Public Square, which had been fenced off in 1857.

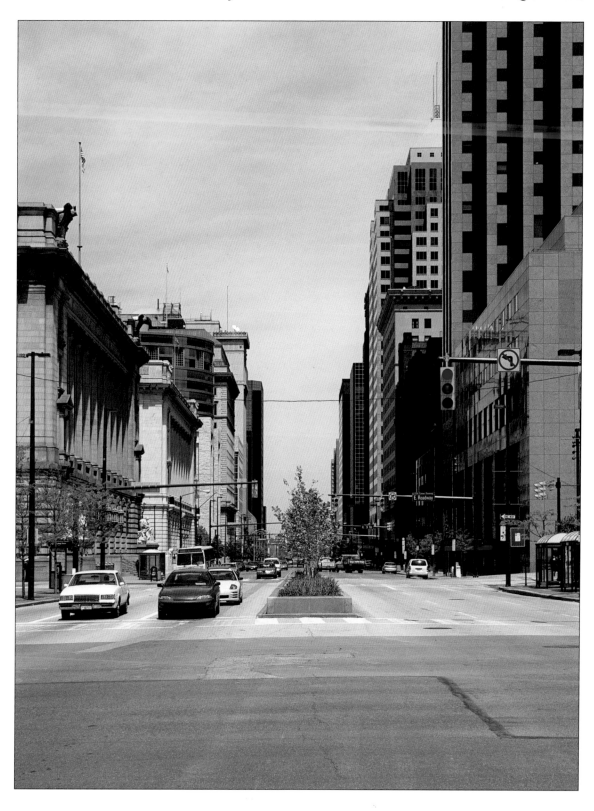

This created a park in the heart of the growing city and also blocked through traffic on Superior and Ontario streets, infuriating local business interests. Commerce eventually won out, and the fences were removed in 1867, ending Cleveland's "Fence War." The Perry Monument was moved out of the traffic flow in 1878 and off the Square entirely in 1892. The contemporary view looks east along Superior from the Square's center.

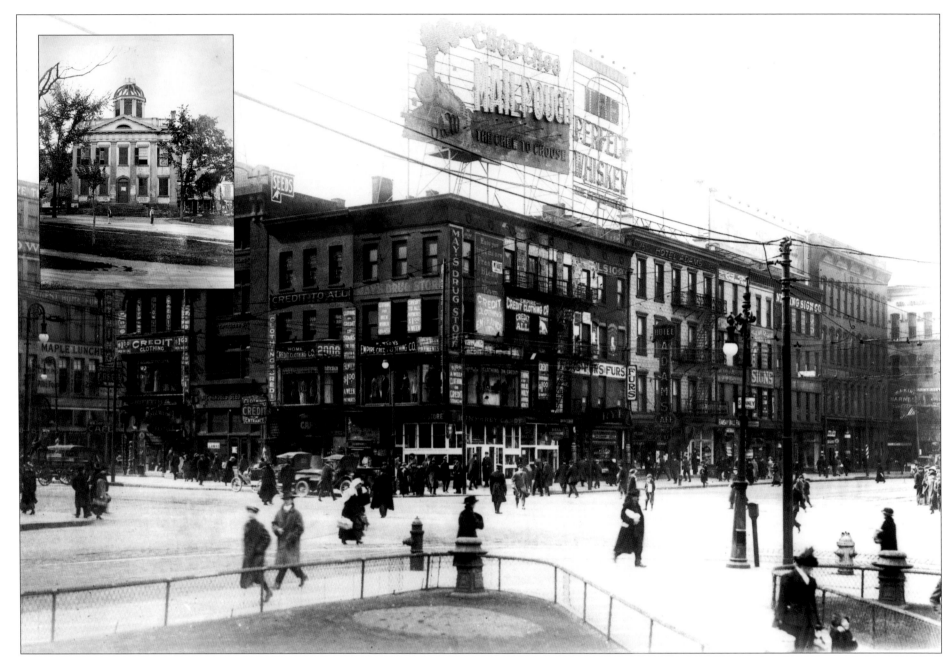

Above: By the 1910s, Public Square was a true American urban space of its day, with many of its surrounding buildings devoted to retail commerce. The inset photograph shows the Cuyahoga County Courthouse, with its dome and Doric pilasters. The courthouse was the city's first monumental public building, constructed on the southwest quadrant of the Square between 1826–28. This photograph dates from 1859; the courthouse, already being dismantled, would be removed from the Square the following year.

Right: If Cleveland has a civic landmark, it is the Terminal Tower. At 708 feet, it was Cleveland's tallest building from its completion in 1927 until 1991. The centerpiece of a seventeen-acre complex designed by Graham, Anderson, Probst & White of Chicago, the tower faces Public Square's southwest quadrant. Built to house Cleveland's passenger train union terminal, it is now the site of Tower City Center, a shopping mall that occupies much of what was once the terminal's waiting room and concourse.

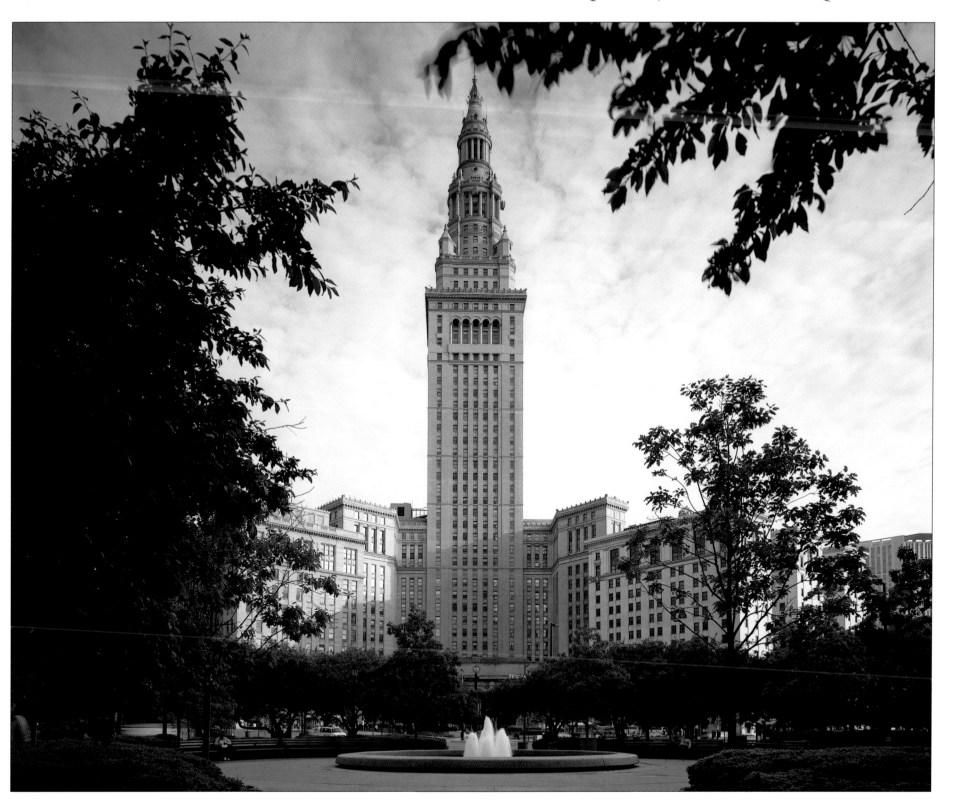

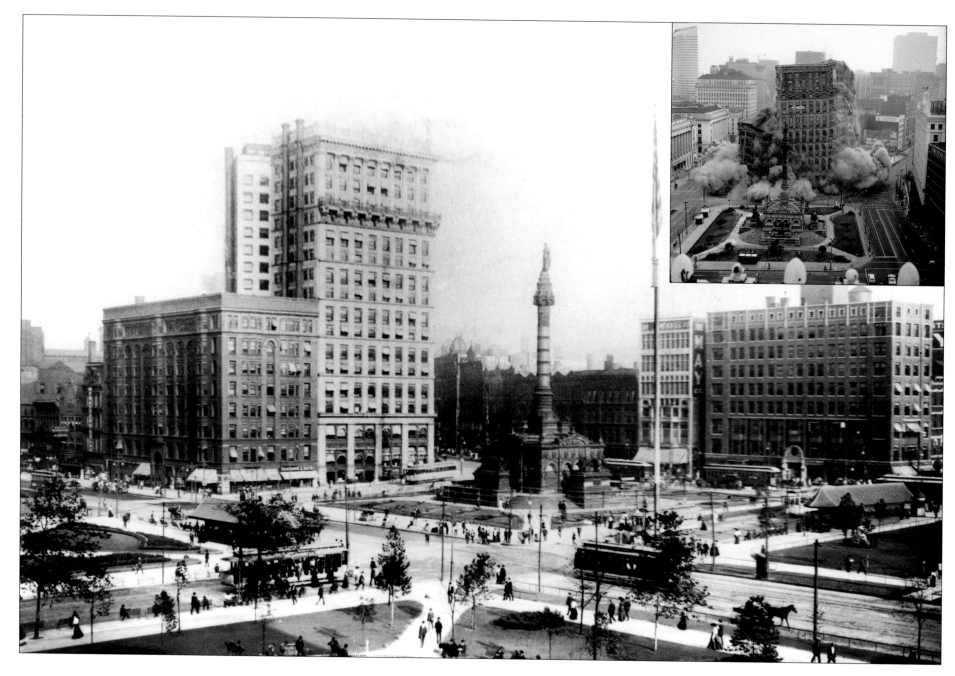

The Cuyahoga and Williamson Buildings and the Soldiers and Sailors Monument, in the early 1900s. The monument on Public Square's southeast quadrant, dedicated in 1894, memorialized the 10,000-plus county residents who served in the Civil War. The Cuyahoga Building (1893), designed by Daniel H. Burnham, was the first structure in Cleveland with a full steel frame, while the Williamson Building (1900) next to it was, at the time, the city's tallest building.

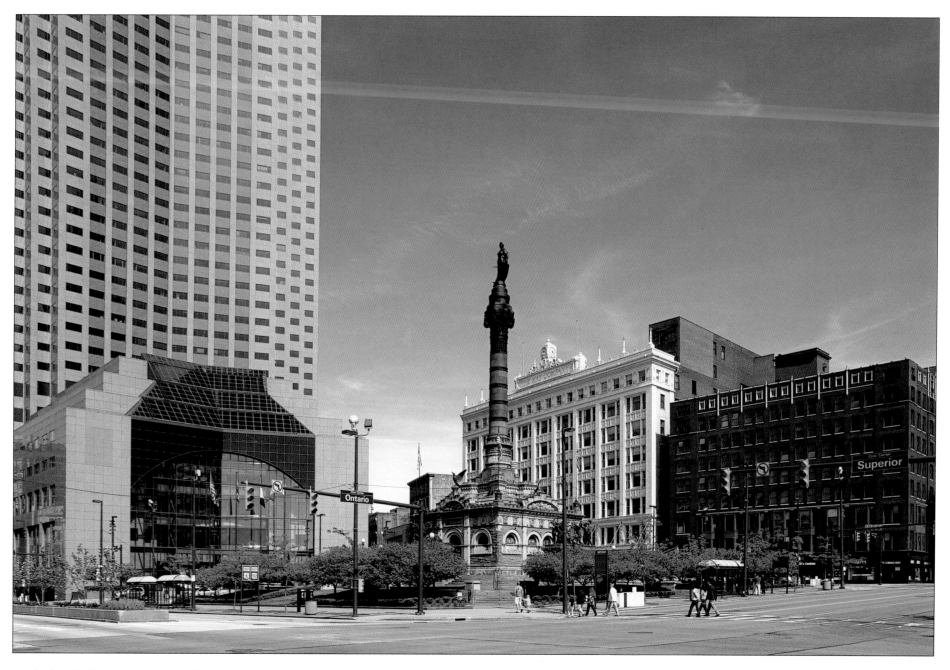

Both the Williamson and Cuyahoga Buildings were imploded (see inset on page 12) in 1982 to make way for the Sohio Building, which served as headquarters for Standard Oil of Ohio. Sohio was the regional remnant of American history's most famous monopoly, the Standard Oil Corporation, begun in Cleveland by John D. Rockefeller. In 1987 Sohio became part of the British Petroleum Corporation, and the structure was renamed the BP Building.

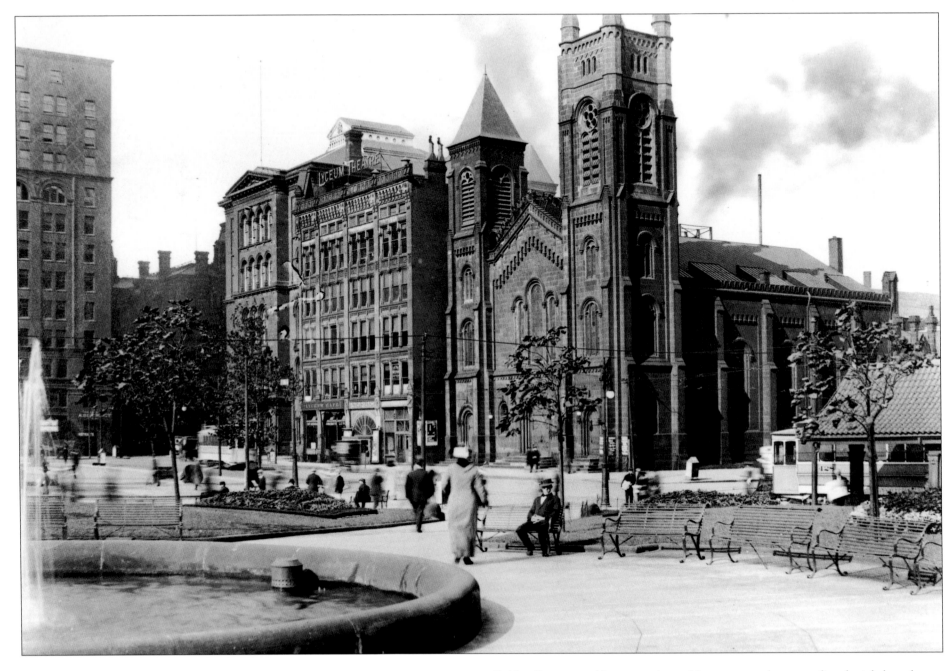

Public Square itself remained a public space and was outfitted with benches, fountains, and plantings. True to its New England heritage, it had a church beside it. Cleveland's First Presbyterian Church stood on Ontario facing the northwest quadrant. The congregation's second building, completed in 1855, once dominated the square, but by the time of this photograph (c. 1910), it was just one among many tall downtown buildings.

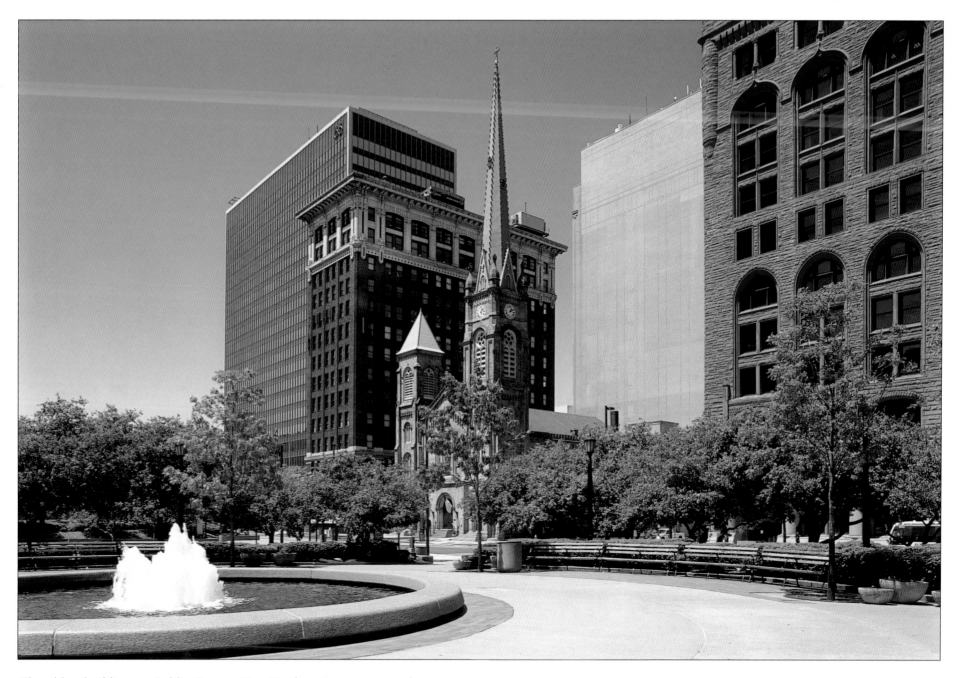

The oldest building on Public Square, First Presbyterian remains a downtown landmark known to Clevelanders as Old Stone Church. Its exterior, almost totally blackened by years of exposure to the urban environment, was cleaned in the 1990s, revealing the sandstone's original color. The interior of the church features stained-glass windows by Louis Tiffany and John LaFarge. First Presbyterian continues as an active congregation, providing religious and social services.

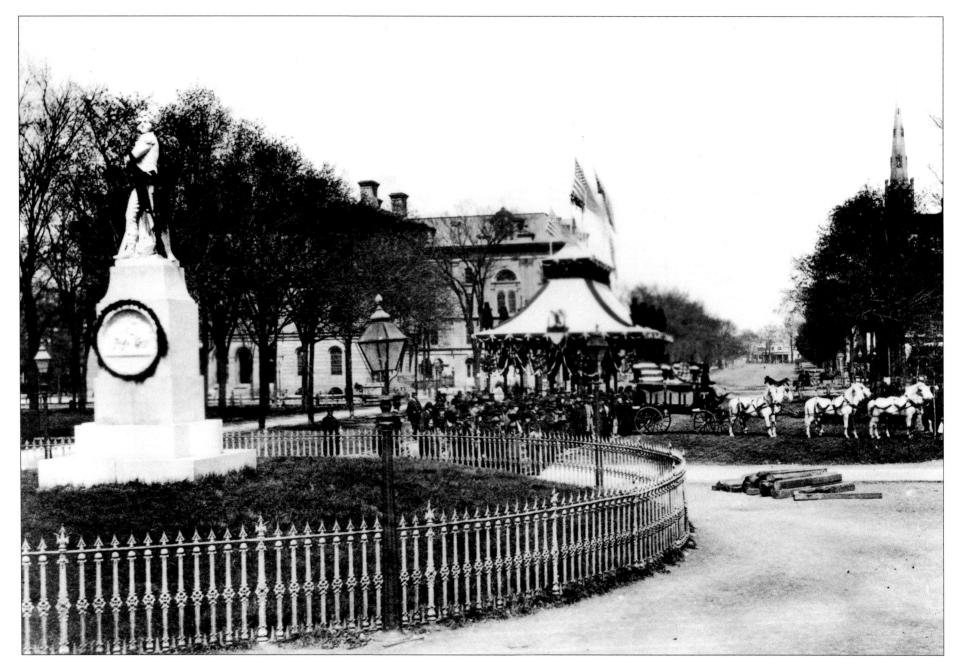

In 1865, the body of assassinated U.S. President Abraham Lincoln was taken by train from Washington, D.C., to Illinois for burial. The train stopped at several cities along the way, so that grieving Americans across the country could pay their respects. It arrived in Cleveland on April 28. The catafalque was placed on Public Square, just east of the Perry Monument. Despite a heavy rain, more than 90,000 people viewed the president's remains during a twelve-hour period.

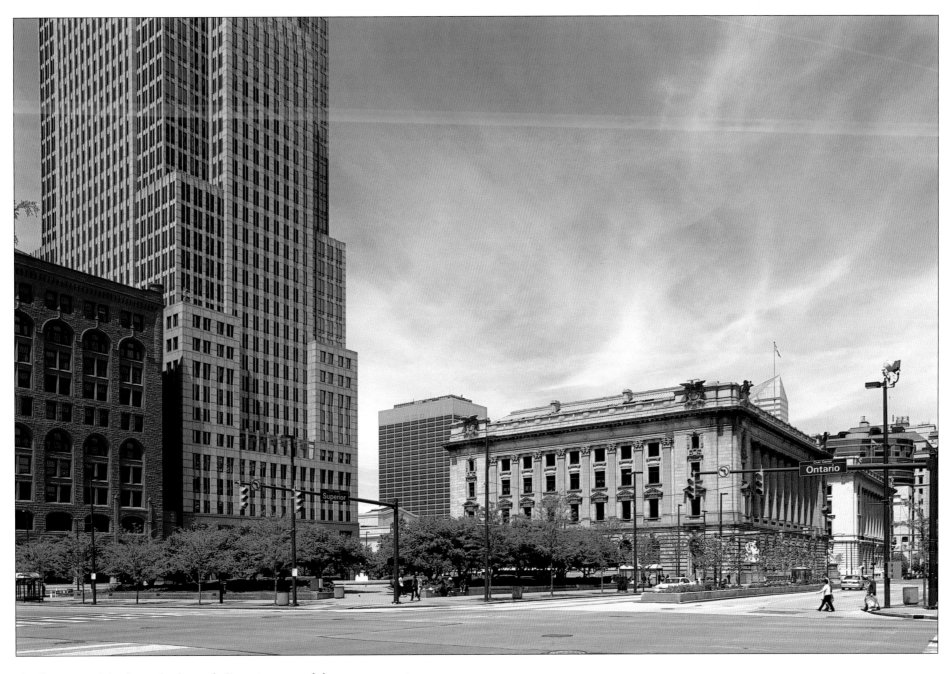

At the time of the Lincoln funeral, Superior east of the square was just beginning to be developed. The most substantial structure was the U.S. Post Office, Custom House, and Courthouse Building (to the left of the catafalque in the archival photo). Today the Metzenbaum Federal Courthouse occupies the same site just beyond the northeast quadrant of Public Square. The next structure to the east (right) is the main building of the Cleveland Public Library.

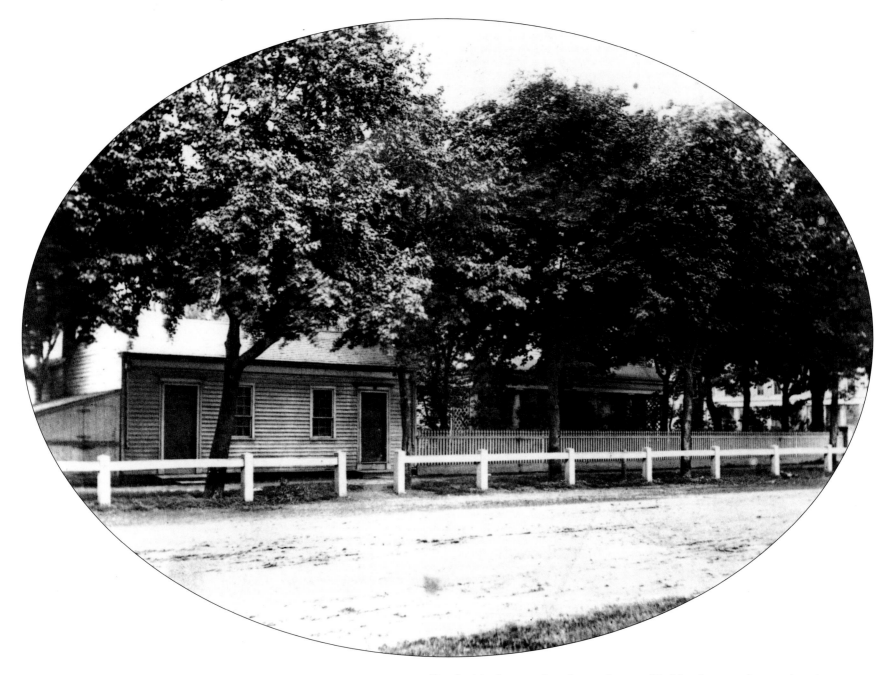

On the block immediately northeast of Public Square, this modest frame structure (shown in the late 1850s) housed the office and residence of William Case, Cleveland's first native-born mayor. Case made his living in business, but had a great interest in science and natural history. He, his brother Leonard, and a group of like-minded young men met informally to discuss scientific and cultural topics in his office. The building became known as "the Ark" because the members filled it with their collections of specimens and curiosities.

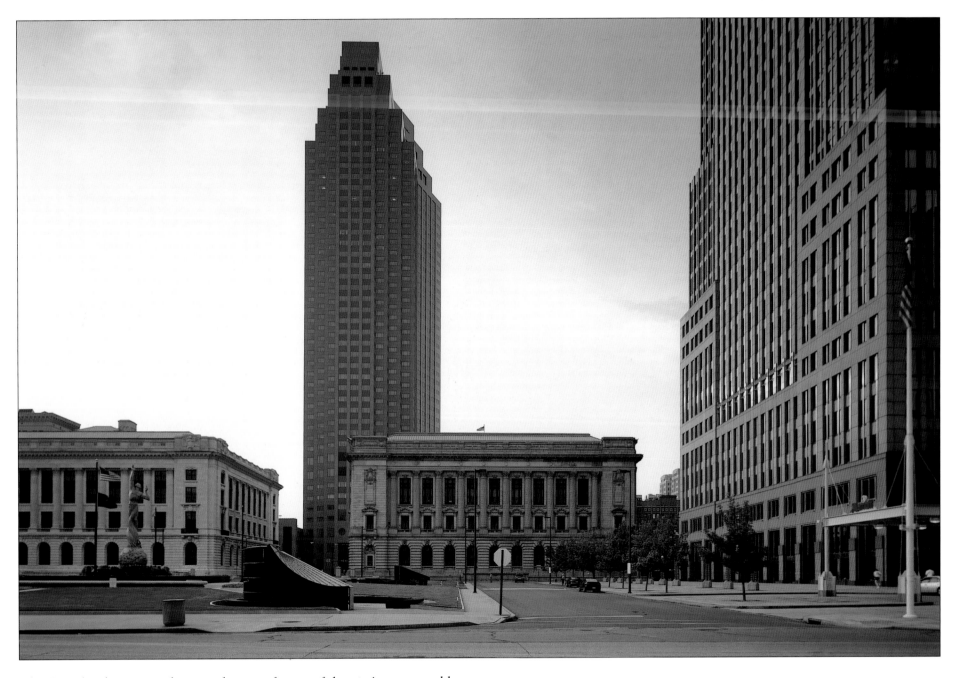

The Case family property became the site of some of the city's most notable
public buildings, including the first U.S. Post Office in the 1850s, which was
joined by Case Hall, a civic and cultural center, in 1867. The Metzenbaum
Federal Courthouse (center) is the most recent structure on the site.
Although the Ark and the Arkites are long gone, the Cleveland Museum of
Natural History, located in University Circle, is their legacy.

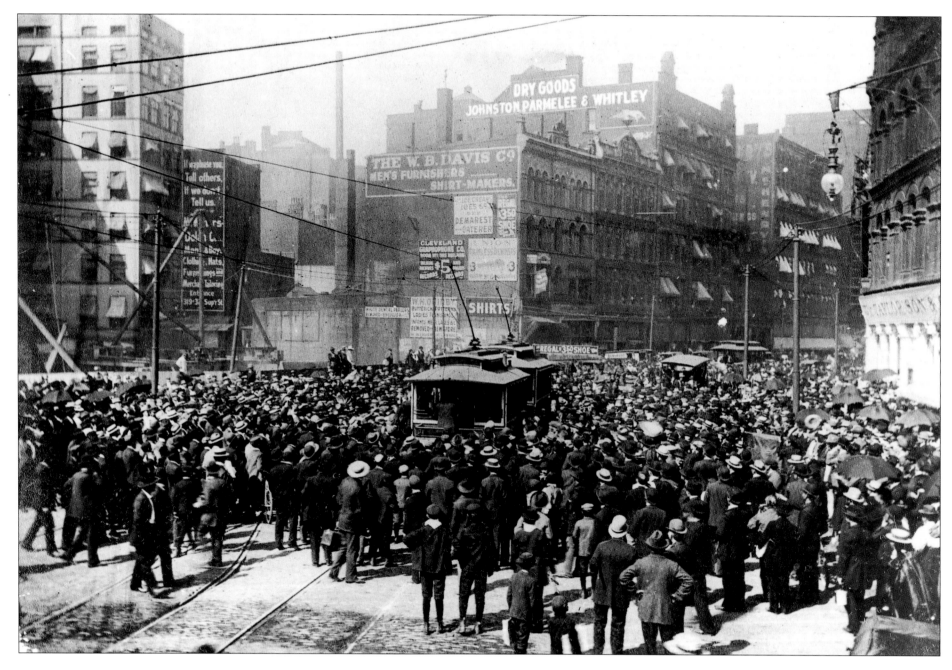

In June 1899, Cleveland streetcar workers went on strike against one of the city's two street railway companies. When the company tried to run cars with nonunion employees, rioting broke out. Here, at the southeast corner of Public Square, a crowd of strikers and onlookers surrounds cars on the Euclid Avenue line, paralyzing traffic. Since electric streetcars were the prime mode of urban transportation, the strike significantly affected businesses and commuters.

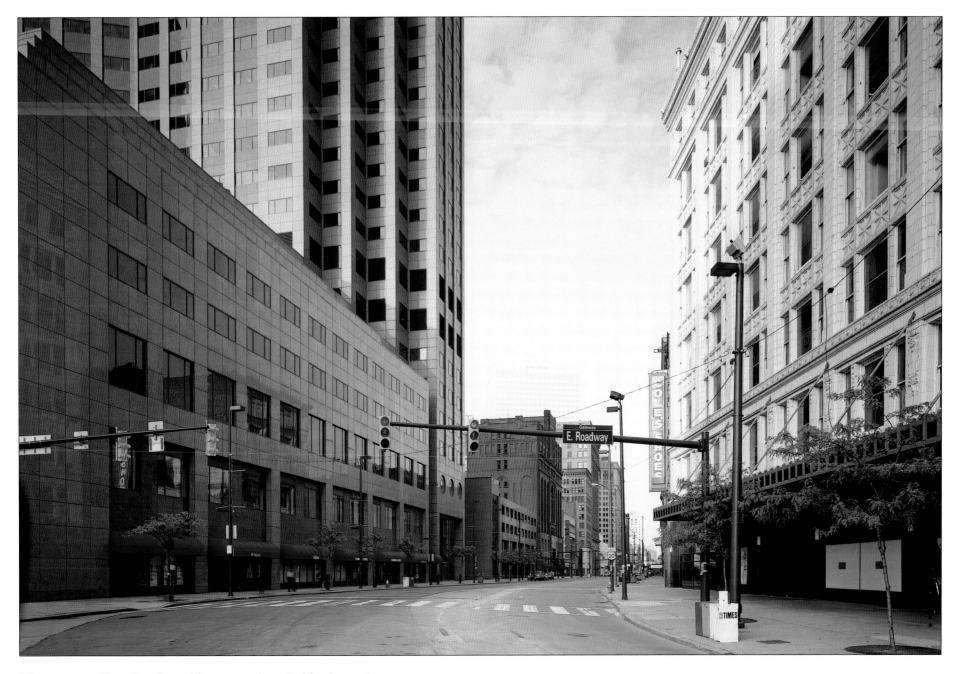

The corner of East Roadway (the street along Public Square's eastern
edge) and Euclid appears much quieter today. While new commercial
and retail development has taken place in several downtown area locations,
this portion of Euclid Avenue, once the heart of the city's shopping district,
is just beginning to undergo revitalization, with adaptive reuse sought for
large, old department stores like the Kaufmann's (formerly May Co.) Building
on the right.

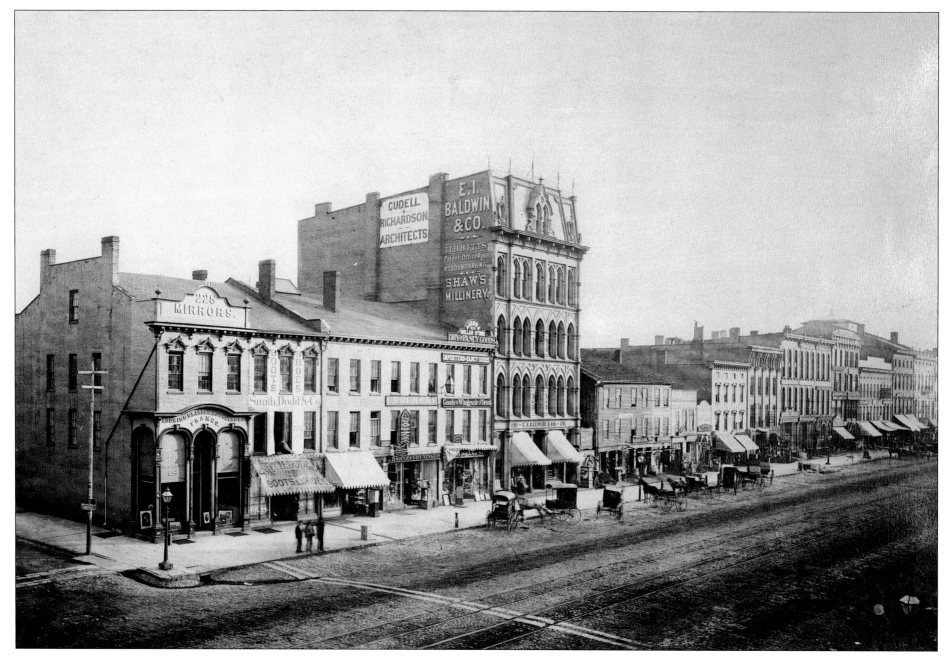

South side of Superior Street, west of Public Square in the 1870s. Superior Street served as Cleveland's first business district. Linking the docks and warehouses along the Cuyahoga River with the town center, Superior Street's importance grew after the opening of the Ohio & Erie Canal increased river traffic. It boasted the town's largest concentration of multistory brick buildings, which housed retail shops, wholesale traders, professional offices, and hotels.

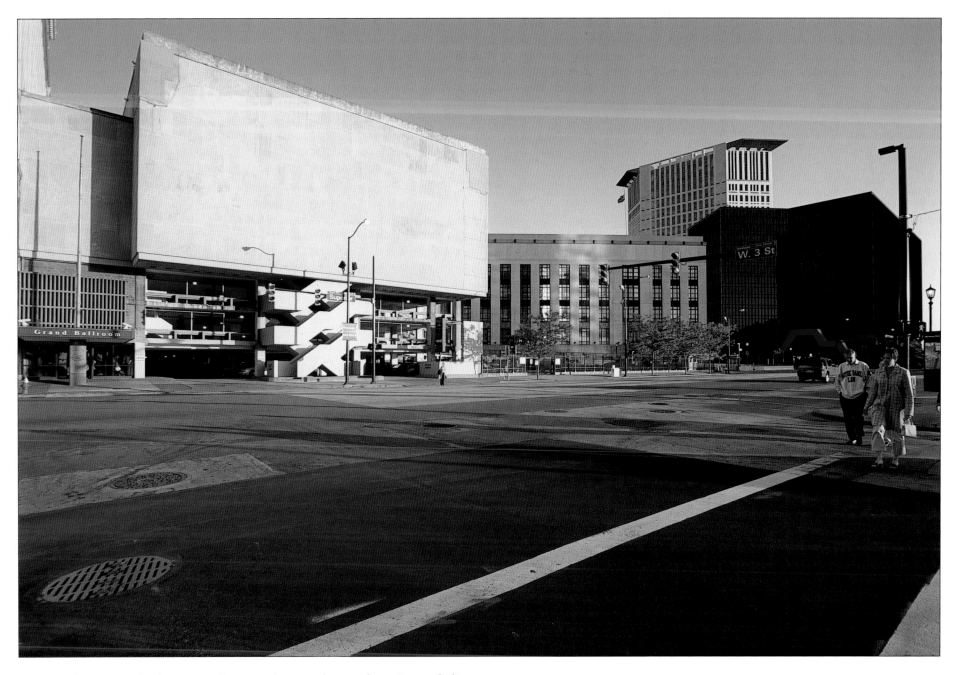

Superior Street is today known as Superior Avenue, having been "upgraded" to avenue status in 1852. A few large structures, including the Renaissance Cleveland Hotel and its ballroom (left), and the Frank J. Lausche State Office Building (right), have replaced the scores of smaller business buildings that once lined this section of the street.

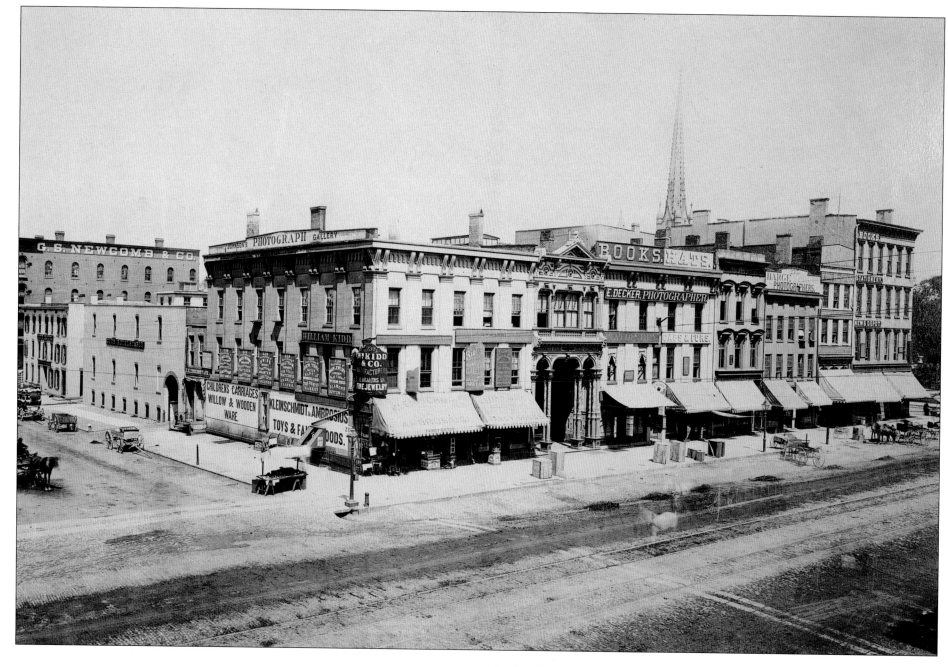

North side of Superior Street, west of Public Square in the 1870s. The one-block stretch of Superior between West Third Street and Public Square hosted a remarkable range of commercial enterprises. Businesses on the north side included stationers and furriers, plus several photography studios. Superior was generally the first of Cleveland's streets to receive the latest municipal improvements, such as the stone paving and gas streetlamps seen here.

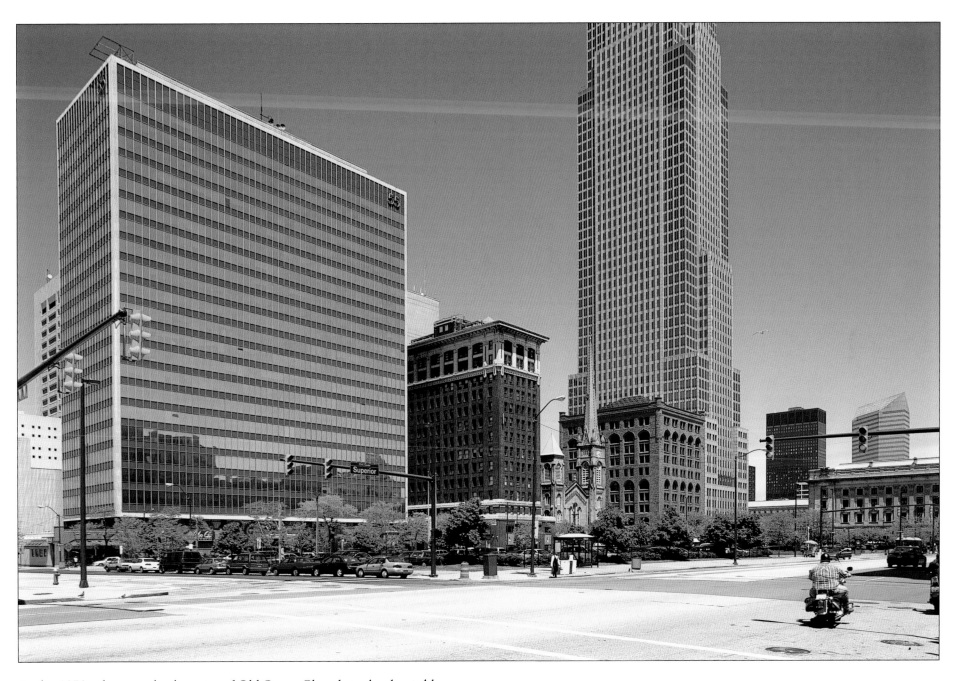

In the 1870s photograph, the spire of Old Stone Church is clearly visible above the roofs of the adjoining buildings. Today the entire church can be seen, as most of the north side of Superior from West Sixth Street to Public Square has been cleared of buildings. A major building project planned for Superior at Public Square in the 1990s failed to materialize, leaving that area as the only open side of the Square.

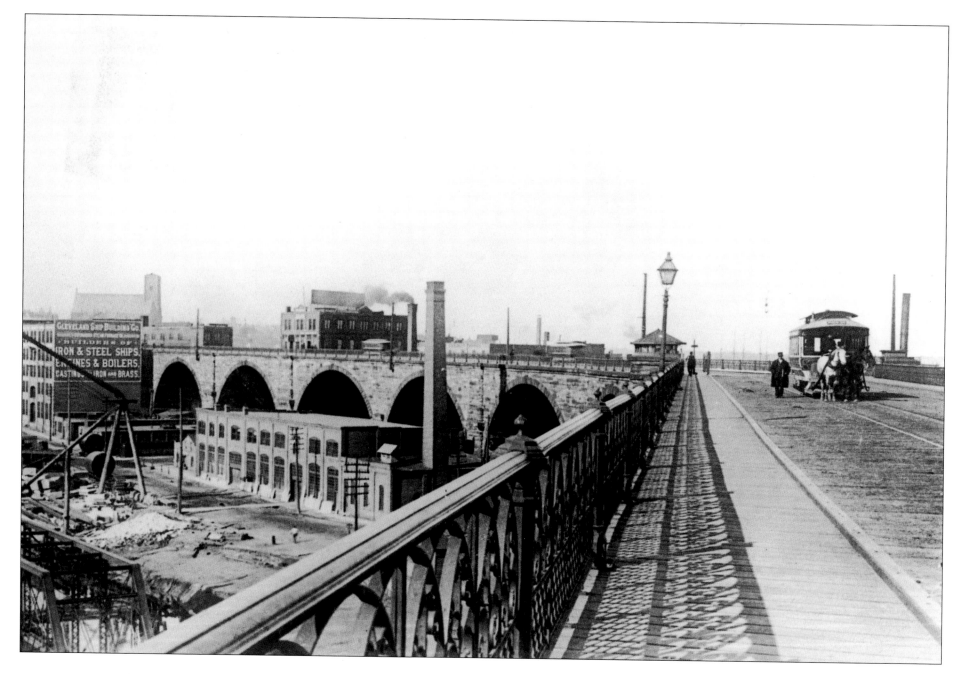

The Superior Viaduct, Cleveland's first high-level bridge, opened in 1878. It connected Superior Avenue on the east bank of the Cuyahoga with Detroit Avenue on the west. The 3,211-foot bridge was carried by grand stone arches at its western end and girders on the east. All traffic, including horse-drawn trolleys like the one in this 1890s photograph, came to a halt when the viaduct's pivoting center section opened to allow very large ships through.

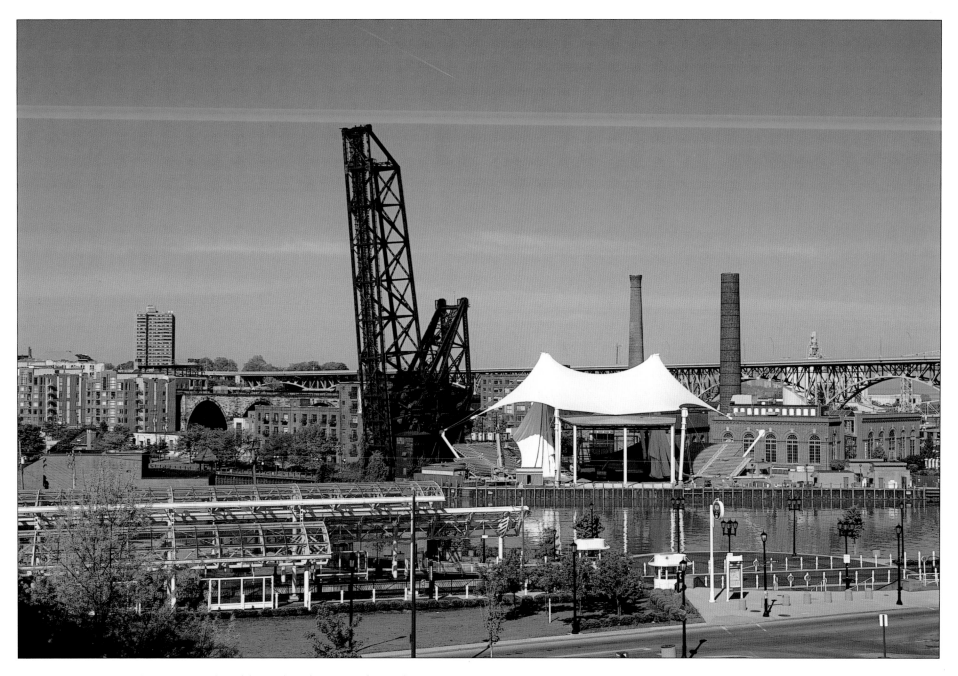

Traffic interruptions became a real problem when large numbers of automobiles began to use the span after 1910. The new Detroit-Superior Bridge opened in 1917, effectively replacing the viaduct, which closed in 1920 and was partially dismantled. Today its remaining stone arches, along with other relics like the Baltimore and Ohio jackknife bridge and a streetcar powerhouse, create a historic ambience for the modern entertainment district that thrives in what is known in Cleveland as the Flats.

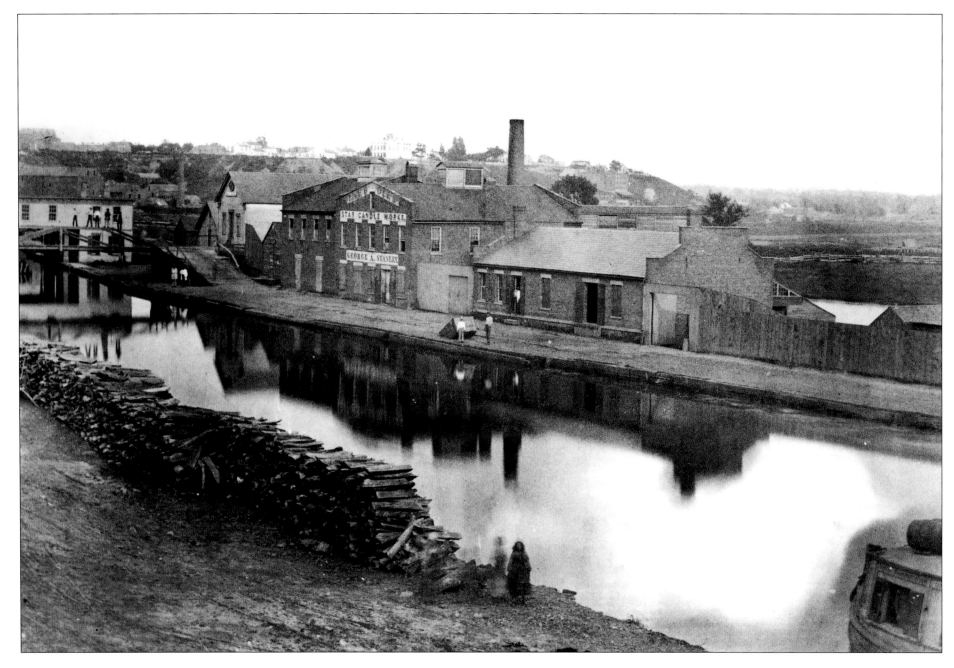

This, the earliest known photograph of the Ohio & Erie Canal in Cleveland, was taken near the canal's northern end at the foot of Superior Street in 1859. By this time, the waterway's useful life was nearly at an end, although it remained open for years. Completed in 1832, the canal linked the Ohio-Mississippi waterway with the Great Lakes. Cleveland, profiting from its position as the connecting port, grew exponentially in wealth and population.

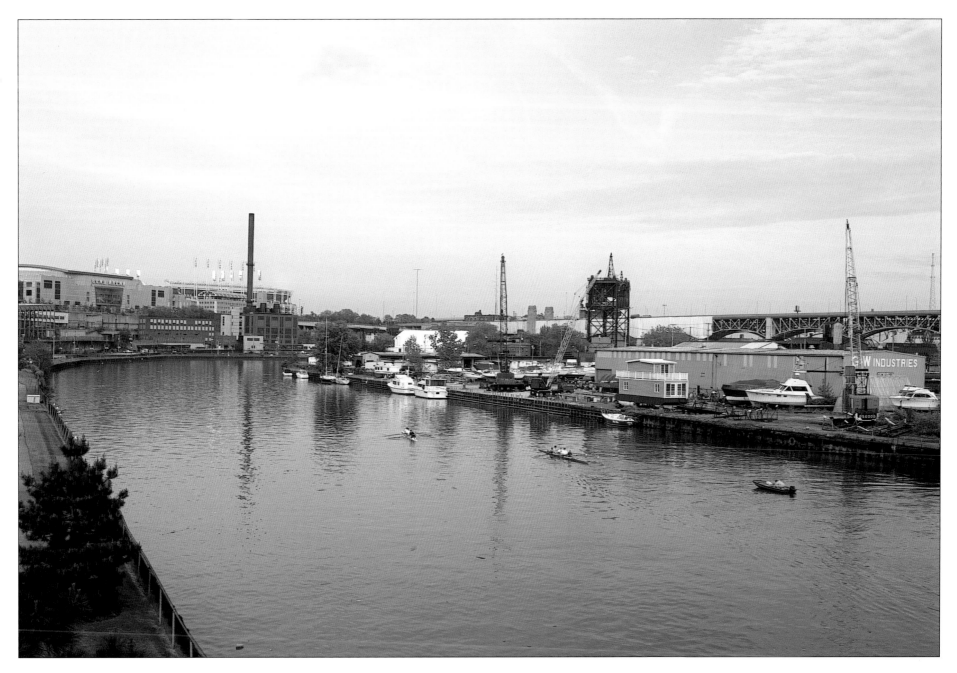

The most striking change in the view between then and now is that the canal no longer exists. The northern part of the canal bed was filled in later in the nineteenth century and used as a railroad right-of-way. The Cuyahoga River, formerly hidden behind the canalside buildings, is once again the sole waterway. Like the Flats, it is used increasingly today for recreation. The scullers are reviving a bit of Cleveland's past: In the 1850s, rowing clubs competed on the Cuyahoga.

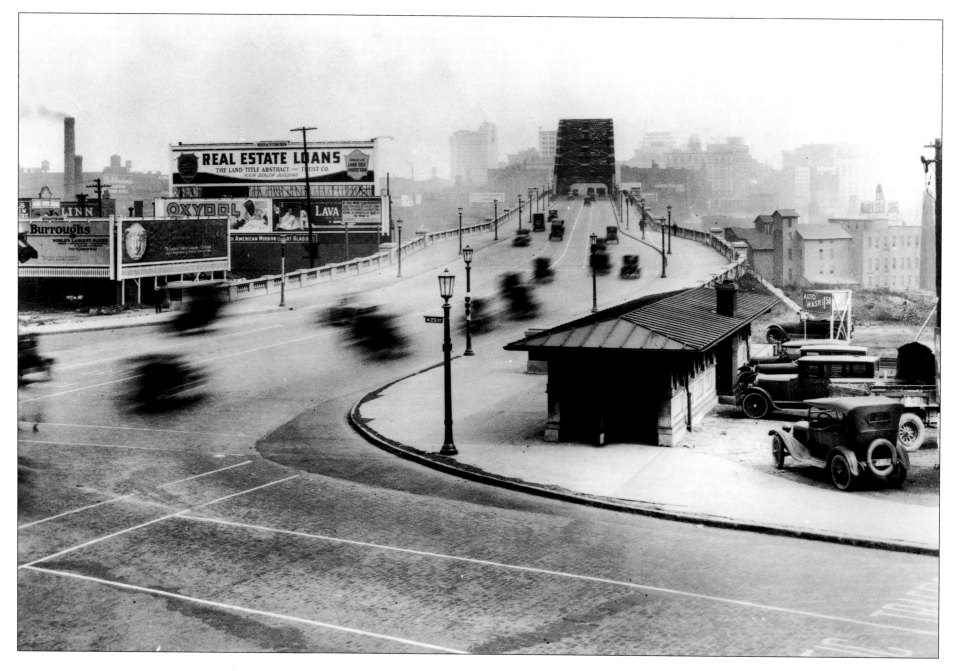

The Detroit-Superior Bridge was built just south of the old Superior Viaduct. Opened in 1917, the new, higher bridge had no need for a movable center span. For the first time, traffic could flow uninterrupted between the city's east and west sides, as in this 1920s view. The bridge had a lower deck with four sets of streetcar tracks. The upper deck was reserved for normal traffic and pedestrians.

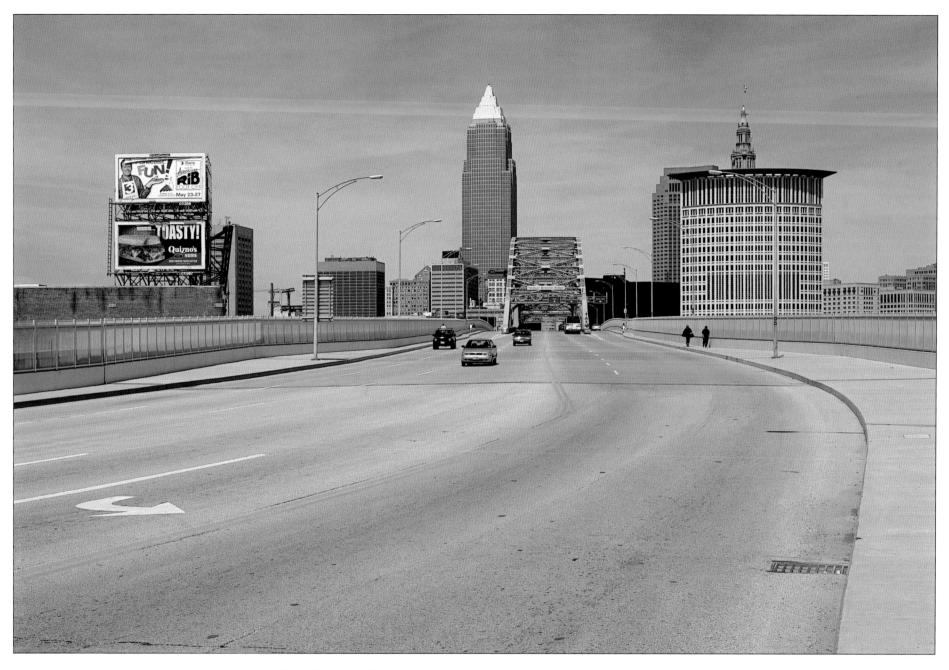

Cleveland's skyline looks very different today. The Terminal Tower, not seen in the older photograph, is here nearly hidden from view by the new Carl B. Stokes Federal Courthouse and eclipsed in height by the Key Tower, Cleveland's tallest building since 1991. Although the bridge itself appears basically the same, it, too, has changed. Its upper deck was widened and its lower level closed after Cleveland's streetcars ceased operation in 1954.

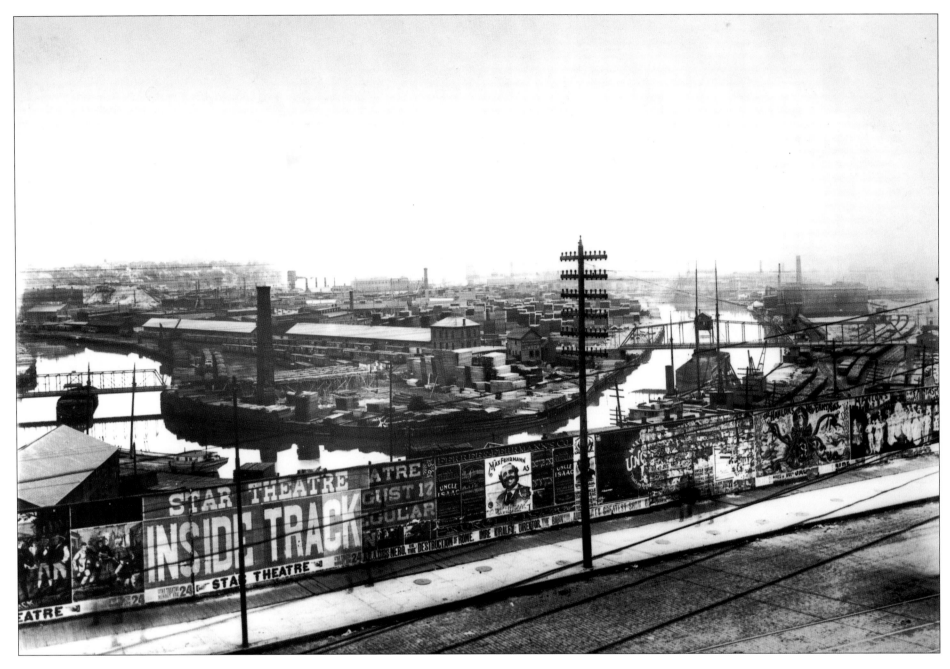

Moving further south along the Cuyahoga, this overview of the Flats shows Collision Bend, one of the biggest curves in the river. Shunned by most early settlers as the breeding ground of malaria, the flatlands along the lower reaches of the Cuyahoga became a flourishing industrial and commercial zone. In the late nineteenth century the area was a center of the lumber trade. Timber, much of it cut in Michigan, fueled the creation of several local fortunes and, on occasion, spectacular fires in the Flats.

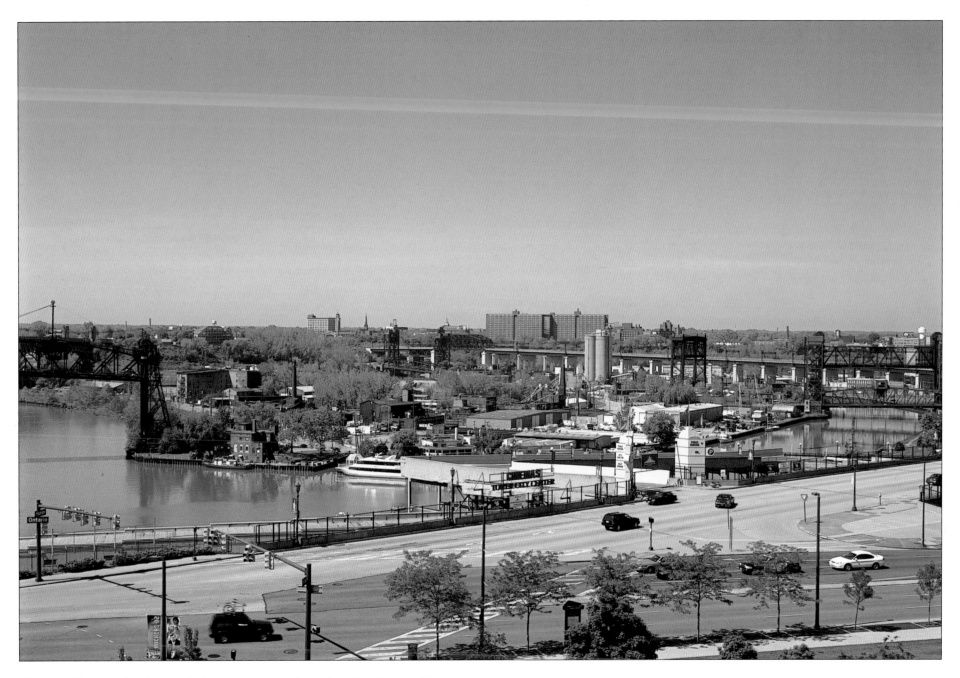

Cleveland's many bridges include more than a dozen low-level, movable bridges of various types spanning the Cuyahoga; some railroad bridges now generally remain open permanently due to lack of traffic. Several vertical lift bridges, including the Eagle Avenue Bridge (left) and the Carter Road Bridge (right), appear here. The city's waterfront firehouse, established years ago to fight lumber fires, also appears (left of the cruise boat).

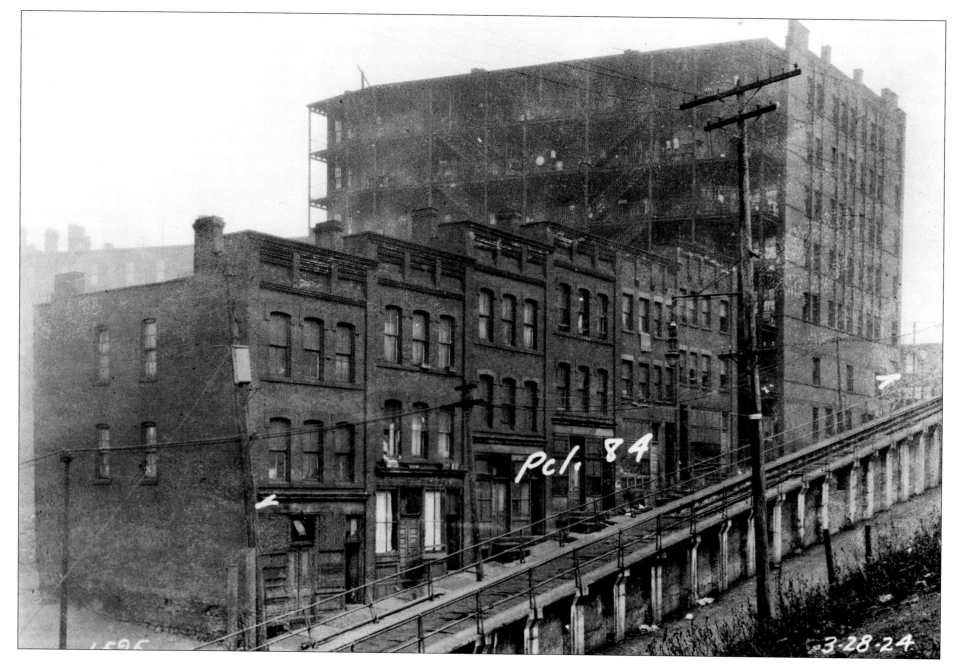

This photograph was taken in 1924 during the property acquisition process for the Terminal Complex construction. All of these structures were demolished for the project. The large building was one of Cleveland's few real tenements. The ramp in front, known as the "rolling road," carried traffic up the steep incline from the Flats beginning in 1905. For a fee, wagons were pulled up the road mechanically, saving horses the difficult climb.

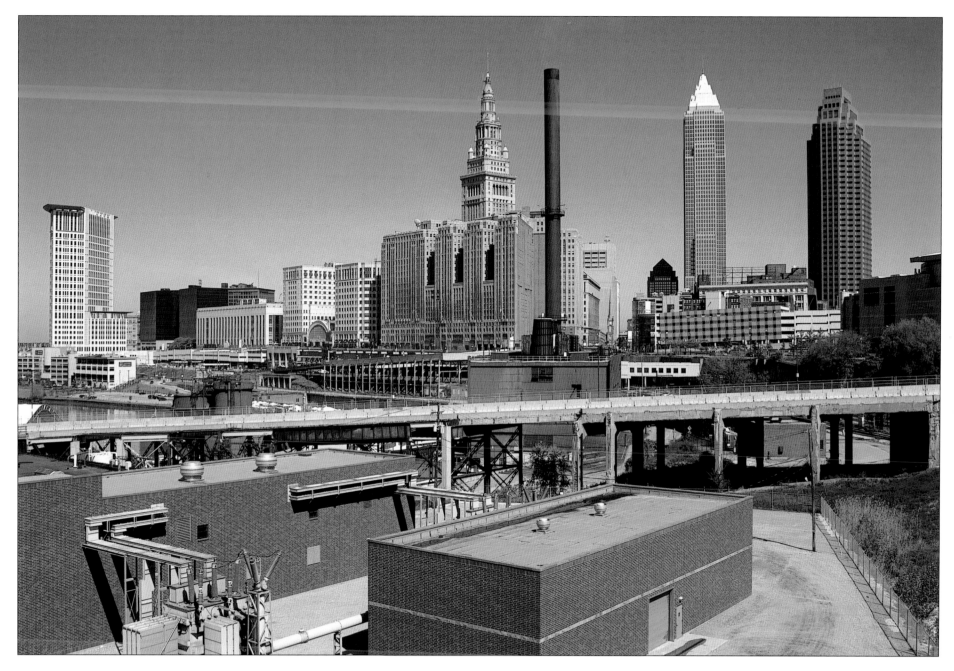

The construction of the Terminal Complex transformed this part of
Cleveland. Laying new rail lines to the terminal (along a route now used
by the Regional Transit Authority's rapid transit) required the obliteration of
streets and old homes on the east side of the valley. Landmarks like Vinegar
Hill, once the site of a redolent vinegar works, and the old rolling road
disappeared. Today the Eagle Avenue ramp approximates the rolling
road's location.

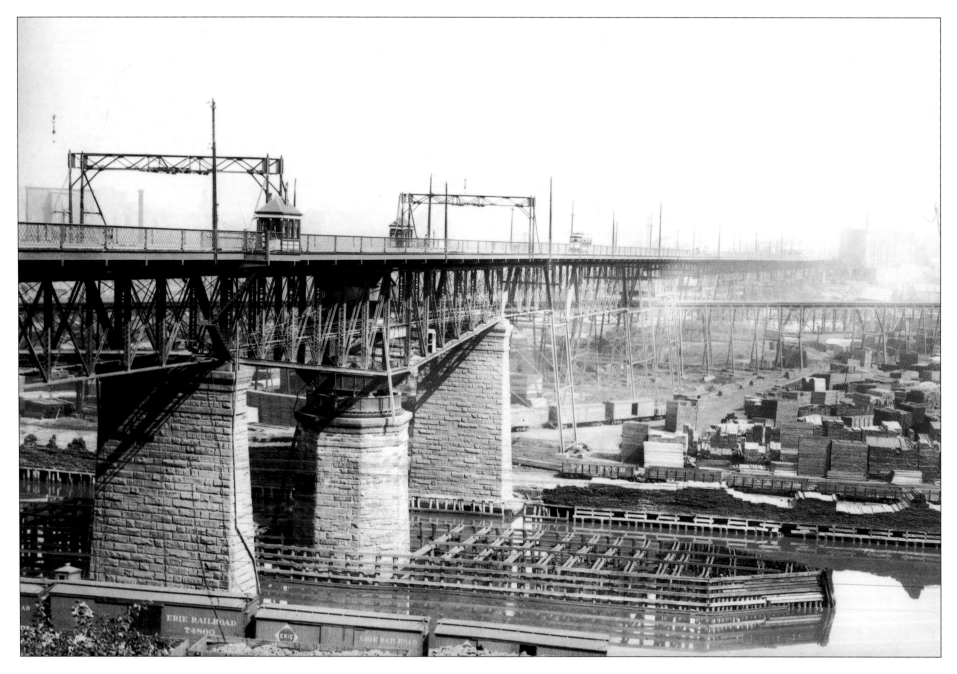

The Central Viaduct, opened in 1888, was the southernmost of the nineteenth-century high-level bridges across the Cuyahoga. Like the older Superior Viaduct, it had a movable section to let very tall ships pass. In 1895 a streetcar fell through the open bridge to the river below, killing seventeen people. In this c. 1900 view from the river's western side, the 2,839-foot viaduct spans a chaotic jumble of railways and lumberyards.

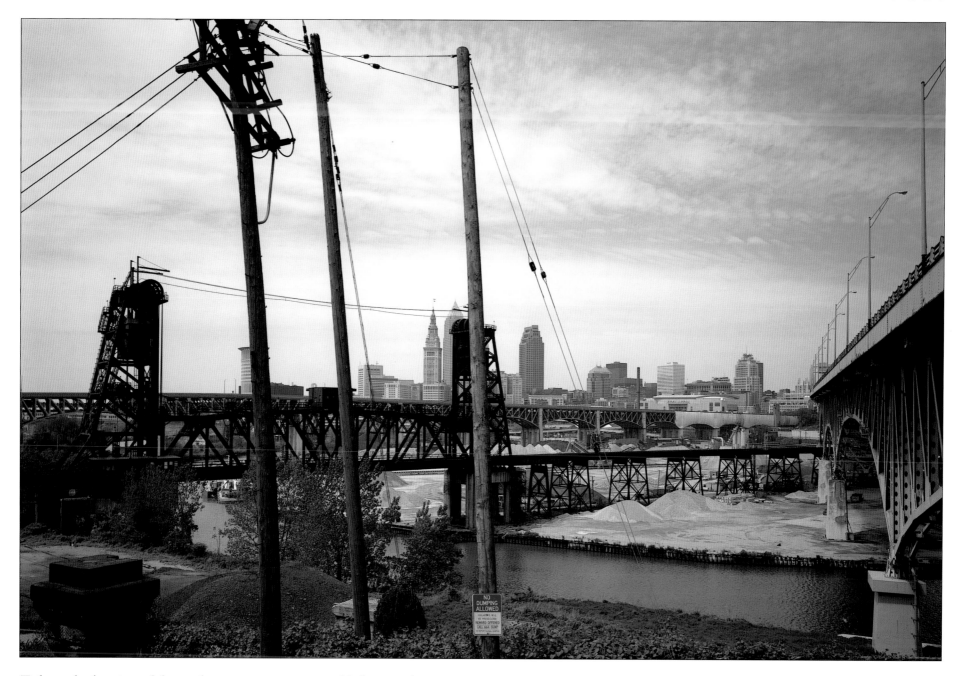

Today only the piers of the viaduct remain; two are visible here in the foreground. The bridge was closed in 1941 and demolished for scrap during World War II. The Innerbelt Bridge, on the right in the photograph, replaced it in 1959. Crossing the valley below the higher bridges in both images is the Nickel Plate Railroad viaduct, which is today very much in use as part of the Norfolk Southern system.

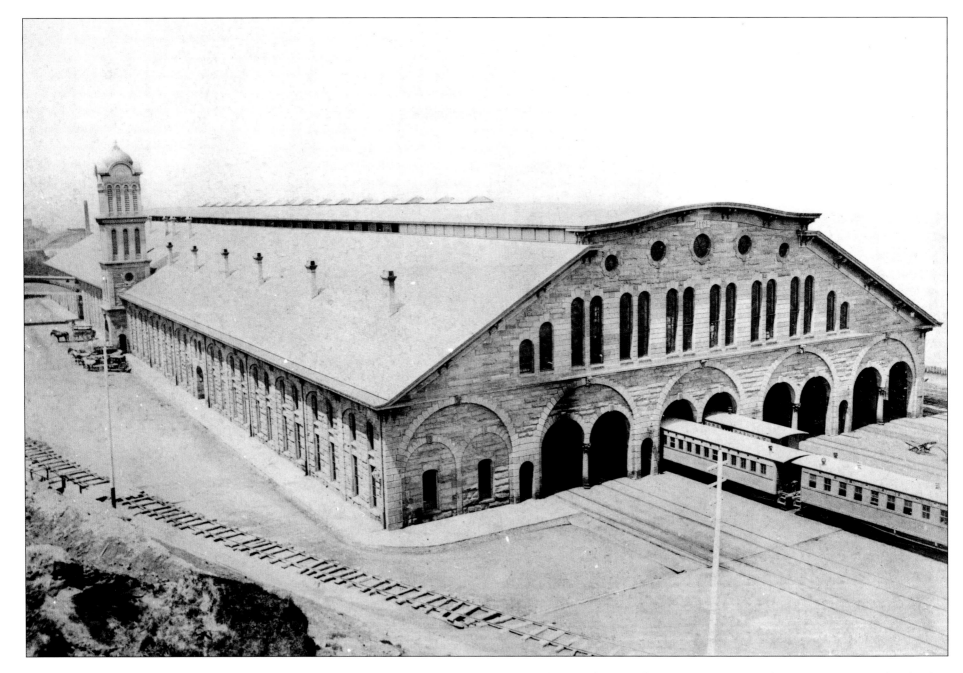

When Cleveland's second Union Depot opened in 1866, it was said to be the largest building under one roof in the world. This was accomplished primarily through the use of structural iron, a major architectural innovation appropriate to a burgeoning iron-manufacturing center like Cleveland. The depot's walls were of sandstone quarried in nearby Berea. The city's first Union Depot, a wooden structure, had burned in 1864.

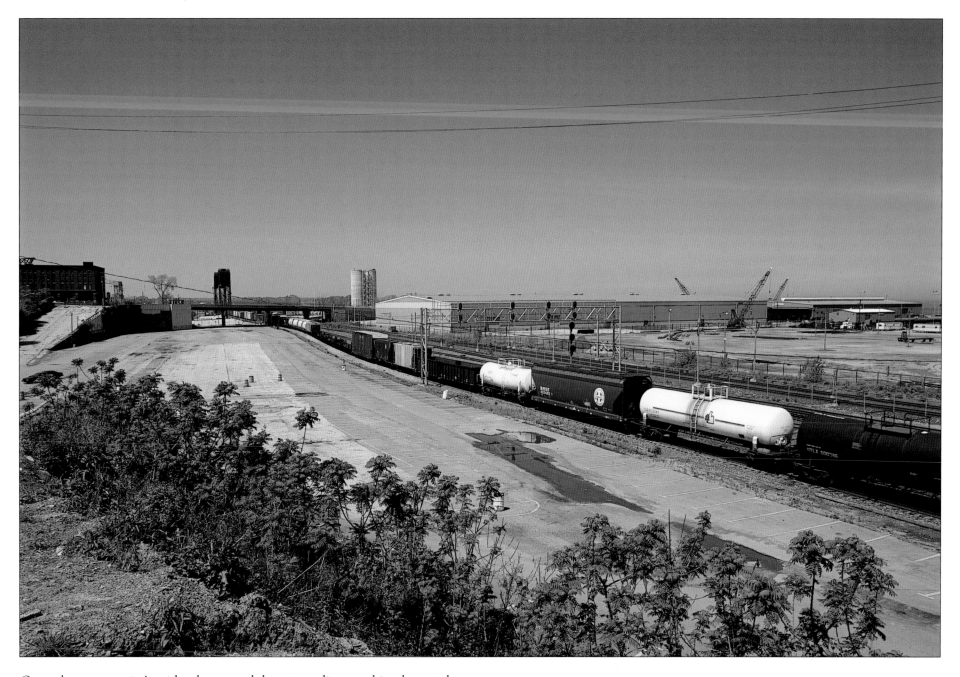

Once the community's pride, the second depot was dingy and inadequate by the time Union Terminal opened in 1930. The Pennsylvania Railroad nonetheless used it until 1953. By then the famous roof had been removed, leaving only the tower and waiting room. Today a sandstone retaining wall is still visible (right of the ramp in this photograph) near West Ninth Street. Although the passenger depot is gone, dozens of trains pass the site daily on the busy New York–Chicago line.

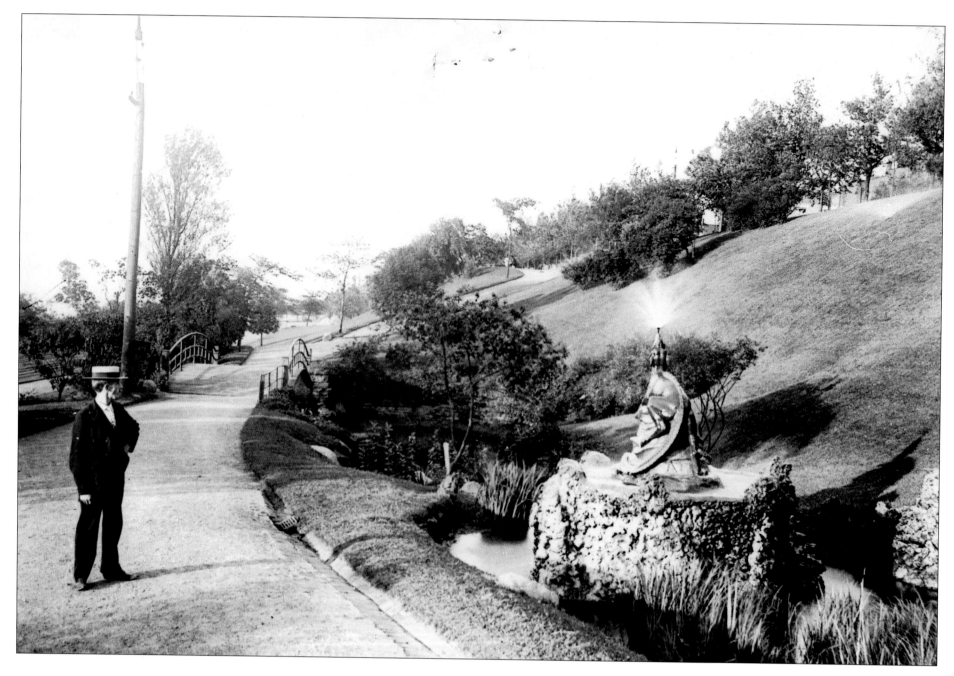

Much of Cleveland's Lake Erie shore was given over to railroads and industry, indicating the city's main priorities in the mid-nineteenth century: growth and prosperity. With the creation of Lake View Park on a bluff of land between Ontario and Erie Streets in the 1870s, the city acknowledged that the lakefront just might have recreational and aesthetic, as well as economic, value. The park, landscaped with drives, walks, and miniature bridges and lakes, was a popular spot for picnics and band concerts.

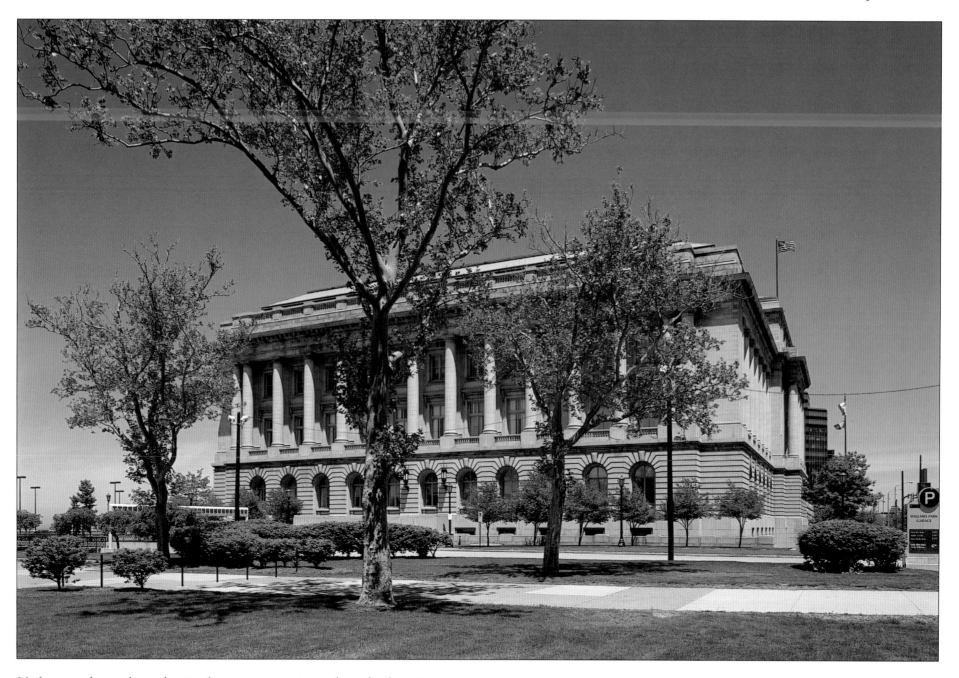

Unfortunately, smoke and noise from passing trains and nearby factories made Lake View Park an increasingly less idyllic spot. It fell into disuse and its site was eventually incorporated into the 1903 "Group Plan" that called for construction of new civic buildings around a central open mall. Today the beaux-arts–style Cleveland City Hall (1916) stands at the mall's northern end on land once occupied by the park.

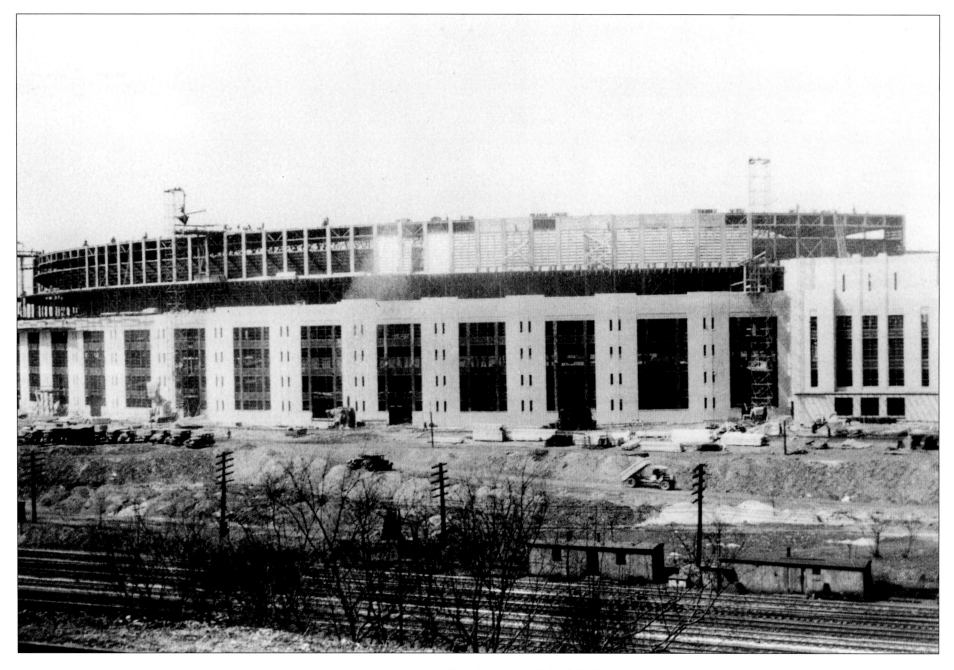

Development of the lakefront for recreation and entertainment made a giant leap forward in the 1930s. Although railroads continued to occupy much of the natural shoreline, landfill created a new shoreline beyond the tracks. Cleveland Municipal Stadium, financed by a voter-approved bond issue, was envisioned as a venue for a variety of sporting and other events. Shown here under construction on the landfill, it opened in 1931 with a championship boxing match. Its nearly 80,000 individual seats gave it the largest official seating capacity of any outdoor arena anywhere.

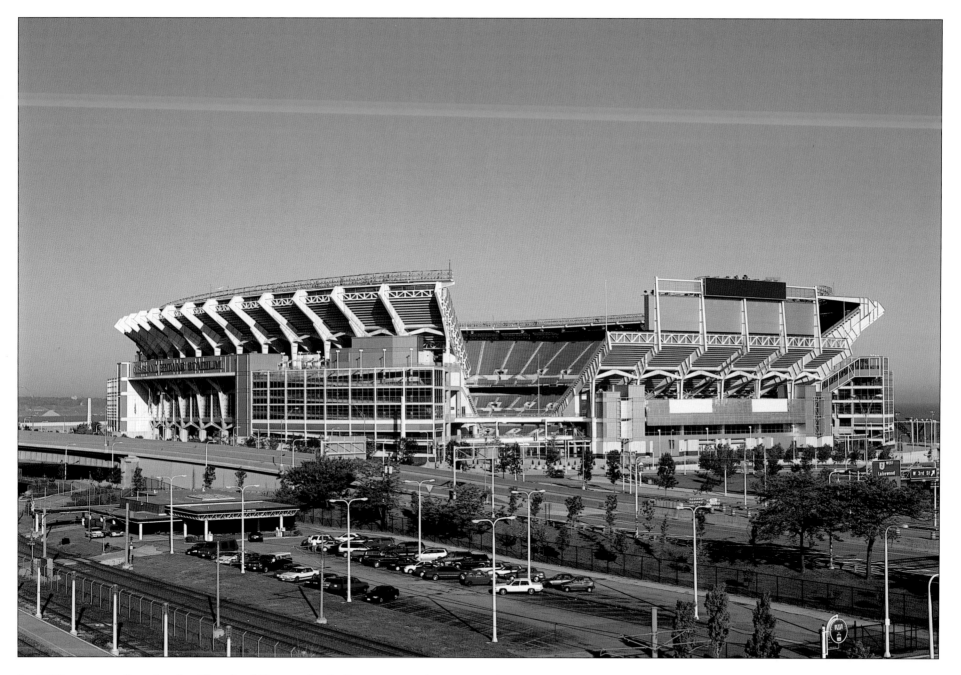

In 1999 a new stadium for the Cleveland Browns football team opened on the site. The old Municipal Stadium, razed in 1996, had accommodated both the Browns and the Cleveland Indians baseball team. As sports teams became civic status symbols in the late twentieth century, competition for major league franchises meant that Cleveland, like other cities, had to provide upgraded, separate facilities for its various teams.

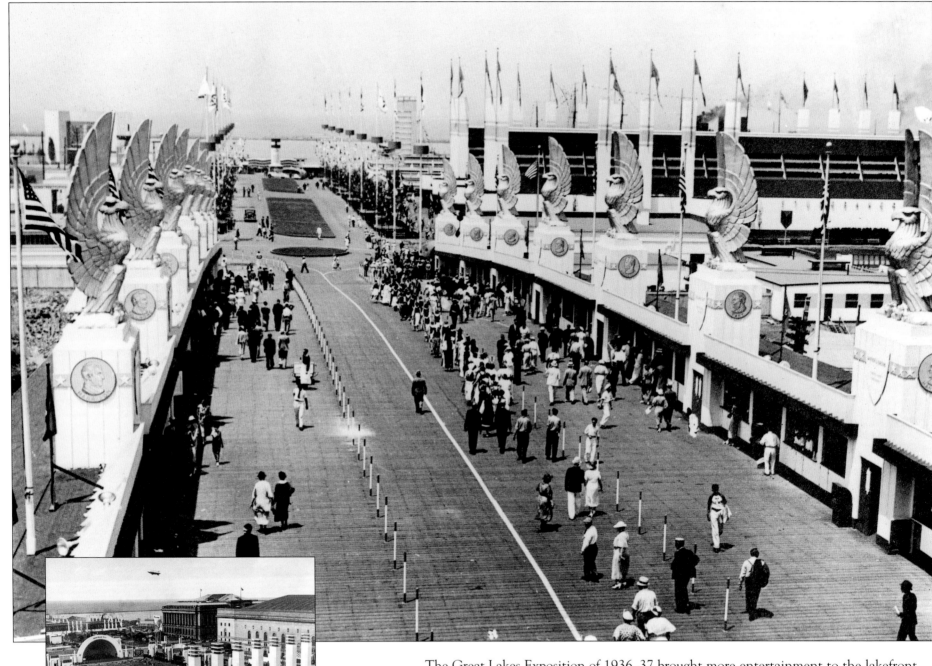

The Great Lakes Exposition of 1936–37 brought more entertainment to the lakefront. Here, visitors use the "Bridge of the Presidents" to cross over the railroad tracks. Like Chicago's Century of Progress and New York's World's Fair, Cleveland's Depression-era exposition featured pavilions in the Art Deco and Moderne styles, housing exhibits, entertainments, and attractions designed to dazzle the public. The inset picture shows the exposition grounds, occupying the landfill area, and the mall, stretching from the east side of Municipal Stadium to today's Burke Lakefront Airport site.

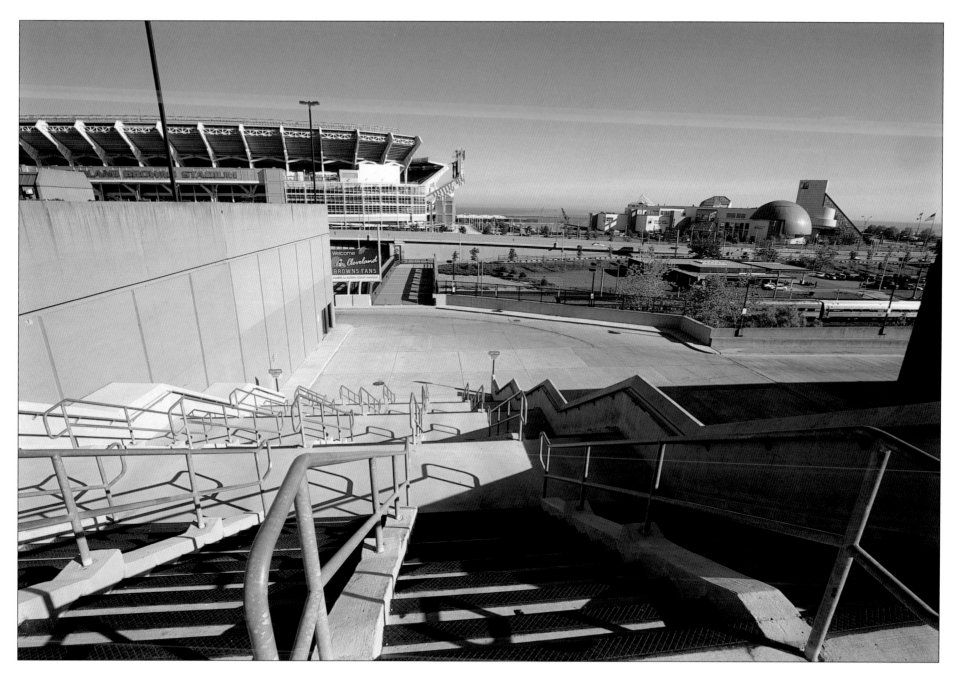

Although the appearance of the site is quite different over sixty years later, the purposes for which it and the surrounding area are used are remarkably similar. In the contemporary view, a utilitarian concrete bridge leads across the railroad tracks to Cleveland Browns Stadium in the background. To the right of the stadium, the Great Lakes Science Center and the Rock and Roll Hall of Fame and Museum aim to attract, delight, and educate local visitors and tourists.

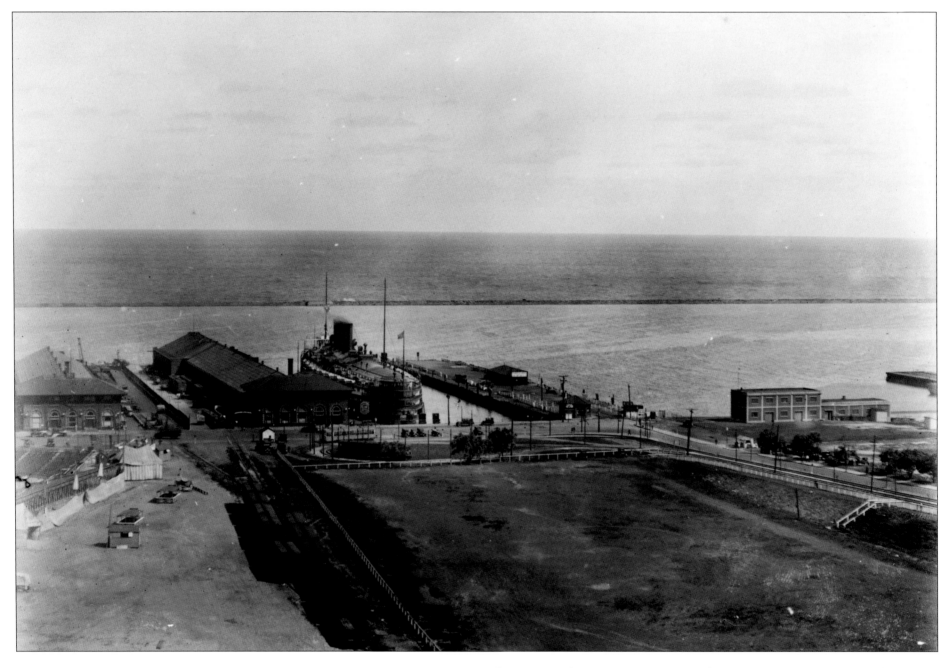

The East Ninth Street Pier was once the scene of many comings and goings to Cleveland. Before its completion in 1915, most passenger-carrying vessels had tied up at a wharf near the mouth of the Cuyahoga. Now passengers could board and disembark at a lakefront pier away from the noises, dirt, and smells of the river docks. Steamship companies offered regular services to Detroit, Buffalo, and holiday destinations, like nearby Cedar Point. A streetcar line took passengers directly to the pier.

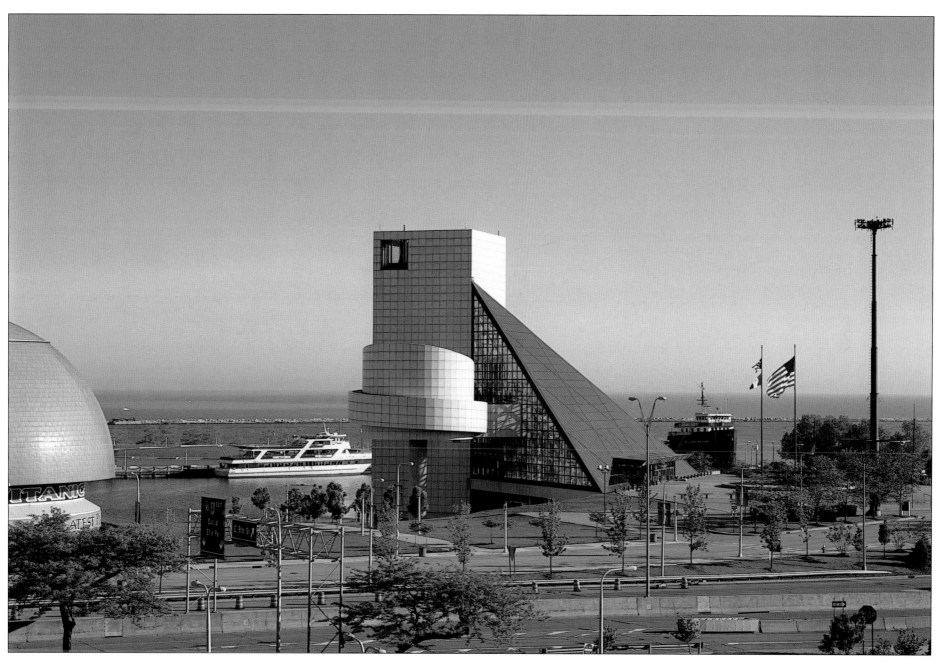

Today the Rock and Roll Hall of Fame and Museum, in a glass-faced pyramid designed by I. M. Pei, dominates the site. Because Cleveland music promoters—in particular disc jockey Alan "Moon Dog" Freed—played a key role in naming and popularizing the new genre, Cleveland claimed the title "birthplace of rock and roll" and mounted a successful campaign to win the proposed Rock and Roll Hall of Fame, which opened in 1995. Docked at the old East Ninth Street Pier, the steamship *William G. Mather* (right), now a floating museum, memorializes another part of Cleveland's history—lake shipping and the iron trade.

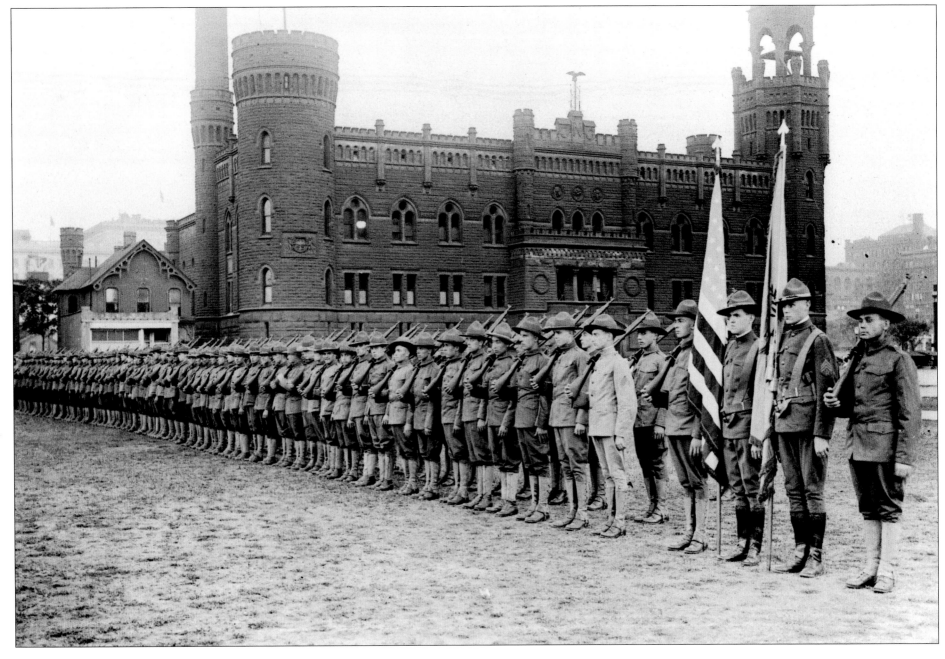

Troops drilling outside Cleveland Central Armory, World War I. The castellated "fortress" stood at Lakeside Avenue and East Sixth Street from 1893 to 1965, reminding us that homeland security is not a new concern. Armories like this were built in many U.S. cities in the late nineteenth century as bastions against civil unrest following violent strikes in 1877. The Cleveland Armory housed local National Guard units, but also served as an exhibition and meeting hall.

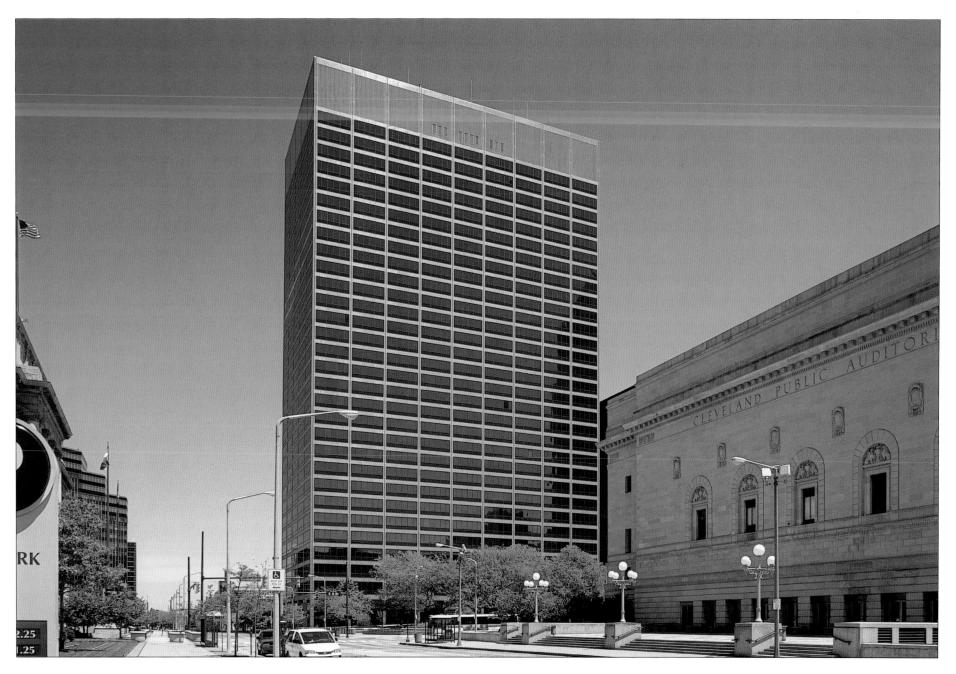

The Federal Building, named for Anthony J. Celebrezze, a popular Cleveland mayor (later U.S. Secretary of Health, Education, and Welfare, and then a federal judge), now occupies part of the site. Completed in 1967 as a component of the Erieview urban renewal plan, this structure is the stylistic antithesis of the old armory. The fanciful fortress, an overt symbol of armed might, has been replaced by a glass and steel monolith whose sleek face conceals its purpose and inner workings.

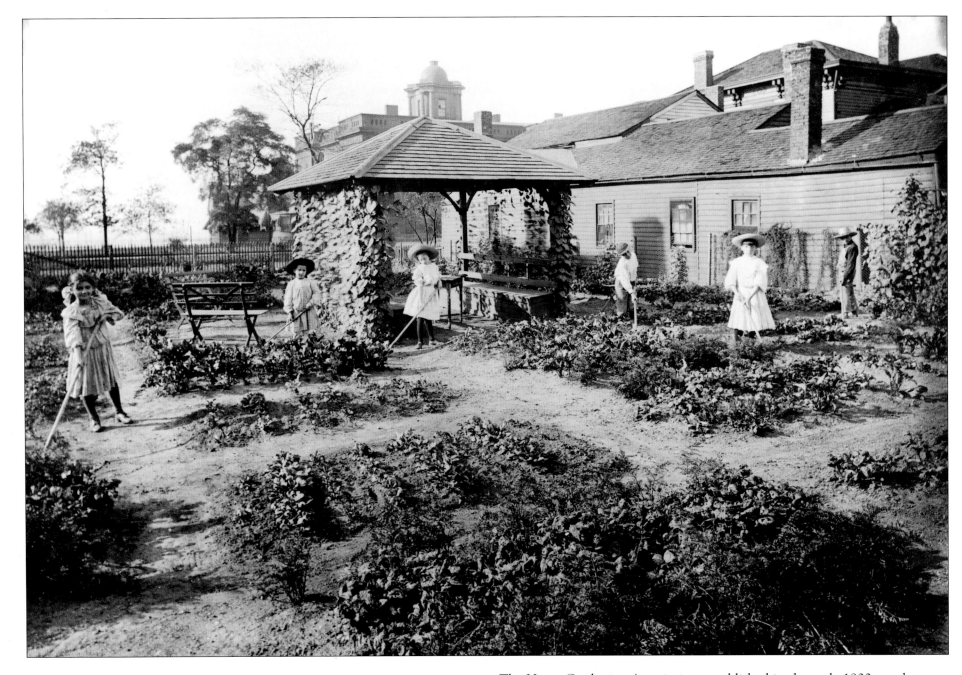

The Home Gardening Association, established in the early 1900s, took a positive approach toward promoting civic harmony. Its founders hoped to encourage urban gardening, beautify the city, and teach children about plants and nature. These children are tending a plot near the southwest corner of Lakeside and East Ninth Street. As with Lake View Park, this scene looks more peaceful than it really was. The lakeshore railroad tracks were only a stone's throw away.

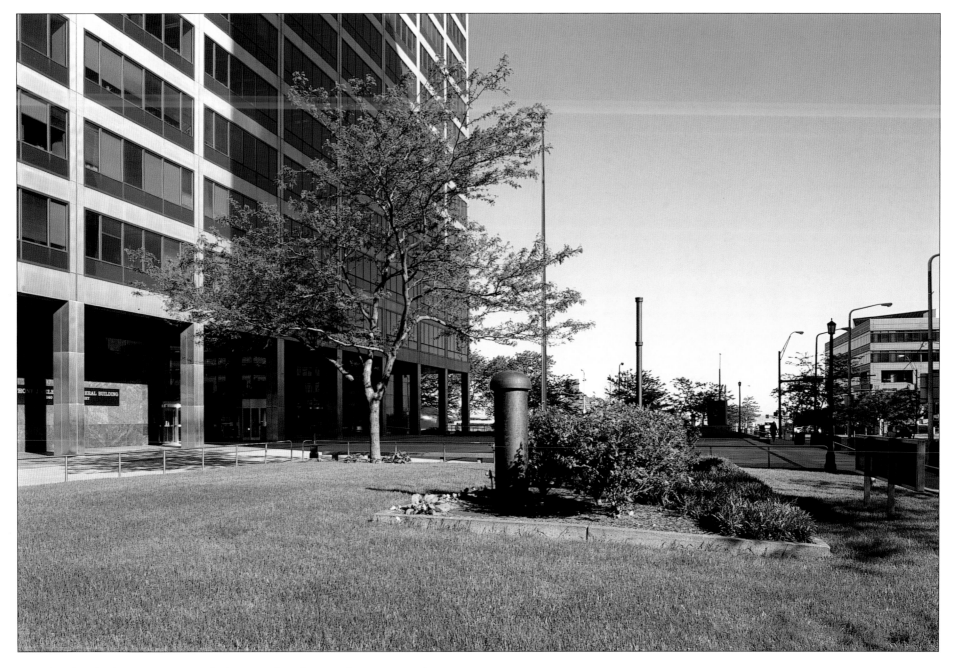

As Cleveland's downtown expanded outward and upward, property values increased and office buildings replaced the area's few remaining homes and gardens. This view, from East Ninth Street looking north toward Lakeside Avenue, shows the side of the Celebrezze Building opposite to that in the previous pair of photographs. A small planting next to the building is the only modern counterpart to the children's garden.

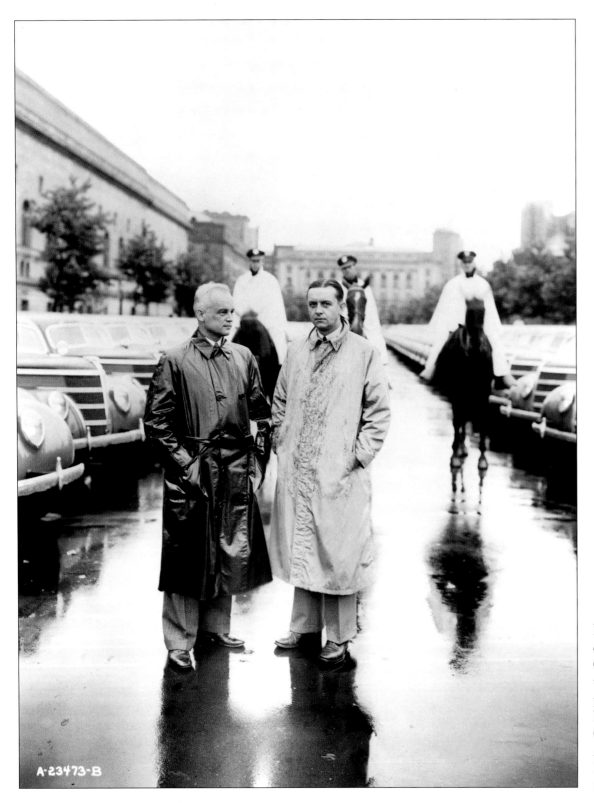

A·23473·B

Eliot Ness, famed as head of the Untouchables, the federal officers who brought Al Capone to justice, served as Cleveland's safety director from 1935–42. Here, he stands with Mayor Harold Burton in front of a double row of new police cars parked on Cleveland's Mall. The cars symbolized Ness's drive to modernize Cleveland's safety forces. Cleveland's convention and exhibition hall, the Public Auditorium (left), the Cleveland Board of Education Building (behind it), and the Federal Courthouse (background) are grouped around the Mall.

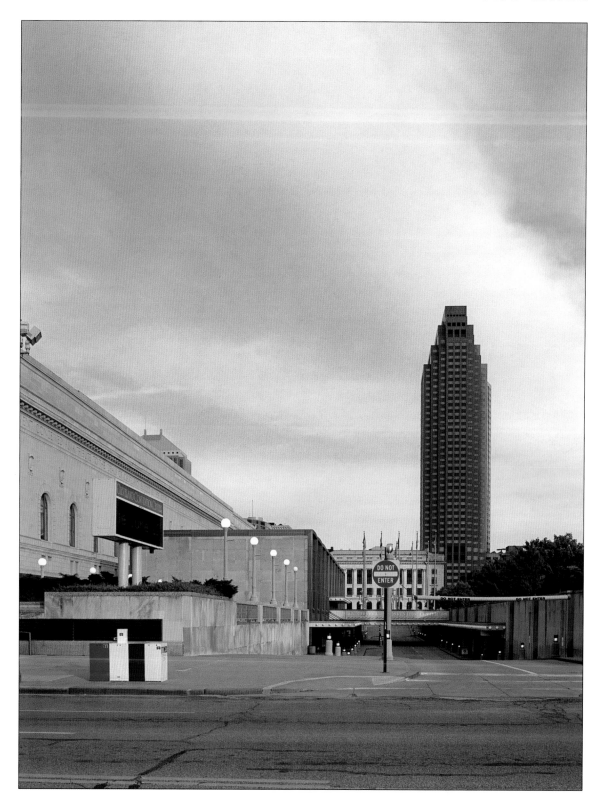

Construction of a new convention center complex designed around the Public Auditorium changed the face of this part of the Mall in the 1960s. The Mall was excavated to provide more convention space and underground parking, with a ramped drive to its new modern lobby. The Federal Courthouse, renamed in honor of U.S. Senator Howard M. Metzenbaum, is in the middle distance across Rockwell Avenue; the BP Building towers above the scene.

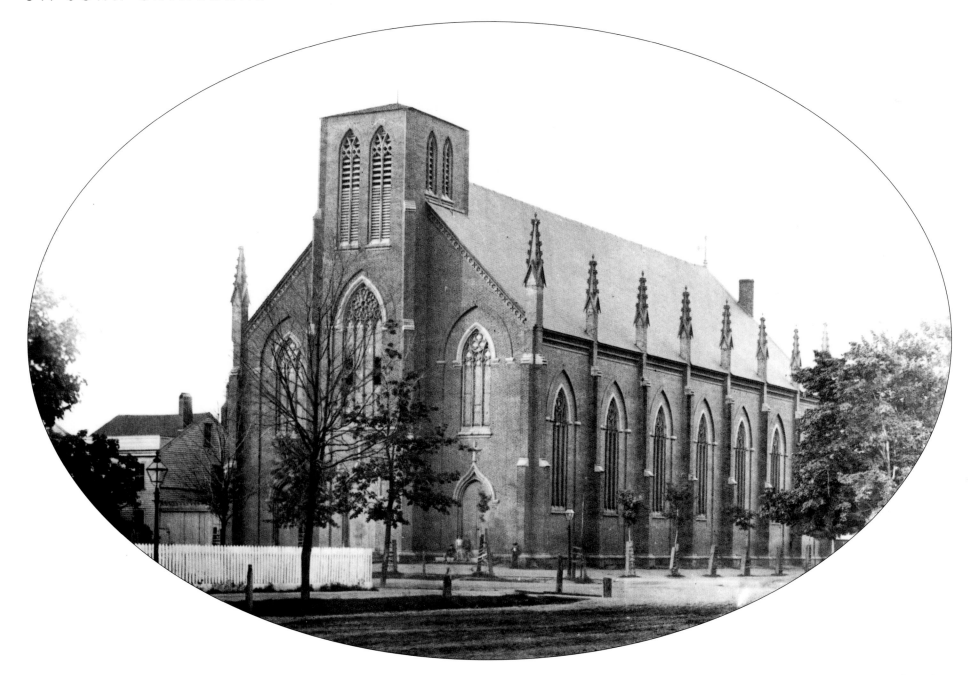

St. John Cathedral, 1859. When the Cleveland Catholic diocese purchased land for its cathedral in the 1840s, the site at Erie (now East Ninth) Street and Superior was at the city's edge. An influx of Irish and Catholic Germans to the largely Protestant town in the 1830s and 1840s created the need for a diocese and cathedral. The building, designed primarily by renowned church architect Patrick Charles Keeley in the Ornamental Gothic style, was completed in 1852.

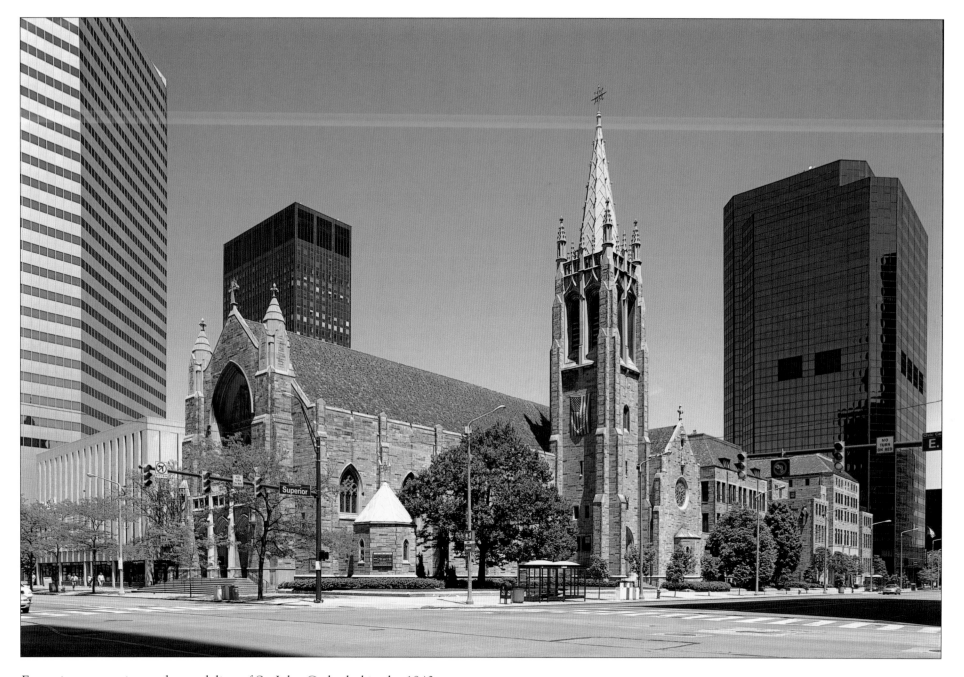

Extensive renovation and remodeling of St. John Cathedral in the 1940s
totally changed its appearance. The auxiliary structures beside and behind the
cathedral include the diocesan chancellery building. The building visible
above the facade of the church is Erieview Tower, centerpiece of the Erieview
Plan, a controversial 1960s urban redevelopment scheme intended to bring
new vitality to the east downtown area.

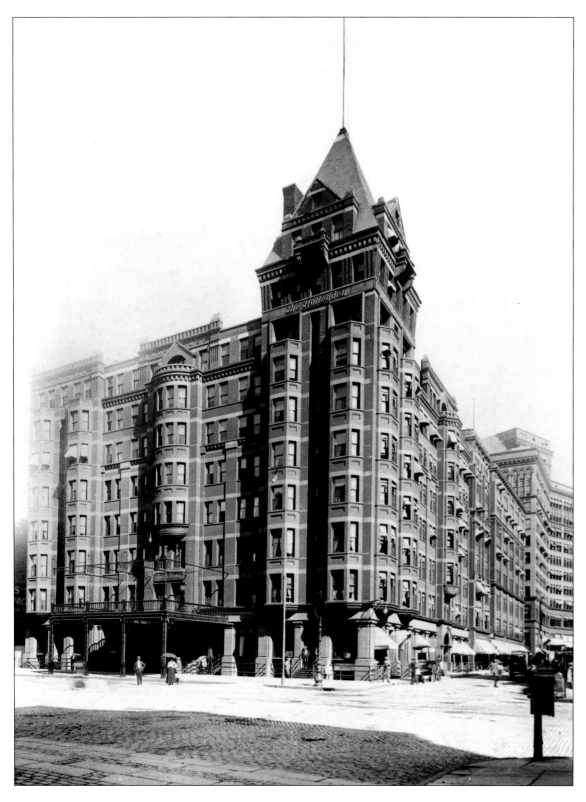

The Hollenden Hotel at the corner of Superior and East Sixth Street was Cleveland's most famous hotel in its day. Opened in 1885, it was the first large hotel east of Public Square. Eight stories tall, the Hollenden had electric lights and luxurious interior fittings, and attracted famous guests including celebrities, industrialists, and U.S. presidents. Its dining room was popular with local politicians. This photograph dates from the early 1900s.

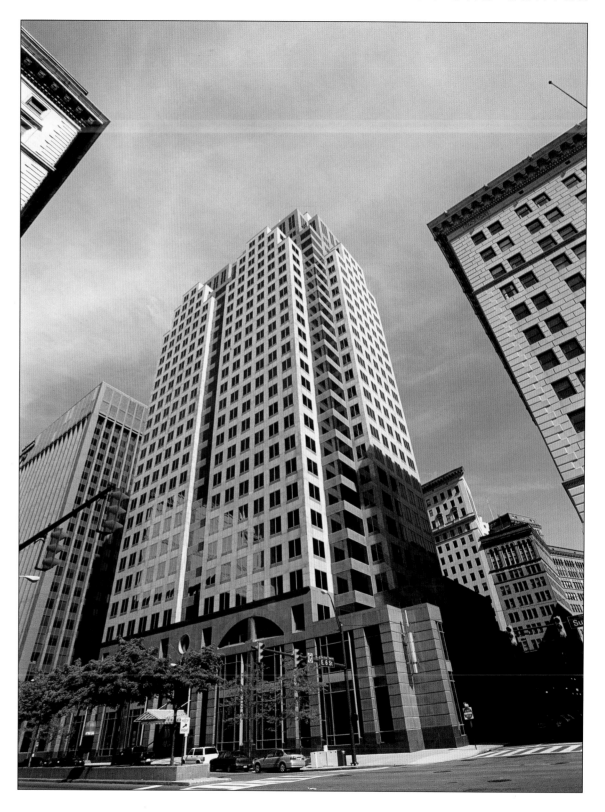

A major addition in the 1920s gave the Hollenden a total of 1,000 rooms, but over the years occupancy rates dropped. The original hotel was demolished in 1963, and the nondescript, 400-room Hollenden House was built on the site. The second Hollenden went the way of its predecessor and was replaced by the far more attractive Bank One Center, shown here.

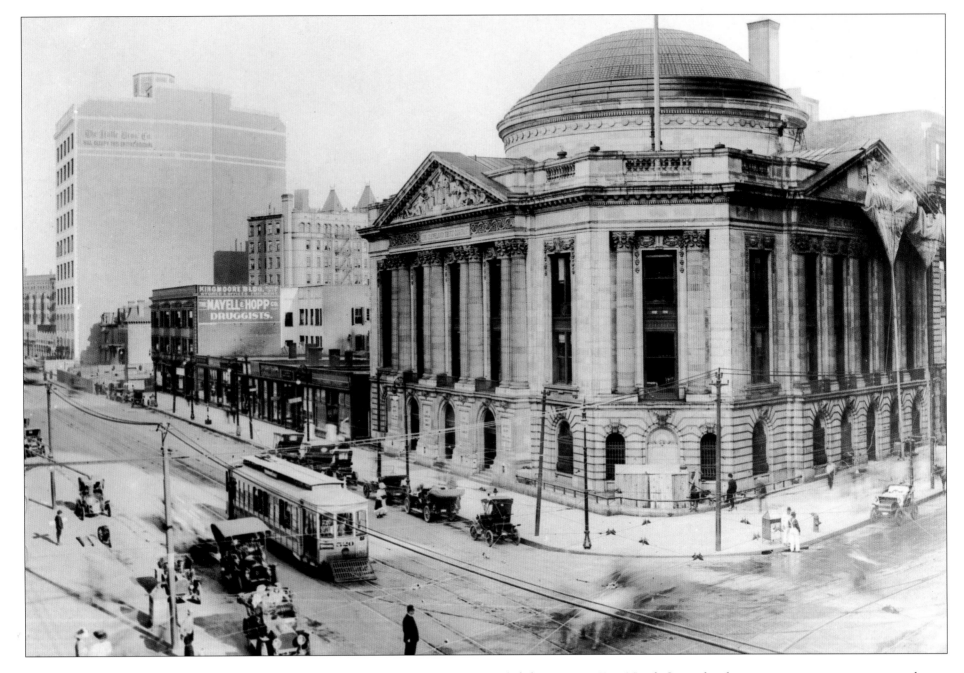

Euclid Avenue at East Ninth Street has been a major intersection since the late nineteenth century. In this 1910s image, streetcar lines and private cars share the road. In 1905–08 the Cleveland Trust Company, for years the city's largest and most influential bank and also one of the nation's largest banks, constructed its headquarters at the southeast corner. A sixty-one-foot Tiffany glass dome graces the interior of the temple-like building's rotunda.

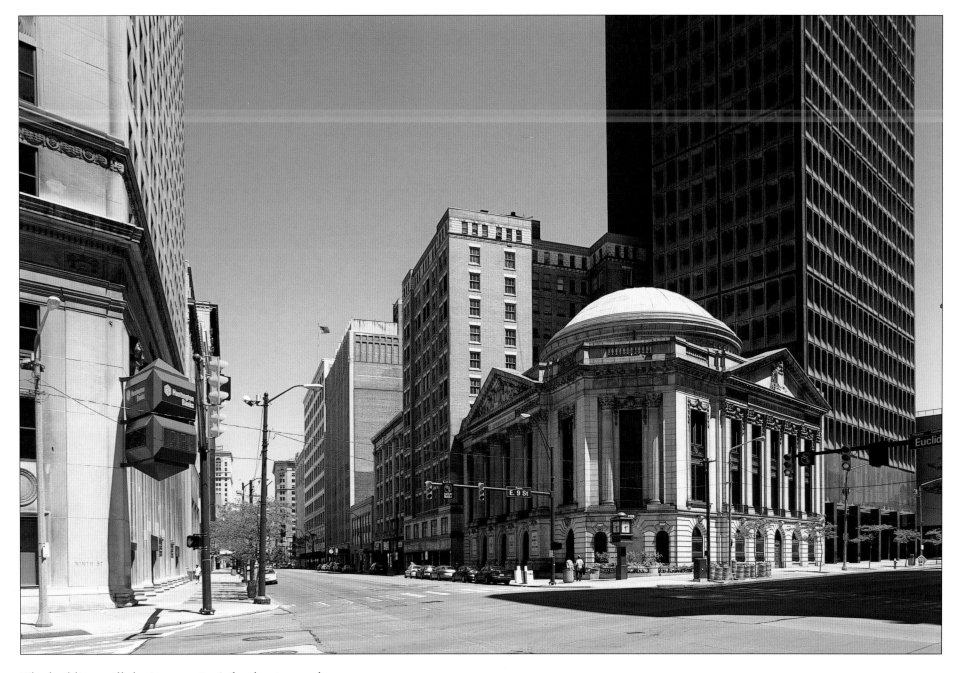

The building, still the intersection's focal point, no longer serves as a bank. Cleveland Trust itself is gone, or more accurately, has integrated with other financial institutions through successive mergers. Today its descendant is KeyCorp, which maintains its headquarters in Cleveland's tallest building on Public Square. The intersection remains a financial hub. Huntington National Bank occupies the northeast, and National City, the northwest corner.

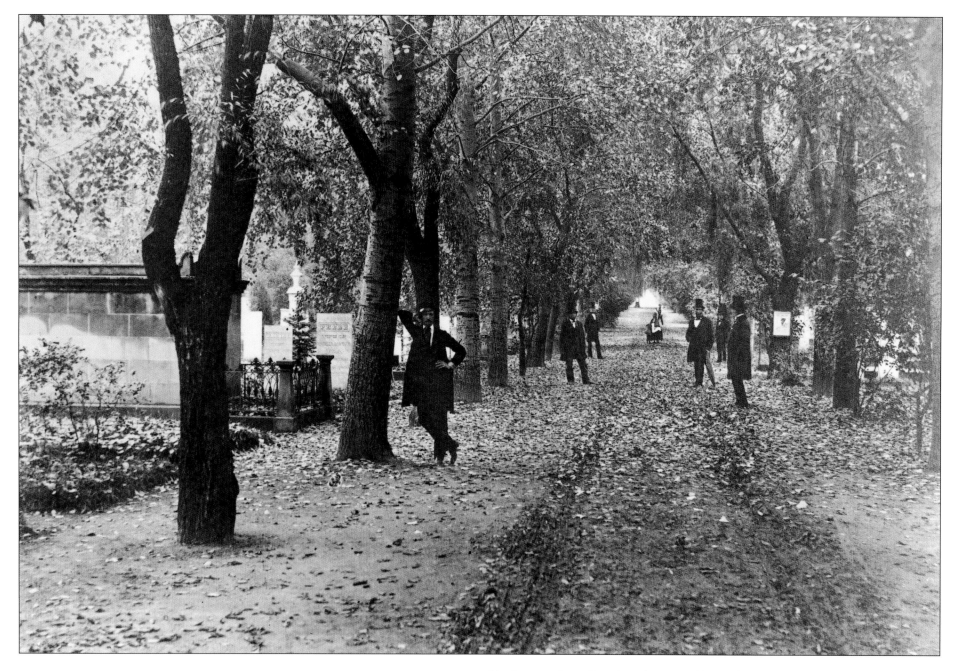

Further south on East Ninth Street (formerly Erie Street) is the Erie Street Cemetery. Cleveland's first major cemetery, it seemed a remote spot when the city government purchased the land in 1826, but was already considered outdated by the time of this photograph (1859). Early Cleveland figures like Lorenzo Carter, a colorful tavern keeper and trader credited as being the town's first permanent settler, and Joc-O-Sot, a Sauk chief, were buried here.

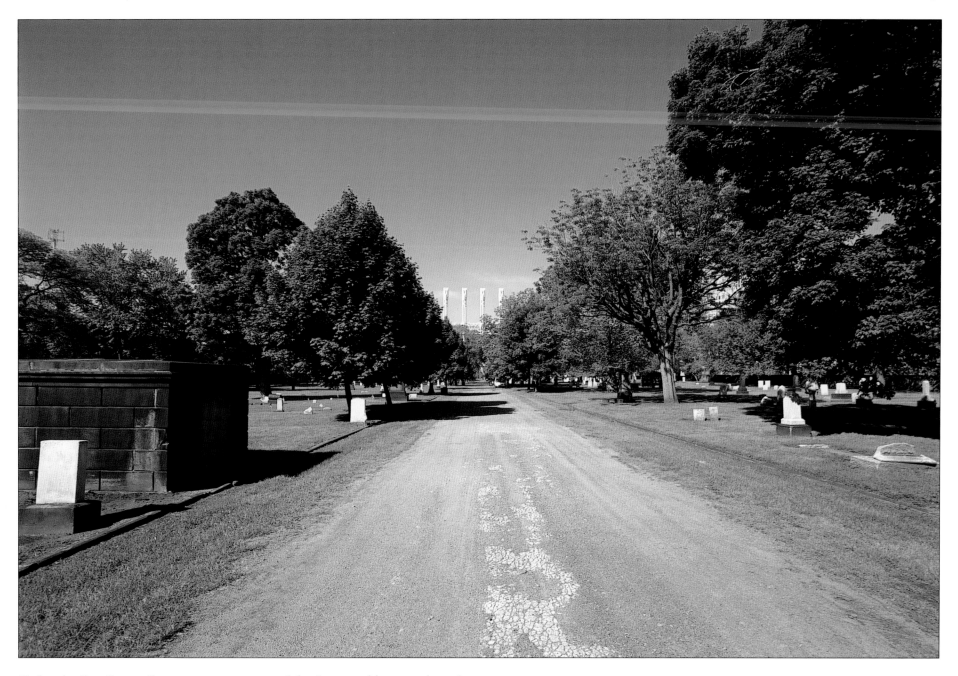

Today the Erie Street Cemetery remains one of the few tangible reminders of Cleveland's pioneer past. Although some families moved loved ones to newer, fancier cemeteries like Lake View on the far east side, other descendants banded together in the 1920s to preserve what remained of the old ground. The modern view still shows old markers and graves, notably the mausoleum on the left. A new civic landmark, Jacobs Field, looms in the background.

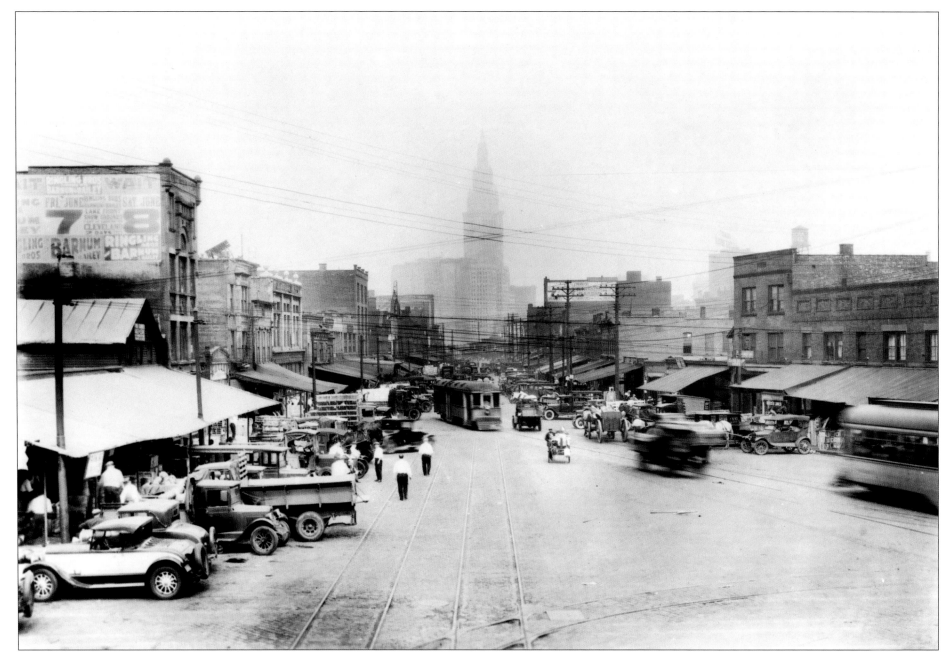

The nearly completed Terminal Complex overlooks this view of Cleveland's traditional market district on Woodland Avenue near Broadway in the late 1920s. Early farmers had brought their wagons to the old Haymarket at the end of Woodland Avenue. The district continued to provide poultry, fresh meat, fruits, and vegetables in an atmosphere of delightful, multicultural chaos. Many groups, including Syrians, Greeks, Jews, Irish, African Americans, Italians, and Slovaks, clustered in the surrounding neighborhoods and found work in the markets.

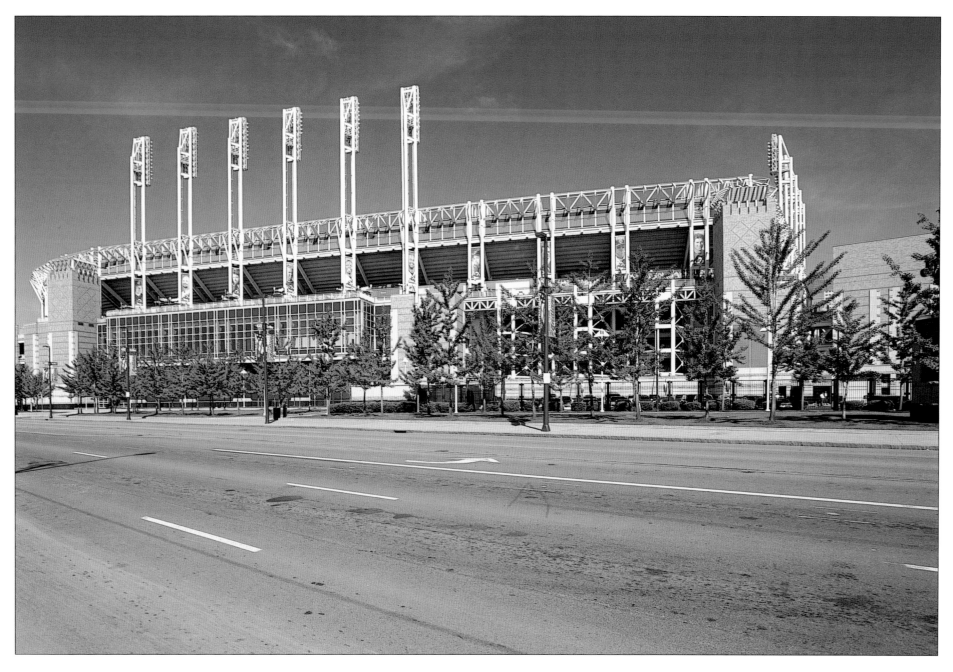

Today the scene is unrecognizable. The old market center, where people gathered to buy the necessities of life, has been transformed into a center of a different sort, dedicated to sports. The Gateway development occupying much of the site includes the Cleveland Indians baseball park, Jacobs Field (shown here), as well as Gund Arena, home of the Cleveland Cavaliers and Rockers basketball teams and the Cleveland Barons hockey team.

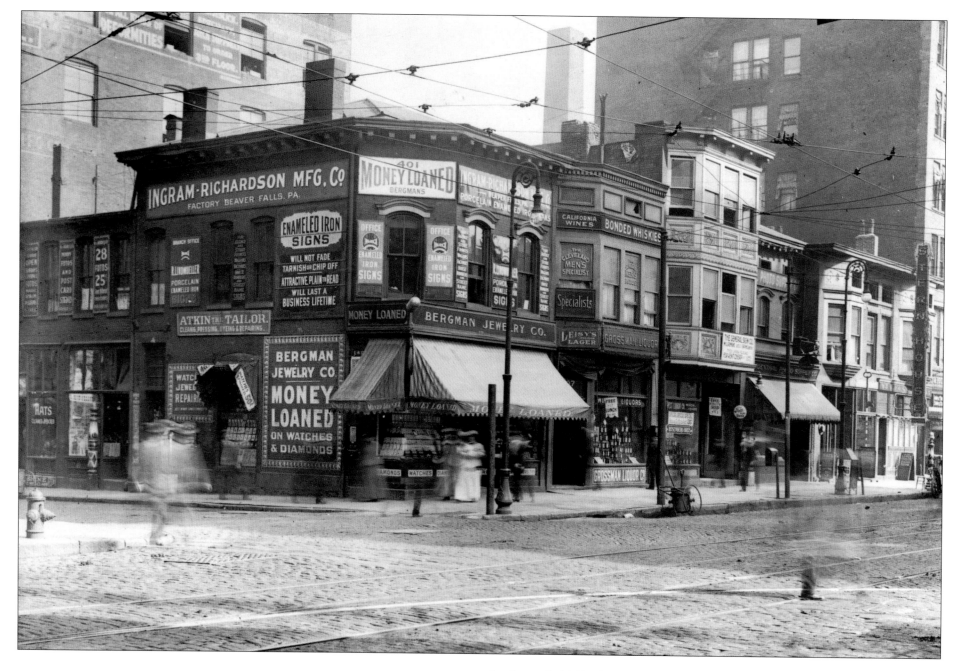

In the early 1900s, businesses on the northeast corner of Prospect Avenue and East Fourth Street offered a variety of services catering primarily to the male population of the day. Signs advertised pawnbroker-jewelers, bonded whiskies and Leisy's lager, cleaning and refurbishing of suits and hats, and "the Cleveland Men's Specialist." Medium-sized hotels like the Colonial Hotel, the tall building on the right, provided accommodation primarily for salesmen and other middle-class business travelers.

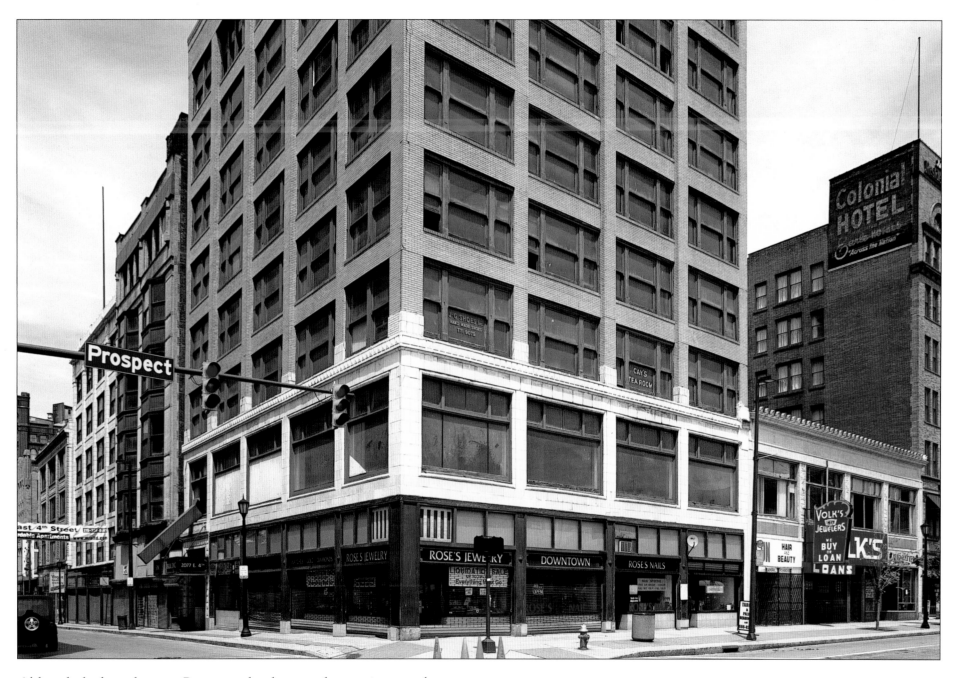

Although the loan shops on Prospect echo the past, the area is currently undergoing enormous change. Its proximity to Gateway has attracted developers and led to efforts at revitalization. The Colonial Hotel, anchoring one of Cleveland's four historic shopping arcades, remains and has been renovated. The building on the corner is being gutted prior to remodeling, with the ground-floor jeweler advertising a liquidation sale.

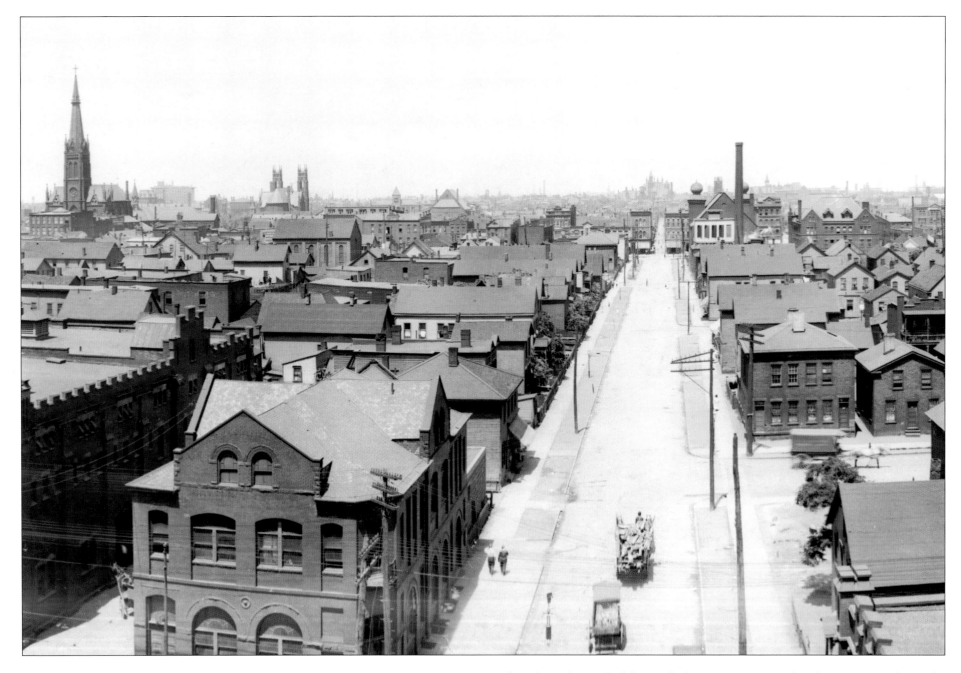

Taken from the roof of the Diebolt Brewery on Pittsburgh Avenue in the early twentieth century, this view looks north along East Twenty-fifth Street toward Woodland. Numerous spires and domes punctuate the landscape of closely packed houses and businesses. A German suburban community around the time of the Civil War, the neighborhood became one of the city's most crowded districts by the early 1900s, home to Jewish, Italian, Slovak, and other immigrants.

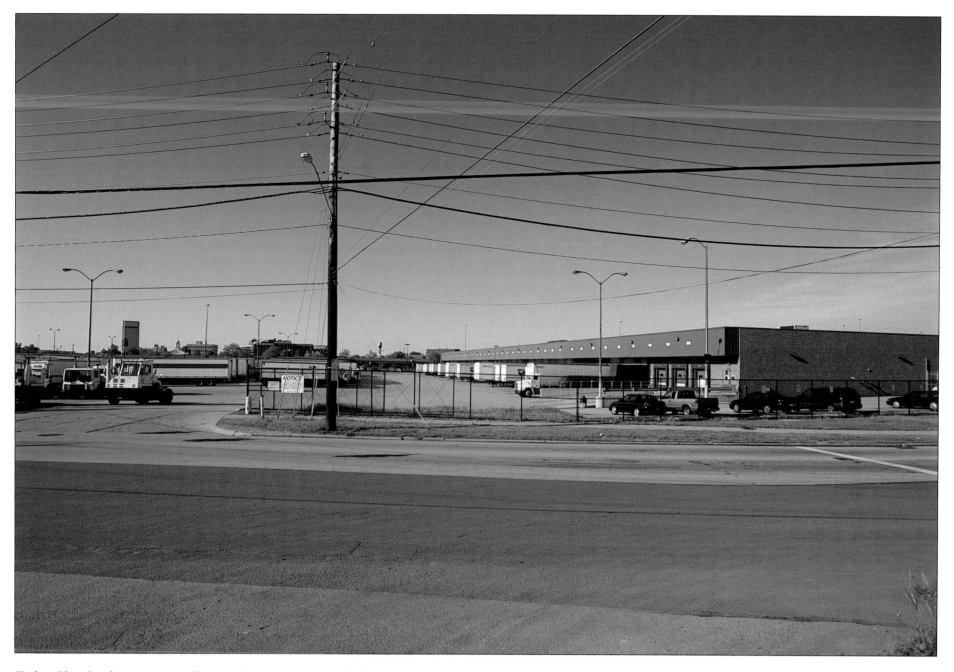

Today Cleveland's main post office on Orange Avenue, which replaced a
railroad yard and warehouse built in the 1910s, covers a large part of the old
neighborhood. With few exceptions, the buildings in the panorama are gone.
The large church on the left, St. Joseph, was one of the last survivors
remaining on Woodland Avenue until its closing and deconsecration in 1986.
It was demolished in 1993 after a fire, to the regret of many former
parishioners and preservationists.

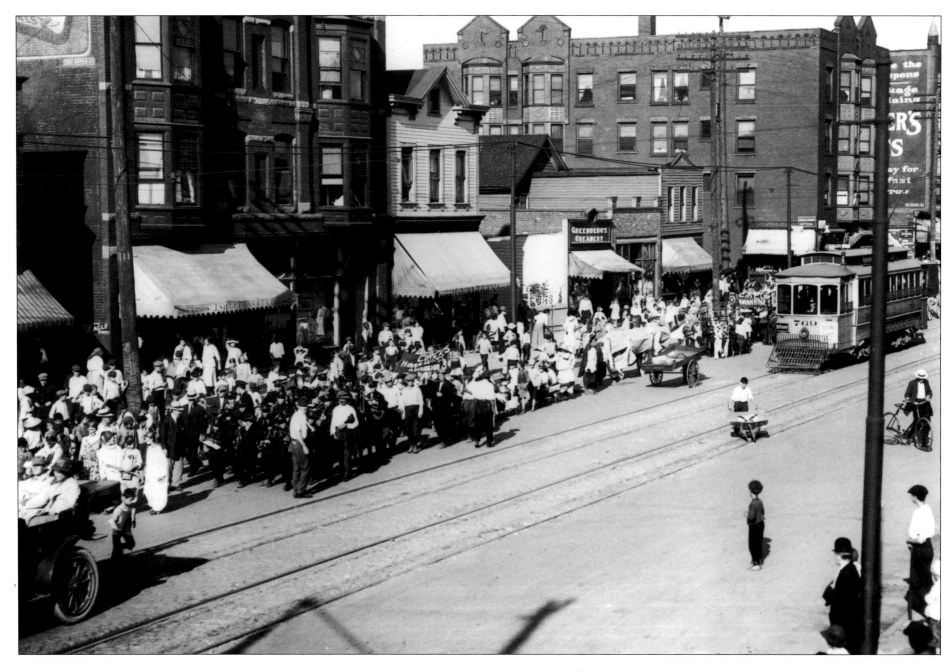

As lower Woodland Avenue's everyday bustle goes on around them, children from the Hiram House social settlement line up for their own circus parade near East Twenty-seventh Street. In this early 1900s street scene, pedestrians cross Woodland between an automobile and an oncoming streetcar. Generations of neighborhood youngsters—Jewish, Italian, and African American—participated in Hiram House activities.

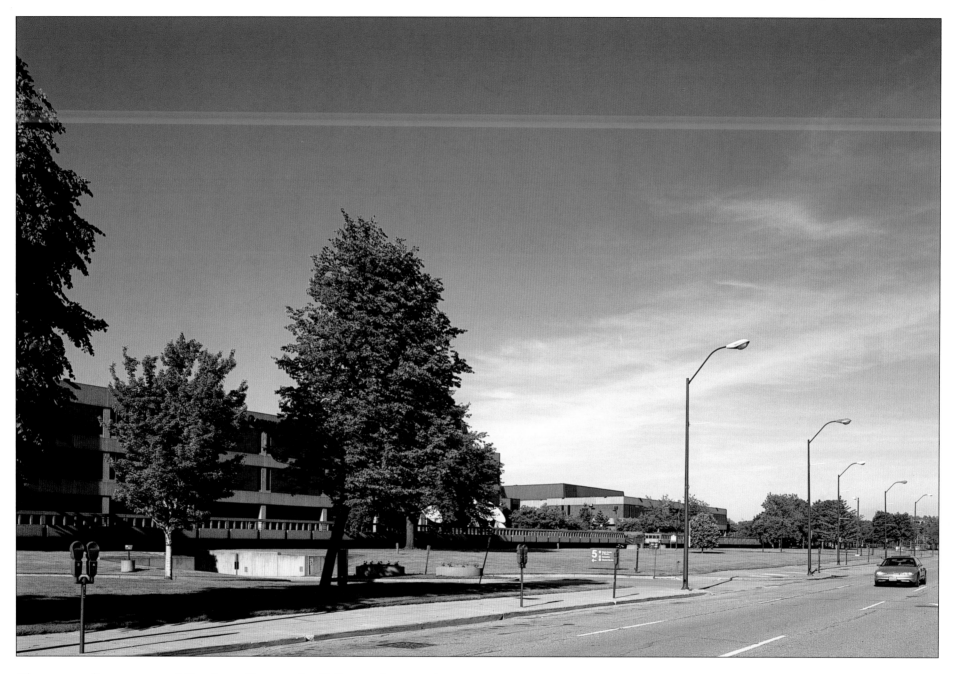

The metropolitan campus of Cuyahoga Community College today occupies the same stretch of Woodland Avenue. Its construction in the early 1960s marked a major step in the revitalization of an old Cleveland neighborhood. Offering two-year programs that include both academic and career training courses, the college gives county residents the opportunity to obtain higher education and job skills at a modest cost.

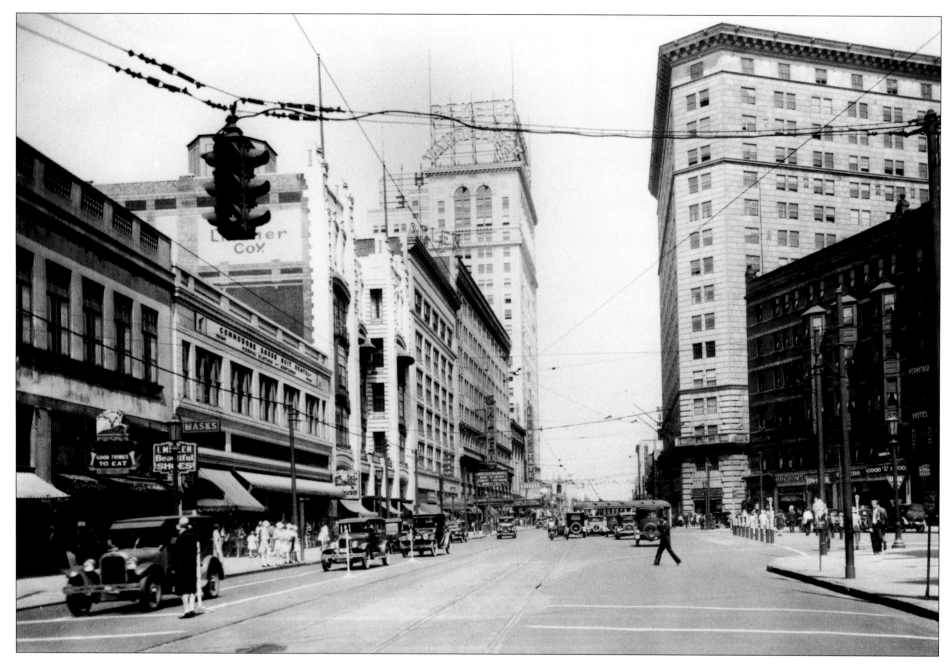

Euclid Avenue, looking east toward Playhouse Square. This was Cleveland's major theater district in the 1920s. There was in fact no square as such, only a triangular corner—unusual in Cleveland's generally rectilinear grid plan—where Huron Avenue intersected with Euclid. The corner of the Hanna Building repeats the visual motif of the angle. The district's theaters included the Hanna and the Ohio, venues for legitimate drama; the Allen, a movie house; the Palace, which hosted vaudeville shows; and the State, which featured both movies and vaudeville.

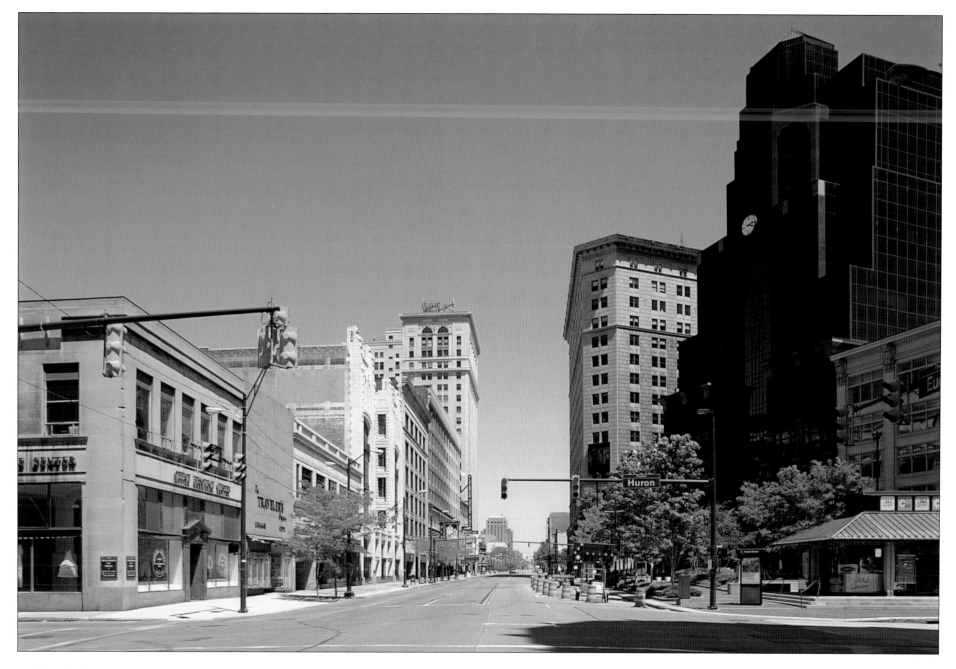

Today Playhouse Square seems virtually unchanged. This is thanks to a major effort by preservationists and civic activists, who led a drive to rescue and restore the grand old theaters after four of them were closed in 1969. The area remains the city's prime theater district, offering shows and concerts ranging from blockbuster musicals and Shakespeare plays to opera and folk dance.

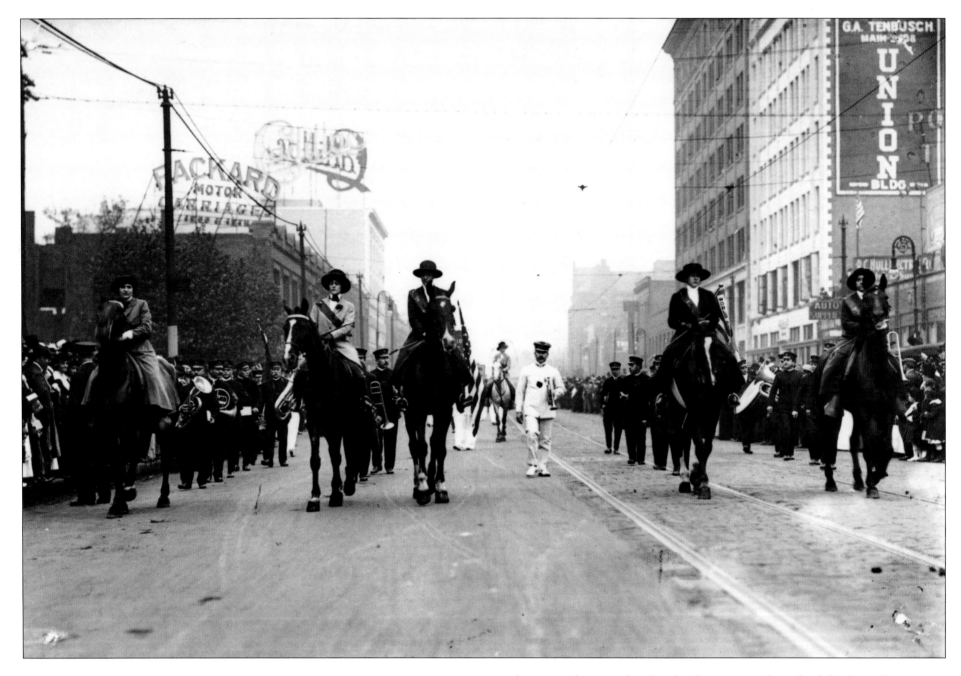

In this 1914 photograph, Cleveland women on horseback lead a suffrage parade westward along Euclid Avenue near East Eighteenth Street. The parade was part of an unsuccessful campaign to give Ohio's women the right to vote. A few years later, the tracks under the hooves of the suffragists' horses would play a small part in advancing the rights of Cleveland women: The city hired its first female streetcar conductors to ease the World War I labor shortage.

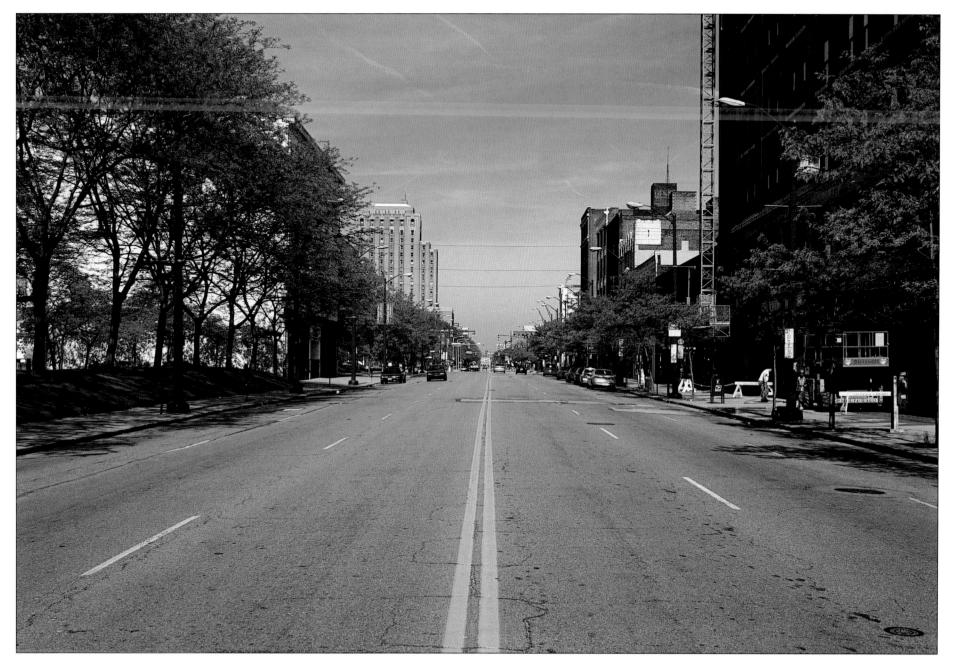

Today the streetcars and their tracks, and the Packards advertised above one of the buildings, have vanished like the suffrage parade into the historical distance. In this area immediately east of Playhouse Square, the street's south side is still lined by similar (although not identical) midsize commercial buildings. The campus of Cleveland State University, established in 1965, now occupies the north side of Euclid, east of East Eighteenth Street.

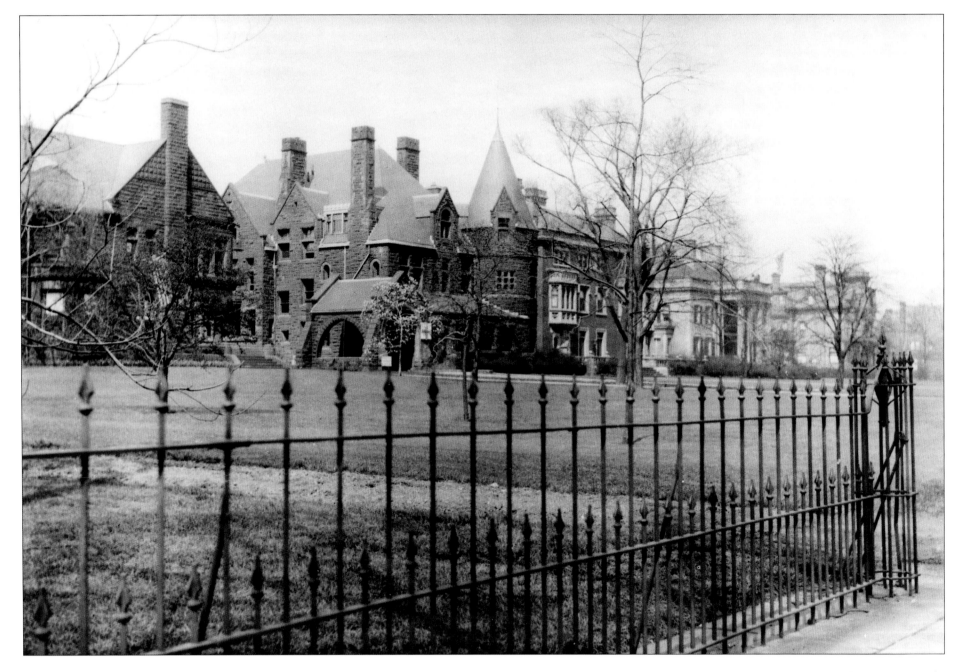

The section of Euclid Avenue east of the downtown business district is famed in local lore as "Millionaires' Row." In the 1870s and 1880s, a number of wealthy Clevelanders built mansions there. People equated Euclid with the famous boulevards of Europe, declaring it one of the most beautiful and elegant streets in the world. But its glory was short-lived. When this photograph (which looks east from near East Twenty-second Street) was taken in the 1910s, Millionaires' Row was already in its twilight.

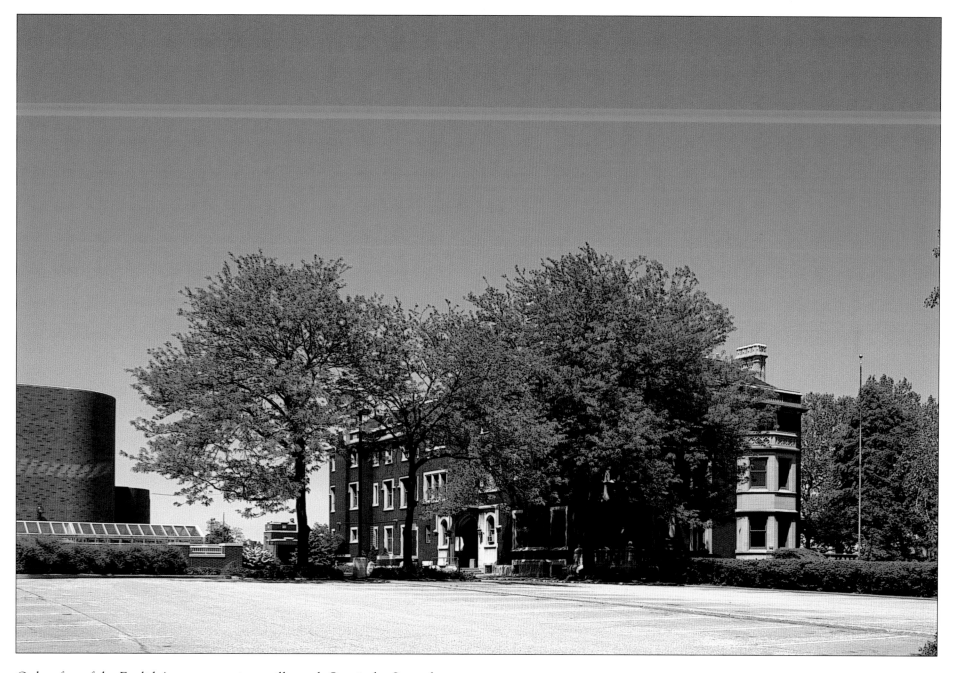

Only a few of the Euclid Avenue mansions still stand. One is the Samuel
Mather house, third from the left in the older photograph. This view shows
the west side and front of the mansion, which today serves as a meeting center
for Cleveland State University. Completed in 1910, it was one of the last of
the great homes built on Millionaires' Row. Mather, who died in 1931, was
the city's most noted industrialist-philanthropist.

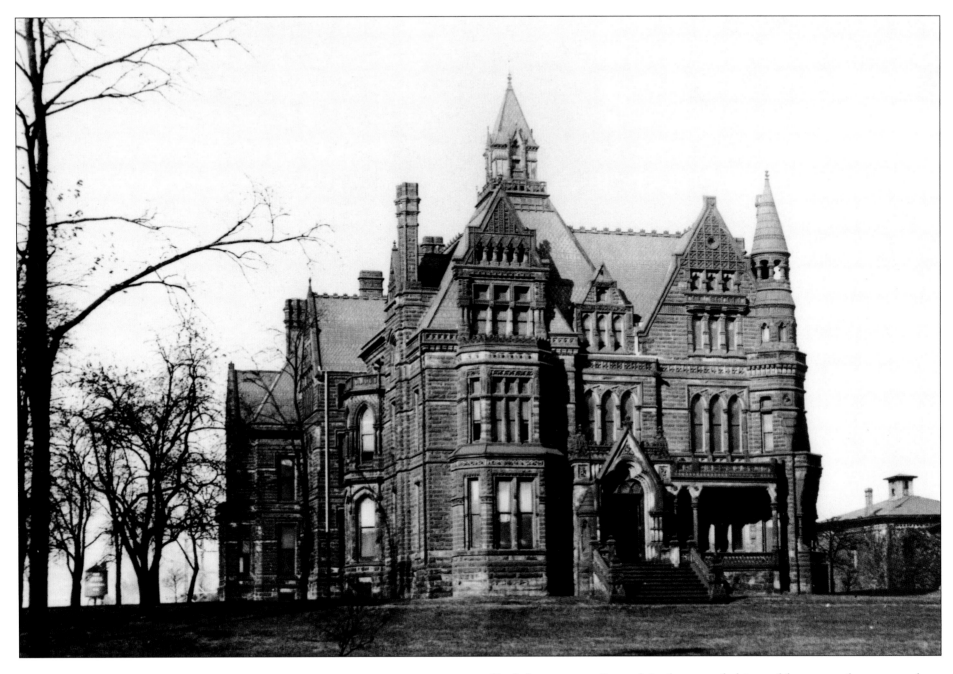

English immigrant Samuel Andrews made his wealth as an early partner of John D. Rockefeller. In 1882–85 he built the largest house in Cleveland on Euclid just east of East Thirtieth, reportedly with the ambition of entertaining Queen Victoria. The immense Victorian Gothic mansion, which became known as "Andrews's Folly," had nearly one hundred rooms and proved impractical to run. Abandoned for two decades by the time this photograph was taken in the early 1920s, it was torn down in 1923.

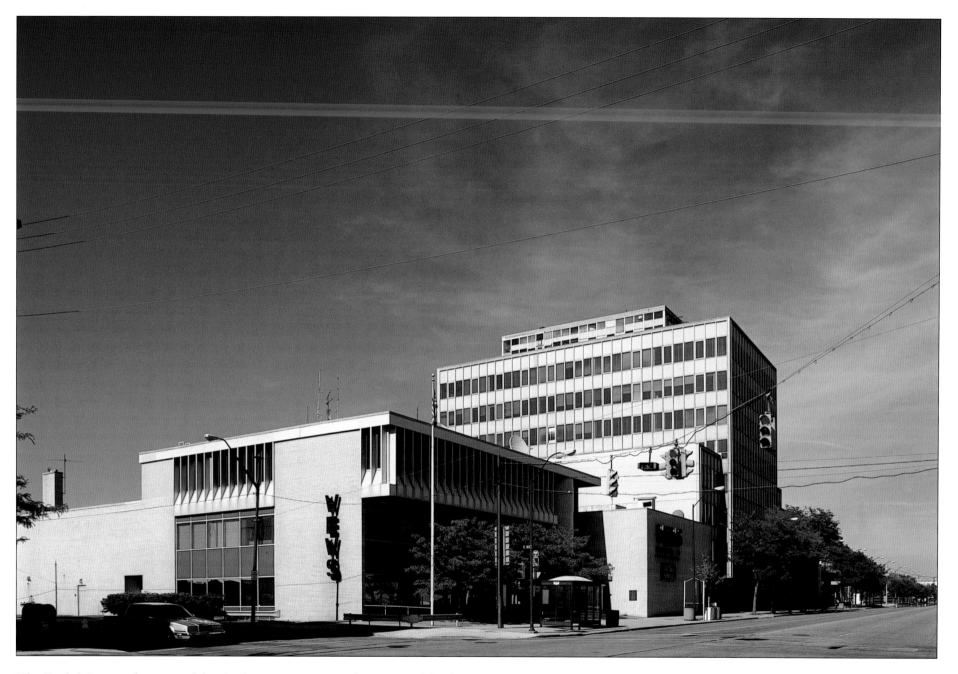

The Euclid Avenue frontage of the Andrews property is today occupied by the studios of WEWS-TV and a parking lot. The Euclid Avenue mansions sat on very deep lots that extended beyond where Chester Avenue is today, and the Andrews house was set well back from Euclid. This section of Chester, a major east-west street one block north of Euclid, was cut through in the mid-1920s, shortly after the demolition of Andrews's Folly.

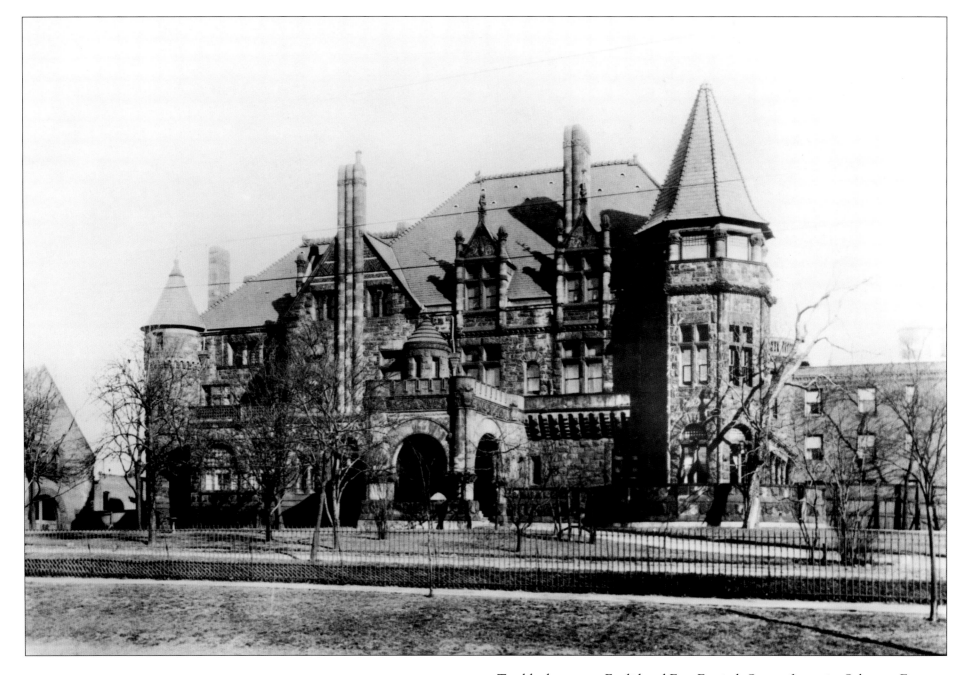

Ten blocks east, at Euclid and East Fortieth Street, financier Sylvester Everett built a smaller but still spectacular Richardsonian Romanesque–style mansion. Designed by local architect Charles F. Schweinfurth and completed in 1887, it featured a "Moorish" room and a stained glass window depicting Everett's hero, Richard the Lionheart. The Everett mansion, one of the last Millionaires' Row houses to be vacated, was demolished in 1938, not long after this photograph was taken.

Today the site is a parking lot for the Jane Edna Hunter Social Service Center located west across East Fortieth Street. As with most of the Euclid Avenue mansion sites, no vestige of past grandeur remains. Instead, the Midtown Corridor, Inc. project being undertaken along this part of Euclid and Chester looks to the future. Initiated in 1982, it has been instrumental in bringing commercial and industrial redevelopment to the inner city.

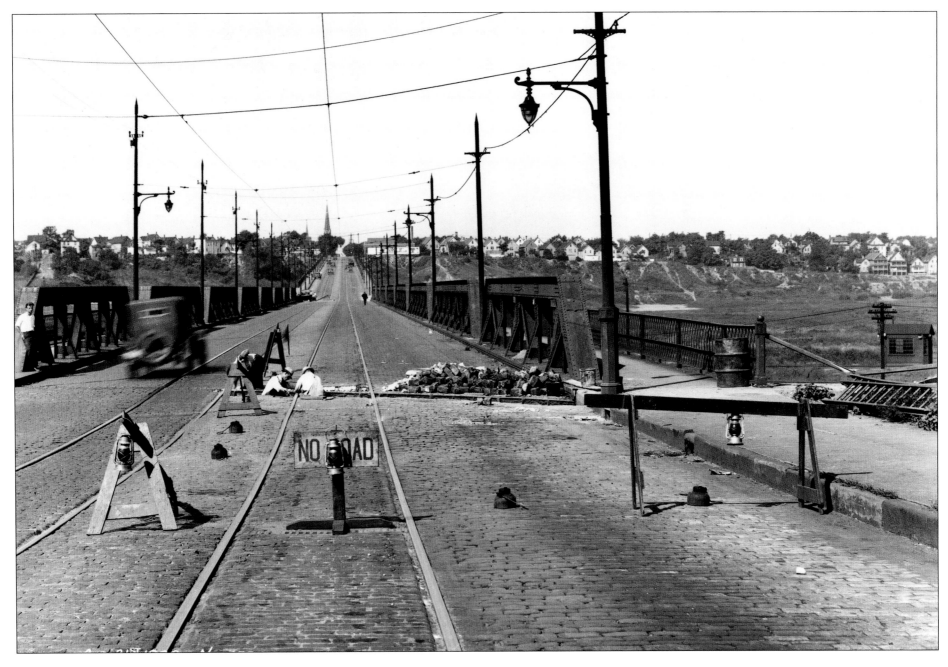

Returning to the Cuyahoga Valley area, we begin to circle west of the central city by way of the Clark Avenue Viaduct. Built in 1917, the viaduct crossed the industrialized valley, linking Cleveland's Broadway neighborhood with Tremont west of the river. This 1930s view looks west toward Tremont. The steeple of St. Michael's Church at Clark and Scranton, sometimes considered Tremont's western border, shows on the horizon.

The steeple is still visible, but the Clark Avenue Viaduct is gone. The road
seen here rises from the west side of the valley below the viaduct's former site.
Heavy pollution from industrial traffic and nearby steel mills took a toll on
the bridge. Dirty, rusted, and potholed, it was beyond salvation and had to be
removed in the 1980s. The new I-490 bridge just to the north carries much of
the traffic that would have used the viaduct.

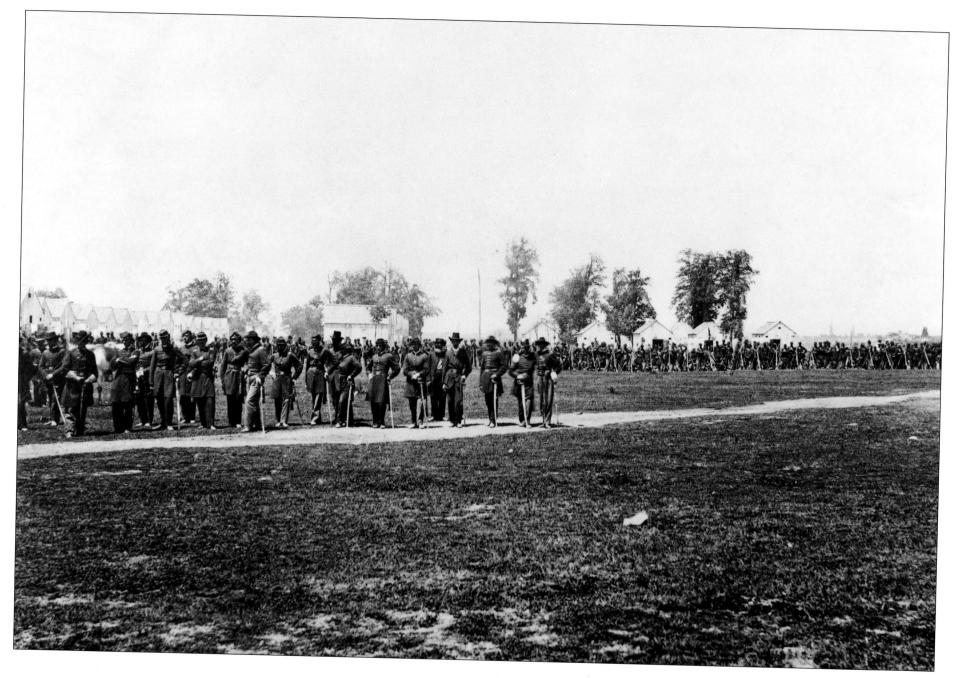

The 107th Ohio Volunteer Infantry at Camp Cleveland. Cleveland's Tremont neighborhood has a rich history. In the early 1850s it was the home of a very short-lived university. During the Civil War it served as the site of the city's principal military training ground, Camp Cleveland, as well as a military hospital. The camp occupied thirty-five acres in an area bounded by today's West Fifth and Seventh Streets and Railway and Marquandt Avenues.

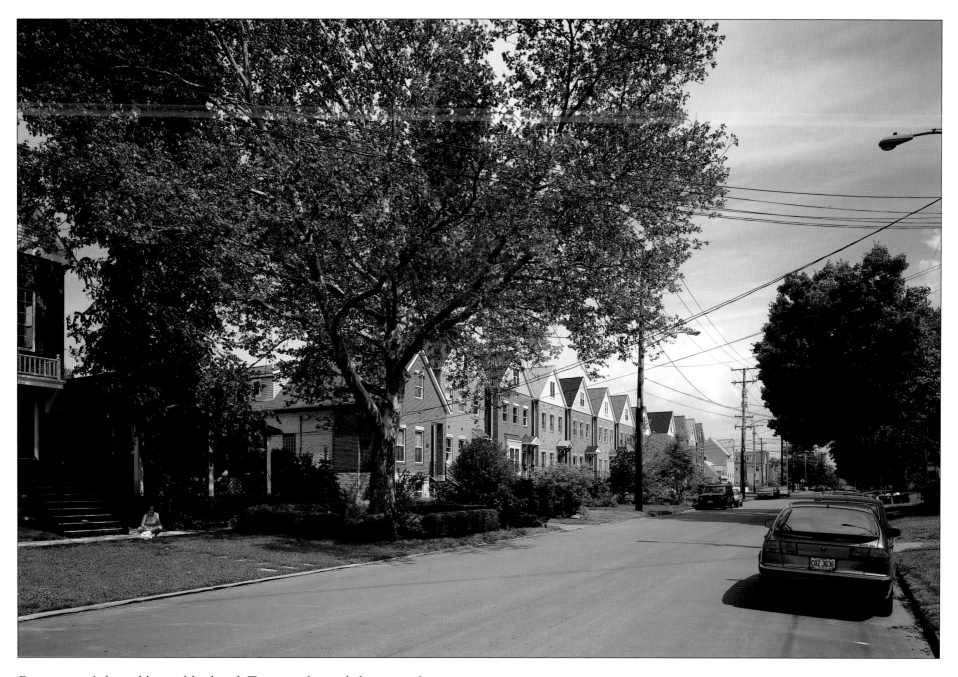

For a time a fashionable neighborhood, Tremont changed character after industry invaded the adjacent valley. It became a working-class district, noted for the ethnic diversity and politically radical tendencies of its residents. After a period of decline, due in part to 1960s highway construction, Tremont has made a comeback as a gritty but hip district sprinkled with art galleries, bars, and some new housing. This row of new town houses on West Seventh Street visually reproduces the row of barracks in the old photograph.

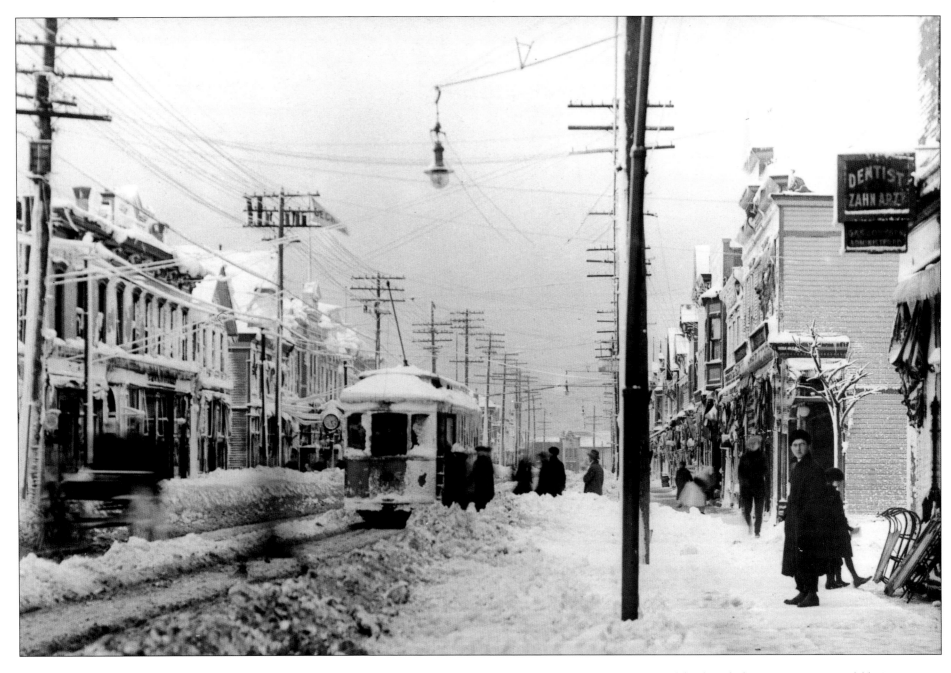

Northwest of Tremont, in a neighborhood along West Twenty-fifth Street south of Lorain Avenue, most people were of German origin, as the bilingual sign over the dentist's office at the corner of West Twenty-fifth and Vega Avenue shows. In November 1913 the district's residents battled one of the largest blizzards in local history. Although streetcars were soon up and running, the boys partly visible in the right foreground seem to be considering an alternative.

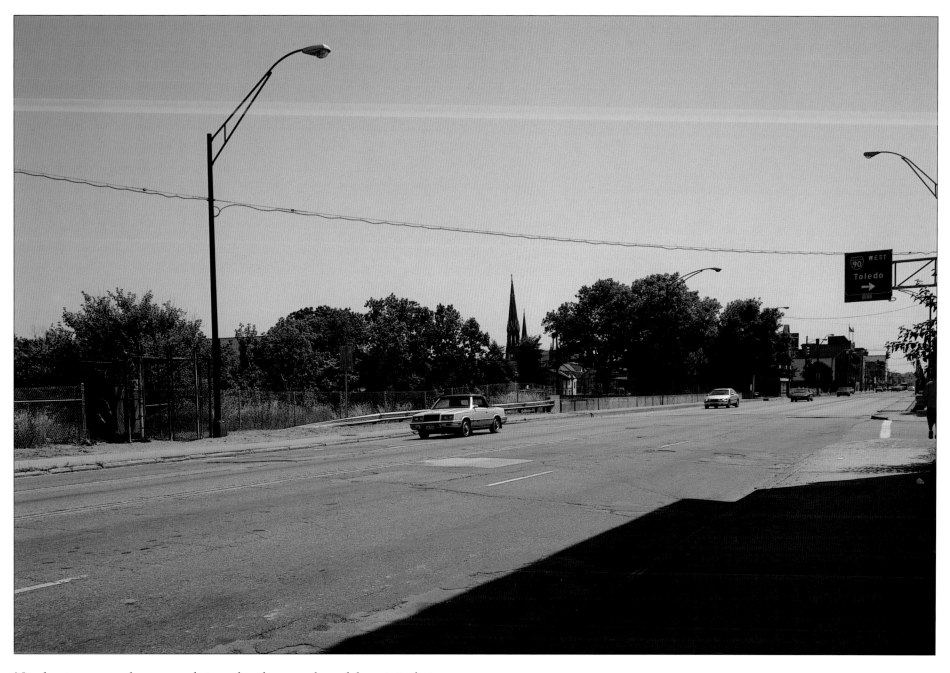

Nearly ninety years have passed since the photographer of the original view stood in the snow on West Twenty-fifth Street; few of the old buildings have survived. Much of the neighborhood was lost to the construction of the I-90 freeway. The surrounding area is today largely a Spanish-speaking neighborhood, a fact that makes the street name Vega and the entrance ramp sign pointing the way to Toledo doubly meaningful.

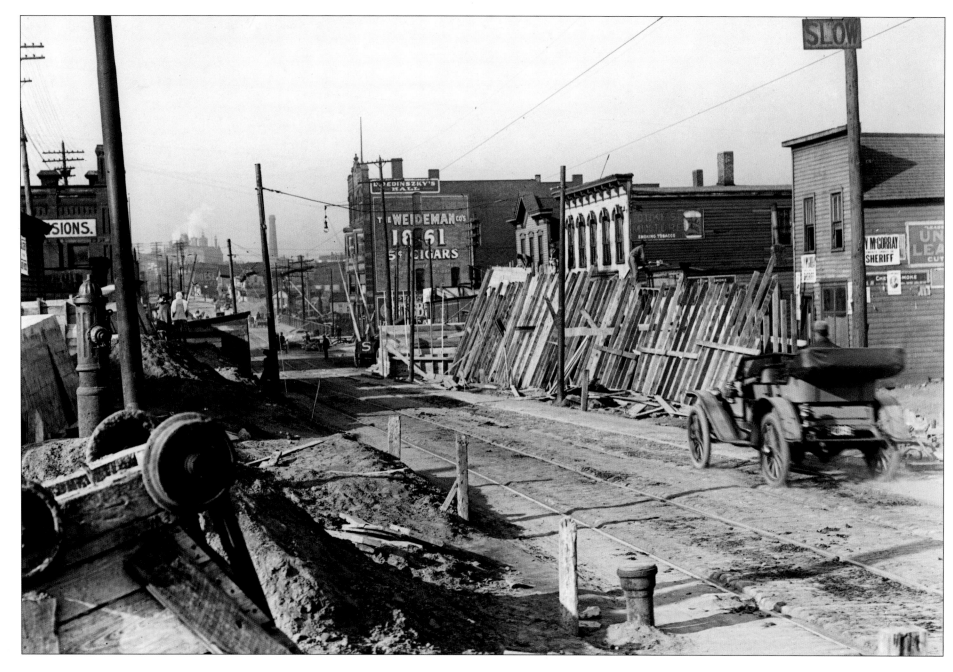

In the early 1900s, Cleveland's administrators initiated an ambitious works project to eliminate railroad grade crossings in the city, citing safety concerns. Here, preparations to construct an underpass on the Nickel Plate Railroad have created minor chaos on West Twenty-fifth Street south of Columbus Road. A fire hydrant has already been raised to the new street level. The gates of the level crossing about to be eliminated are also visible.

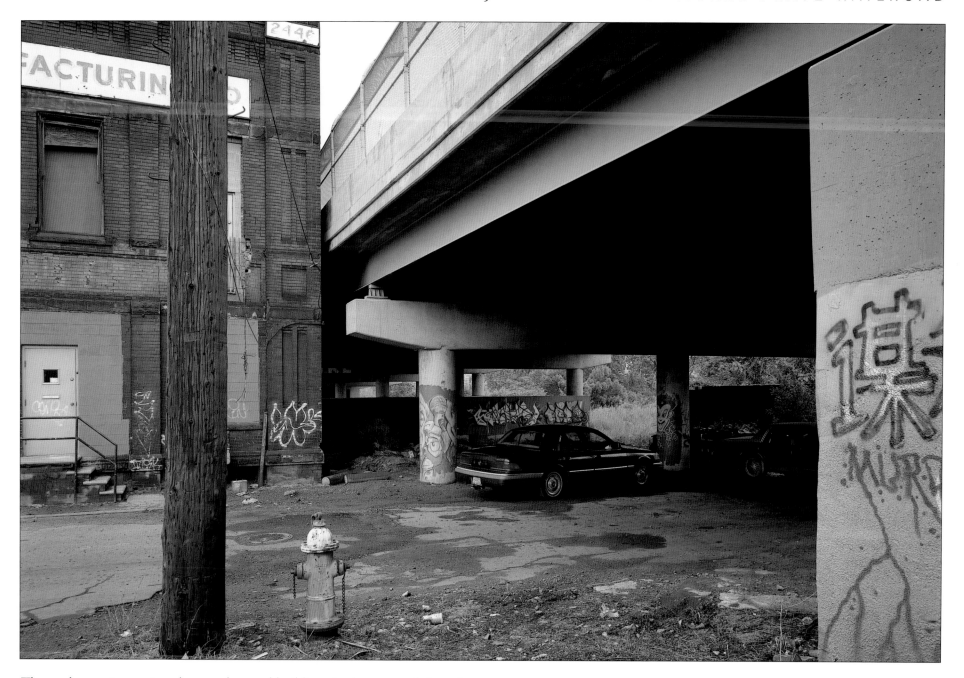

The grade crossing project destroyed several buildings in the area and altered the streetscape forever, much as the construction of I-90 dramatically changed the neighborhood at Vega, several blocks to the south. Today, West Twenty-fifth Street remains elevated at this point, though this is not the original bridge. Urban graffiti adorns the underpass as well as the single building that still survives from the earlier photograph.

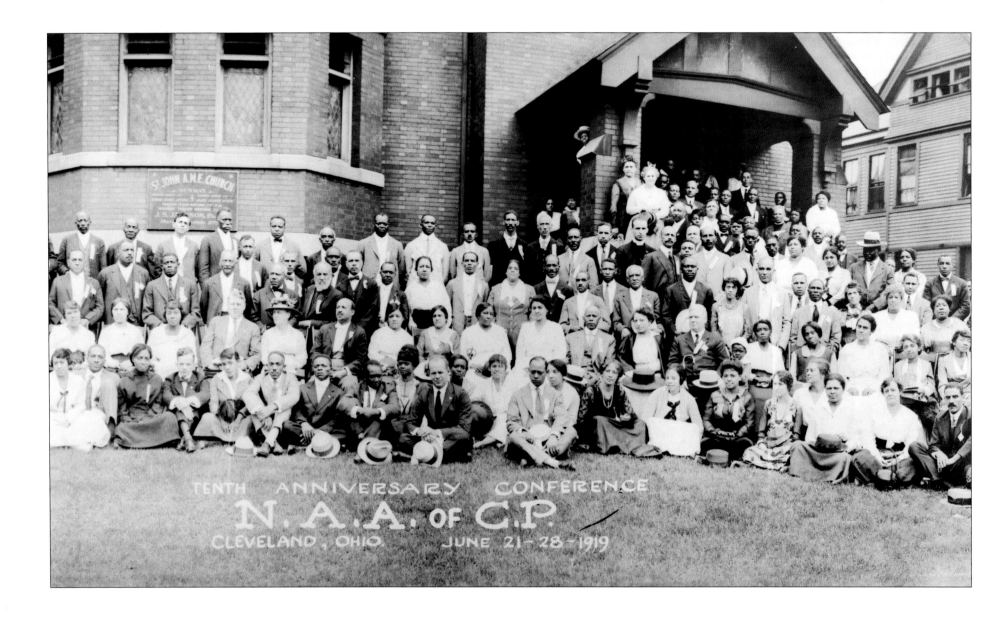

St. John's African Methodist Episcopal Church was the city's oldest African American church, established in the 1830s. St. John's had several successive church buildings during the nineteenth century. In 1908 the congregation built a new church at East Fortieth Street and Central Avenue. The national NAACP held its tenth anniversary conference in Cleveland in 1919. The delegates posed for a photograph in front of St. John's; among them was W. E. B. Du Bois (pictured here in the second row from the front, sixth from the left).

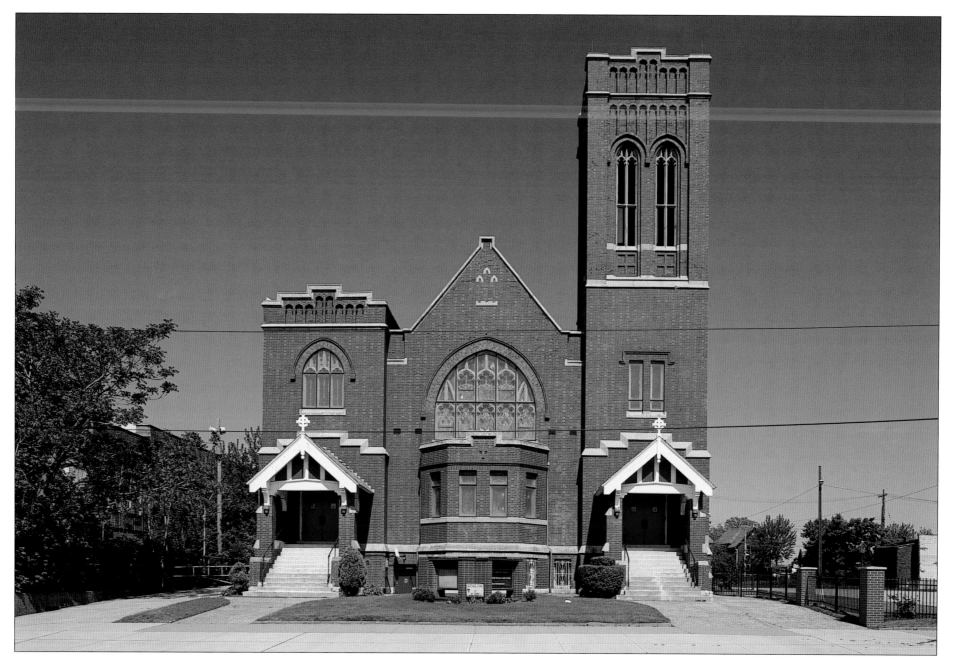

At the time when the older photograph was taken, Cleveland's African American population was growing quickly as migrants arrived from the South. Grand homes lined East Fortieth Street, where many members of the city's longer-established black upper class lived. Today, East Fortieth has become part of Cleveland's inner-city landscape, with many of the old houses gone. St. John's Church remains and continues to serve the community.

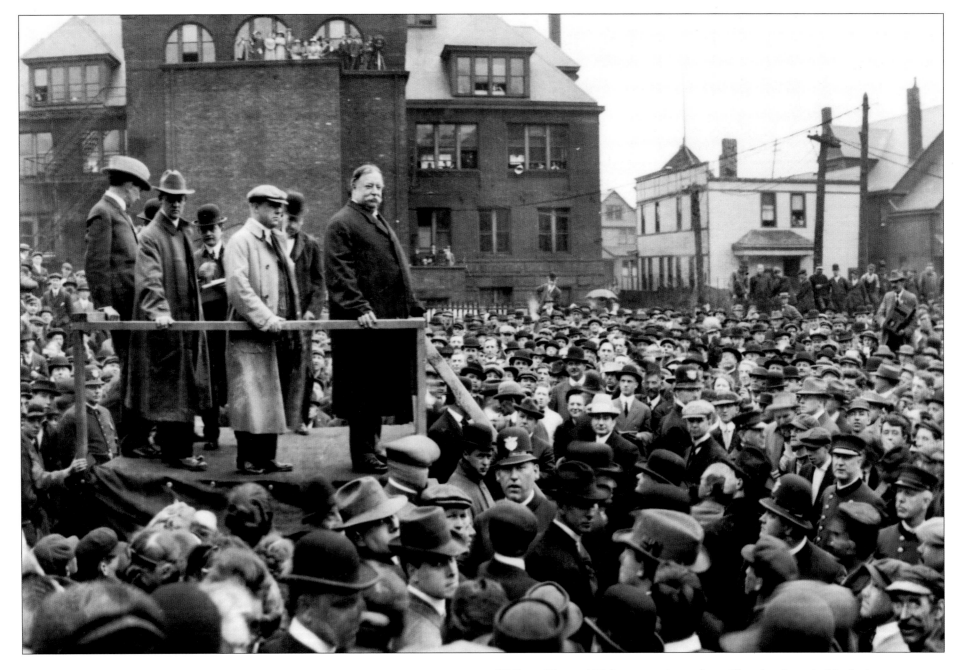

William Howard Taft giving a speech in Cleveland, probably during one of his presidential campaigns in 1908 or 1912. Taft was addressing workers and others assembled in the area behind the Brown Hoisting and Conveying Machinery offices on St. Clair Avenue near East Forty-fifth Street. The company manufactured the Brown Hoist, an invention that partly automated the unloading of bulk cargoes like the iron ore that was so crucial to Cleveland's steel industry.

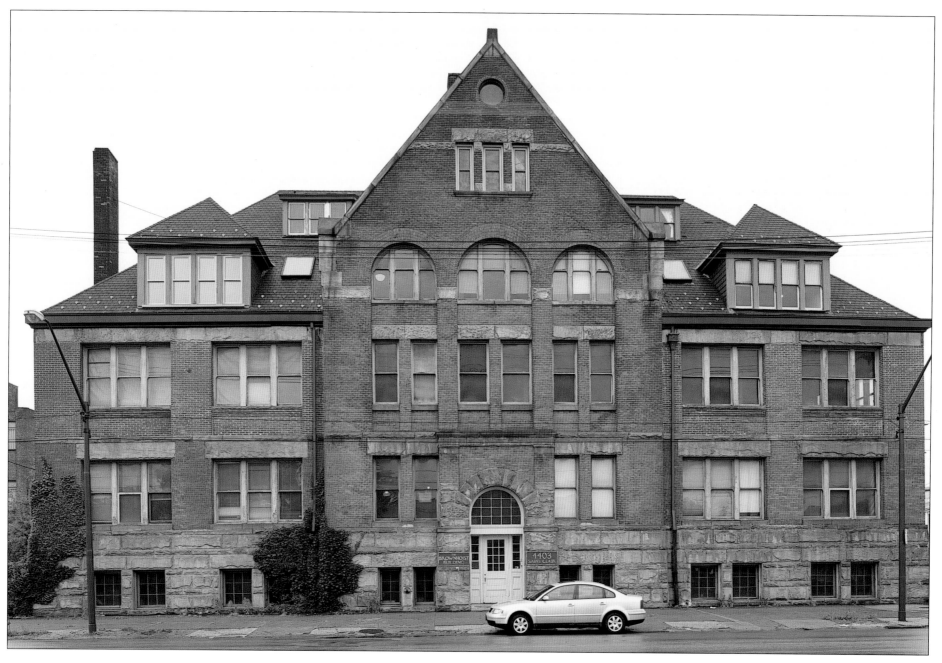

This view shows the front of the Brown Hoist headquarters building today.
The open area shown in the older photograph has been mostly built over. The
building remains a landmark on St. Clair, with some of its old office space
currently in use, while its former factory building, one street north on
Hamilton, serves as one of Cleveland's most unusual industrial warehouses.

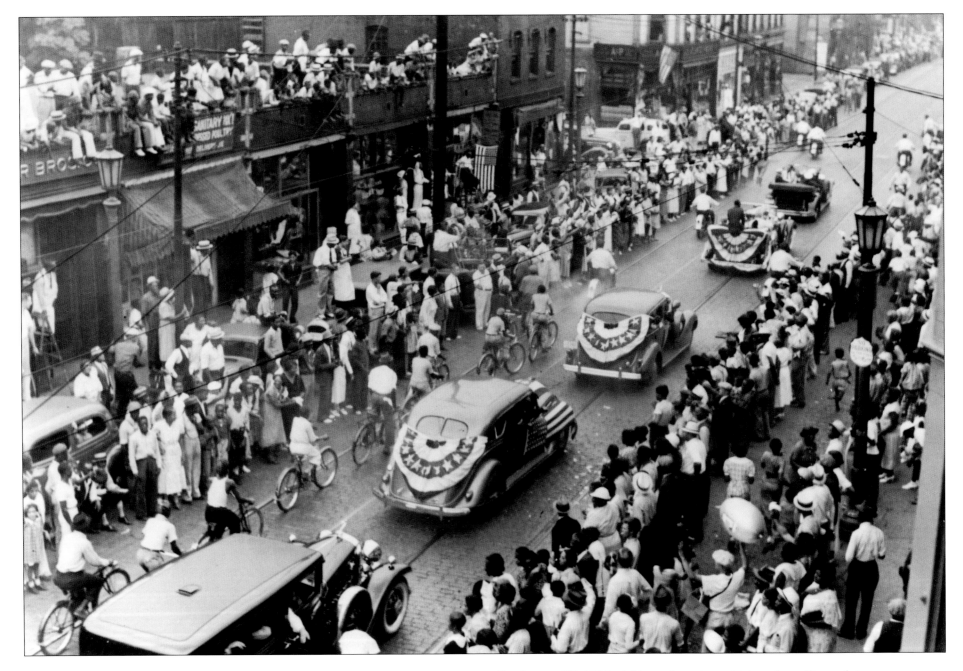

On August 25, 1936, African Americans living along Central Avenue witnessed one of the proudest days in their street's history. A celebratory parade carried Jesse Owens through the neighborhood after he won four gold medals at the 1936 Berlin Olympics. Owens, born in Alabama, grew up in Cleveland and became a track star at East Technical High School. Here, the parade, with Owens seated in the second car, travels along Central just west of East Fifty-fifth Street.

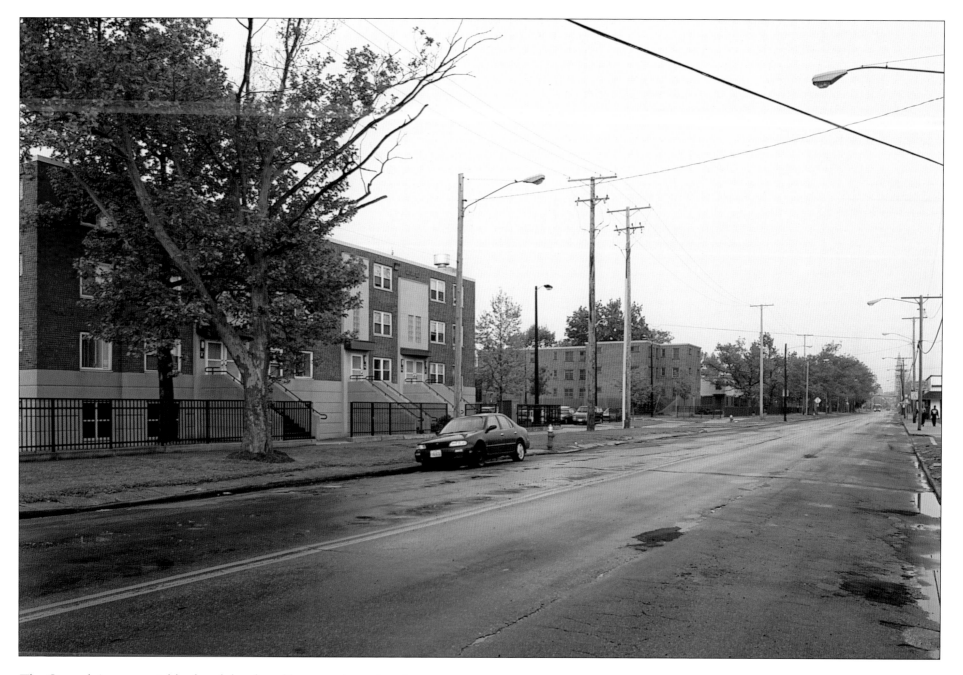

The Central Avenue neighborhood developed by necessity rather than choice, the result of increasing segregation in Cleveland during the first decades of the twentieth century. Within its confines, residents and entrepreneurs created flourishing business districts along Central and Cedar (one block to the north) Avenues. Today the storefronts and businesses are gone from this part of Central, replaced by public housing and low-rise apartments.

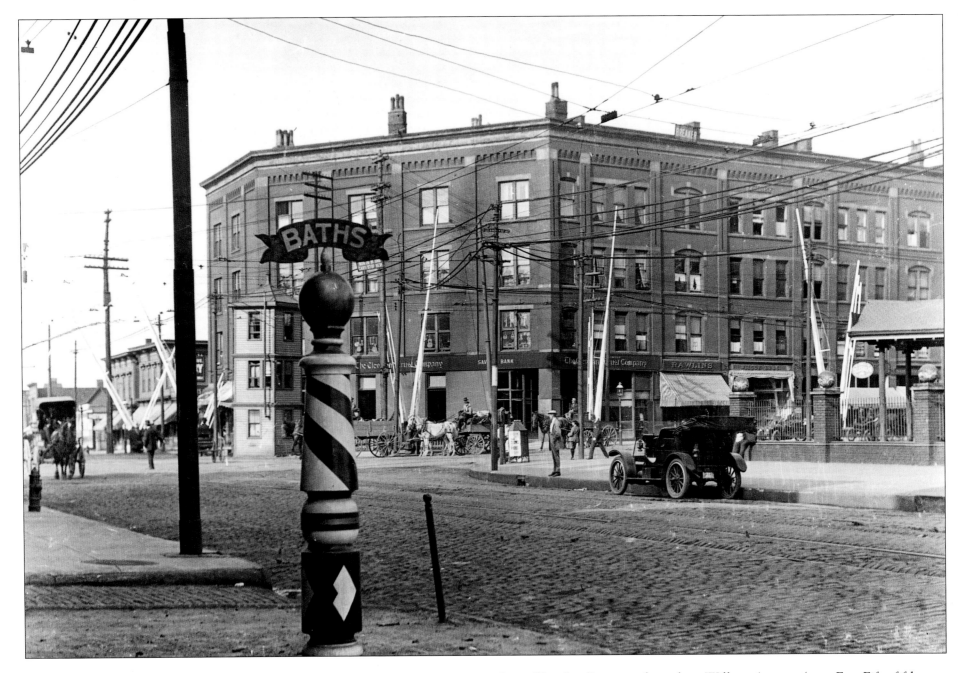

Once Cleveland's eastern boundary, Willson Avenue (now East Fifty-fifth Street) was, by the early 1900s, a major thoroughfare well within the city limits. Its intersection with Euclid Avenue was particularly busy. The Cleveland and Pittsburgh (Pennsylvania) railroad line crossed both streets diagonally there, creating major traffic congestion when long trains stopped at its passenger station on the southeast corner.

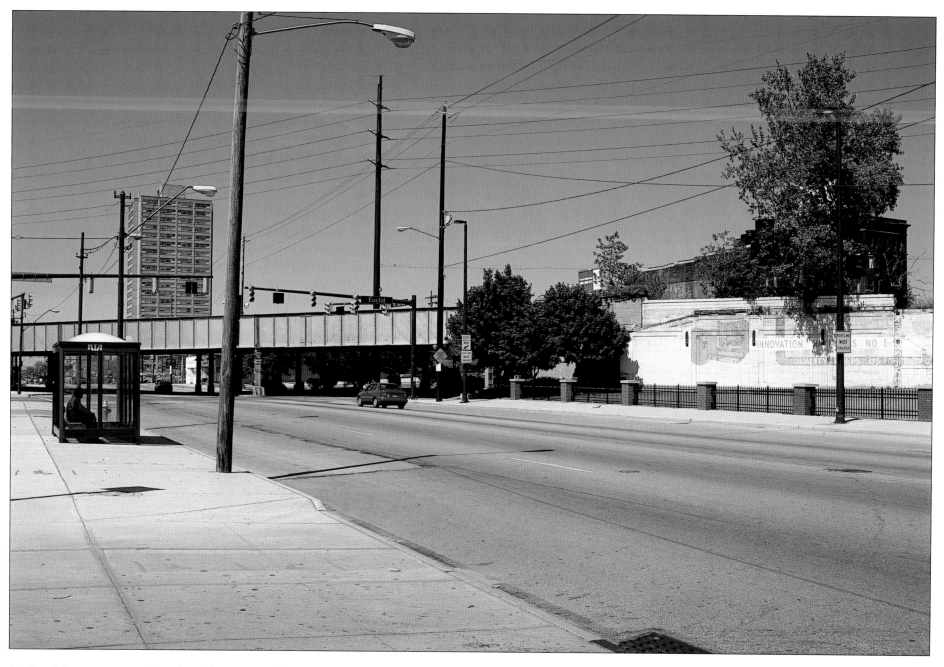

Little of the intersection's earlier fabric can still be seen. Much of it was sacrificed for parking lots and a gas station. Even the site of the train station, which had seen the arrival of the bodies of two assassinated presidents, Abraham Lincoln and James A. Garfield, is today a parking lot. Railroad trains, hauling freight rather than passengers, now go past largely unnoticed above the street.

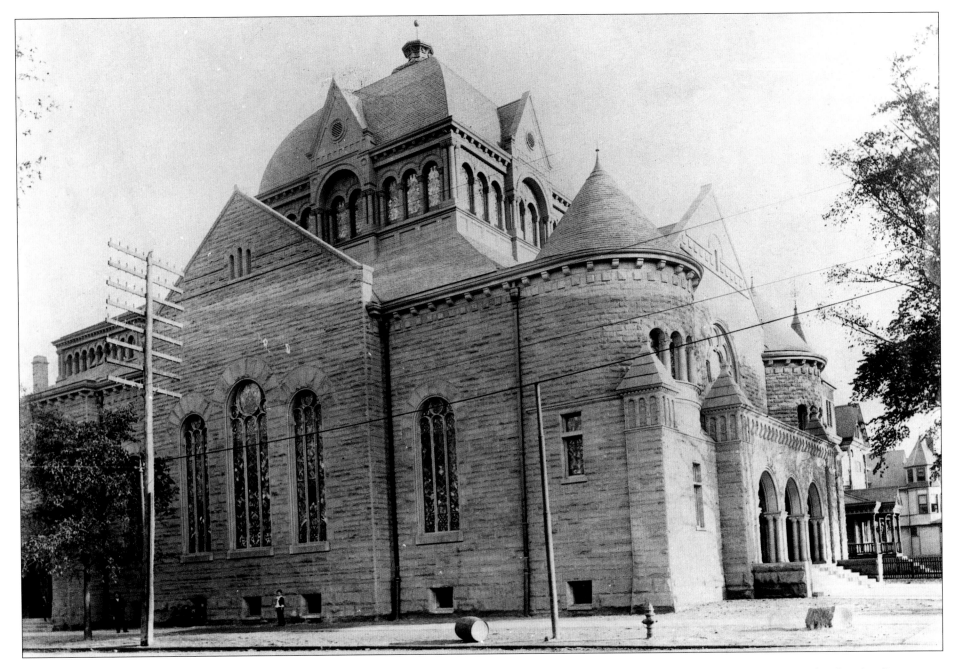

The Willson Avenue Temple was home to Tifereth Israel, Cleveland's second-oldest Jewish congregation. Established in 1850, Tifereth Israel built its second temple on the corner of Willson and Central Avenues in 1894. The area was one of the city's major Jewish neighborhoods at the time, with large homes along Willson beyond the temple. Here, young boys play beside the newly completed building, perhaps on a recess from Sabbath school.

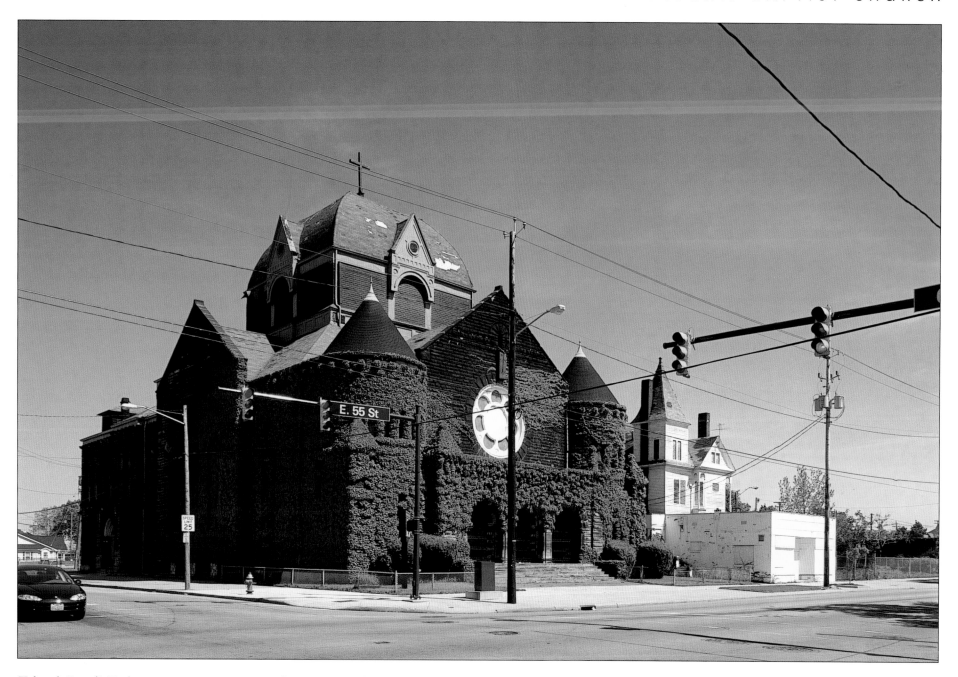

Tifereth Israel's Reform congregation occupied its new temple for only three decades. As the Jewish population moved eastward, a new place of worship became necessary. In 1924 it dedicated a magnificent new structure in University Circle, where Rabbi Abba Hillel Silver built a career that would bring him and his congregation international notice. Today the congregation maintains the Temple at Silver Park as well as a suburban branch. This building now serves as the Friendship Baptist Church.

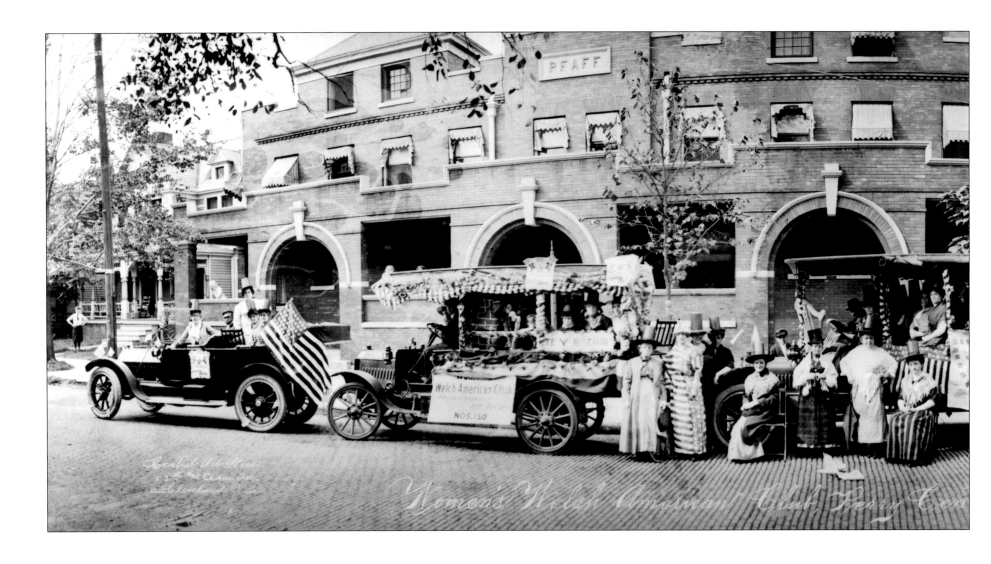

In 1913 the Women's Welsh American Club gathered on Carnegie Avenue to take part in a parade celebrating the 100th anniversary of Commodore Perry's victory. Their costumes and decorations displayed a mixture of ethnic and American pride, juxtaposing the Stars and Stripes with the traditional Welsh hat. An important component of Cleveland's British-born population, the Welsh had provided skilled ironworkers for the city's earliest mills.

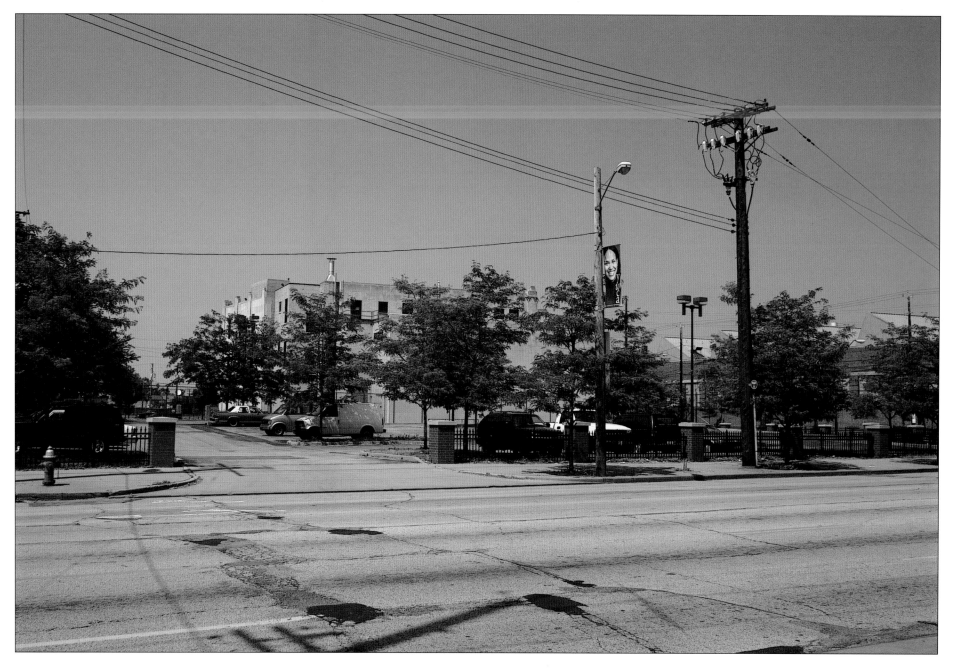

The backdrop in the older photograph, the Pfaff Building, stood near the northeast corner of the East Fifty-fifth Street intersection until recently. It was a landmark for commuters traveling downtown via Carnegie. In its day, the Pfaff was a trendy row of terrace apartments, and Carnegie a fashionable address. Today the corner bears little evidence of its residential past, although one old apartment building, the Monroe, survives nearby across Carnegie.

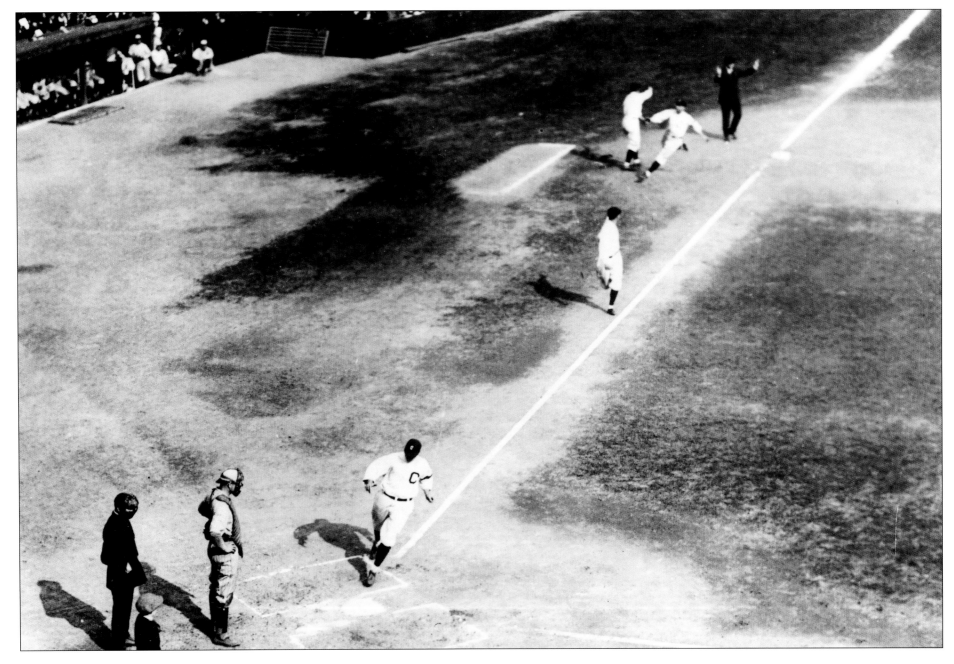

League Park, opened in 1891, was for many years Cleveland's professional baseball field. Undoubtedly the most legendary contest played there was game five of the 1920 World Series between Cleveland and Brooklyn. That game included the following Series game firsts: first home run by a pitcher, first grand slam, and first and only unassisted triple play in Series history. Here, runners Charlie Jamieson, Bill Wambsganss (author of the triple play), and Tris Speaker score on Elmer Smith's grand slam.

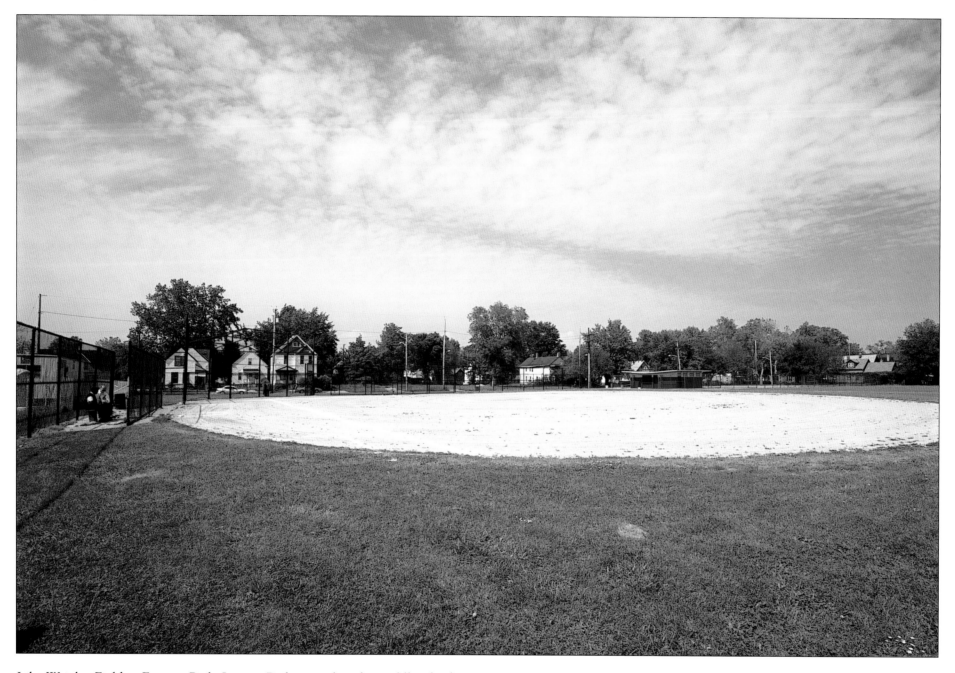

Like Wrigley Field or Fenway Park, League Park existed in the middle of a thriving city neighborhood, at the corner of East Sixty-sixth Street and Lexington Avenue. The Negro American League Cleveland Buckeyes played there in the 1940s, as did the Cleveland Rams of the National Football League. In 1951 the city purchased the aging facility and tore down the stands. Today the field, declared a Cleveland landmark in 1979, has two ball diamonds, one (shown here) on the approximate site of the old; neighborhood youngsters now play baseball on this field of memories.

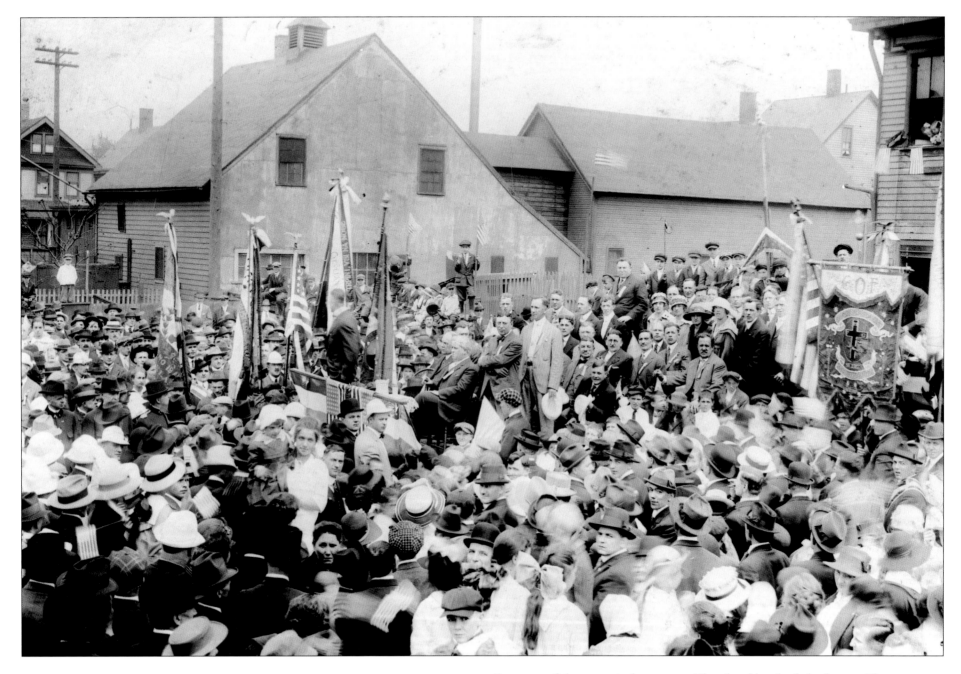

For most of the twentieth century, Cleveland has had the largest Slovene community in the United States. In 1923 the cornerstone-laying ceremony for the Slovenian National Home on St. Clair at East Sixty-fourth Street took place, accompanied by speeches and festivities. "National homes" served as social and cultural centers in Cleveland's several Slovene neighborhoods, providing office and meeting space for community organizations, and halls for concerts, plays, and social events.

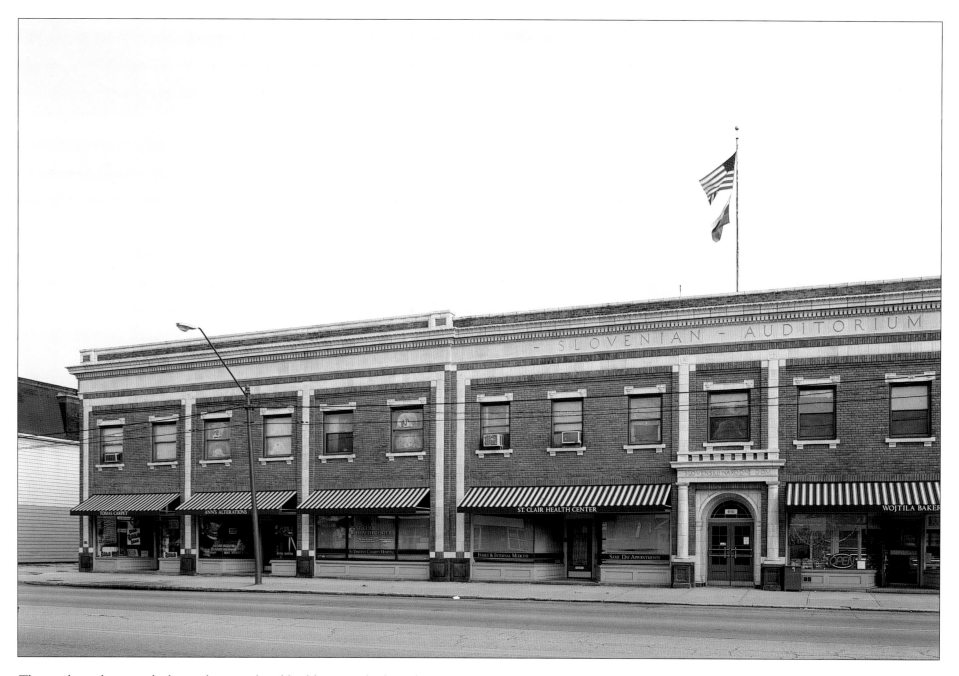

The modern photograph shows the completed building as it looks today. It was designed with street-level storefronts, which could, like the hall, be rented out as a source of income. The home anchors what remains of Cleveland's St. Clair Slovene community. Its hall is still in demand for wedding receptions, meetings, and performances, while its storefronts reflect the changing tastes and needs of the neighborhood's increasingly diverse population.

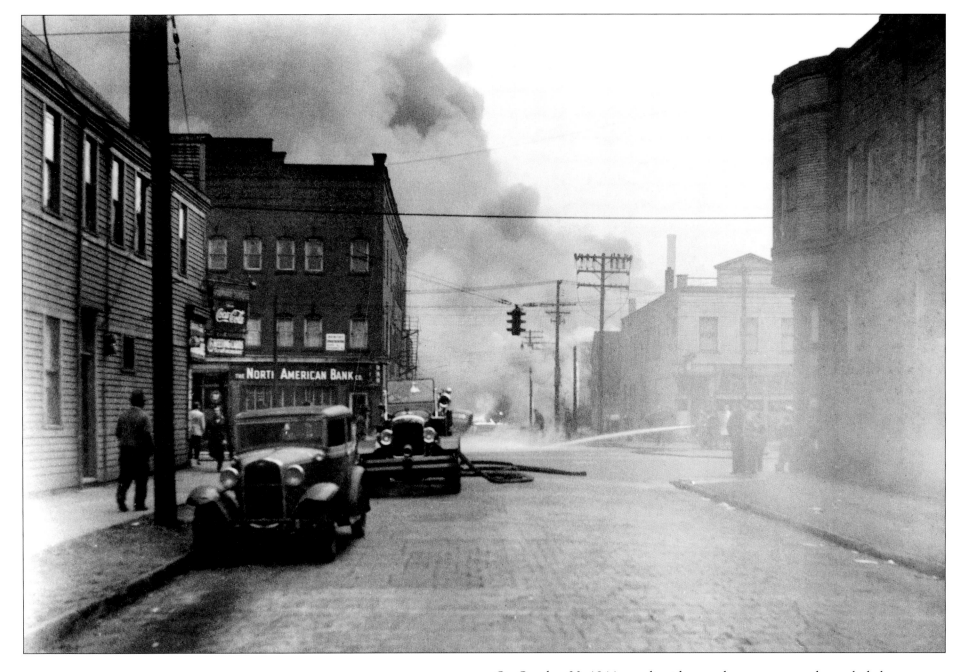

On October 20, 1944, two liquid natural-gas storage tanks exploded, enveloping the St. Clair Avenue neighborhood in smoke and flames. The tanks were located north of St. Clair near East Sixty-first Street. This view, looking north from the corner of St. Clair and Norwood, shows firemen battling the blaze on East Sixty-second Street. The fire spread over twenty blocks.

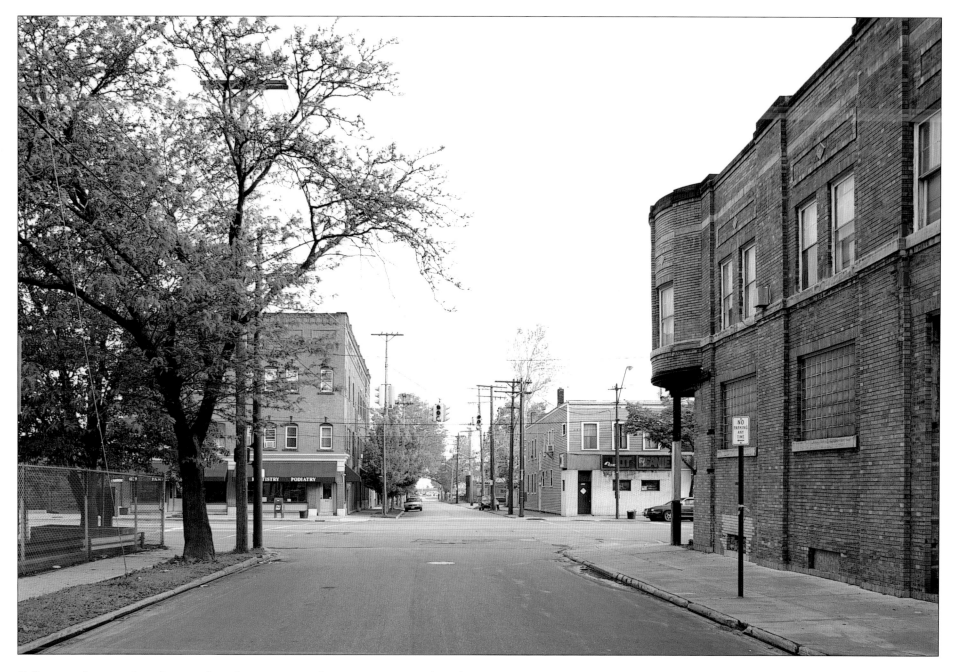

Following the initial explosions, liquid gas ran into the sewers, vaporized, and exploded, blowing apart the houses above. Cleveland's most disastrous fire killed 130 people and destroyed seventy-nine homes. Today the corner looks much the same as it did before that tragic day in 1944. North on East Sixty-second and on nearby streets, however, a series of small, newer brick houses marks the place where the disaster occurred.

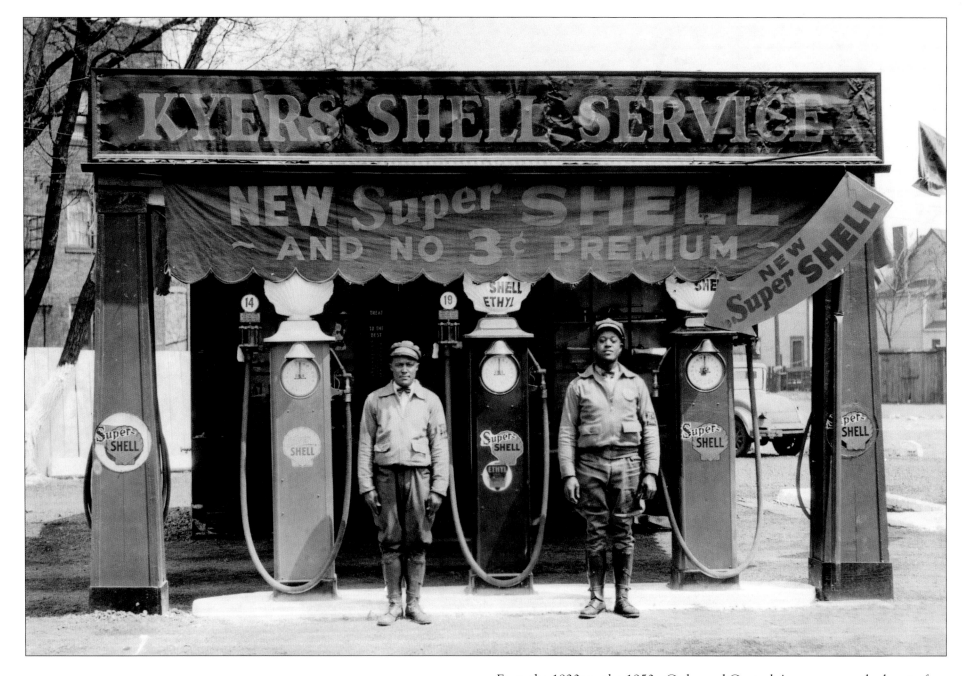

From the 1920s to the 1950s, Cedar and Central Avenues were the heart of Cleveland's African American community. As Cleveland's black population grew, the district's edge moved eastward toward University Circle. Ninety-five percent of Cleveland's African Americans lived along Cedar and Central in the 1930s. Some of its many black-owned businesses, like the Kyers Shell Station at 7901 Cedar, catered to white commuters on their way home.

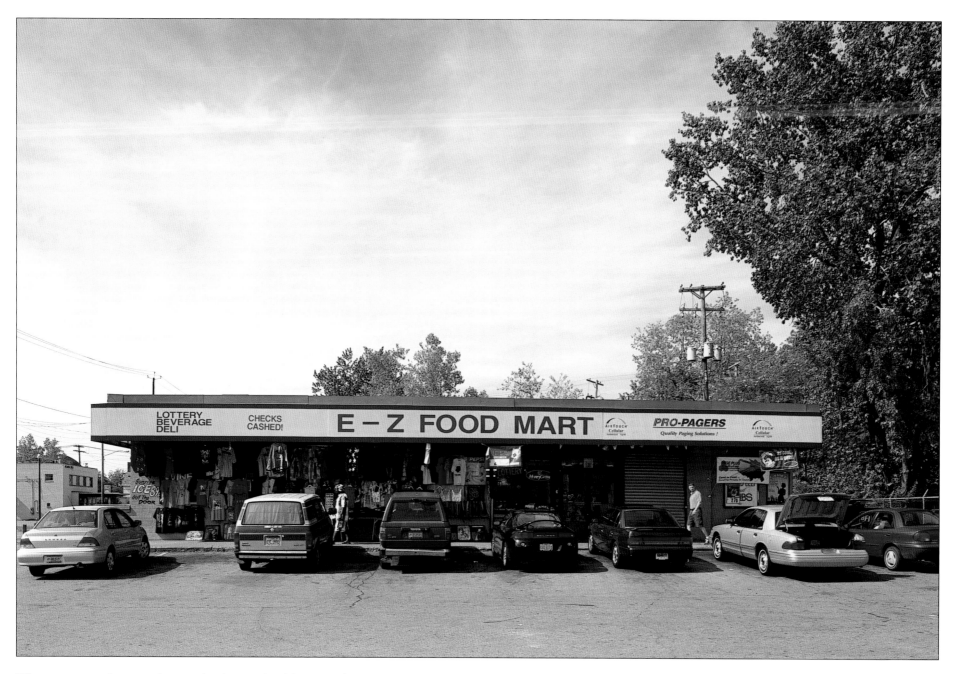

The gas station business has evolved considerably since the 1930s. Signs on the suburban plaza-style pump-your-own stations advertise one-stop "convenience" rather than the "service" formerly offered with pride by small businesses like Kyers. Although there is no longer a gas station where Kyers once stood, people still drive up to the spot to buy everything from pagers to snacks to T-shirts.

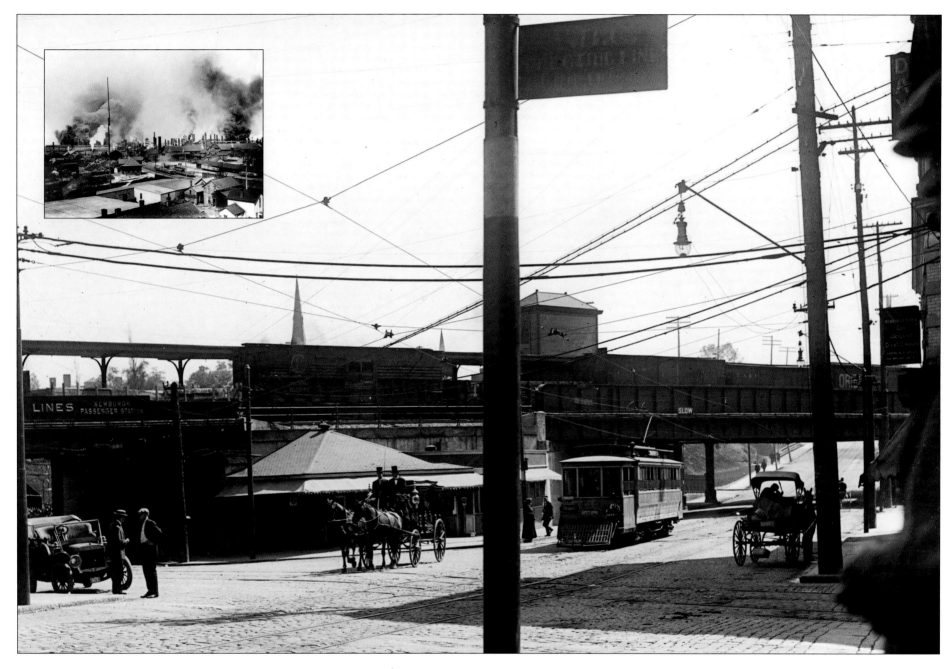

Once within the village of Newburgh, the intersection of Harvard Avenue and Broadway had been incorporated into Cleveland before this photograph was taken in 1913. The Pennsylvania Railroad (formerly the Cleveland and Pittsburgh) line to Pittsburgh, which crosses the intersection diagonally, had made the sleepy town of Newburgh an important steel center. Inset is a photograph of the mills just northeast of this intersection as they looked a decade or so earlier.

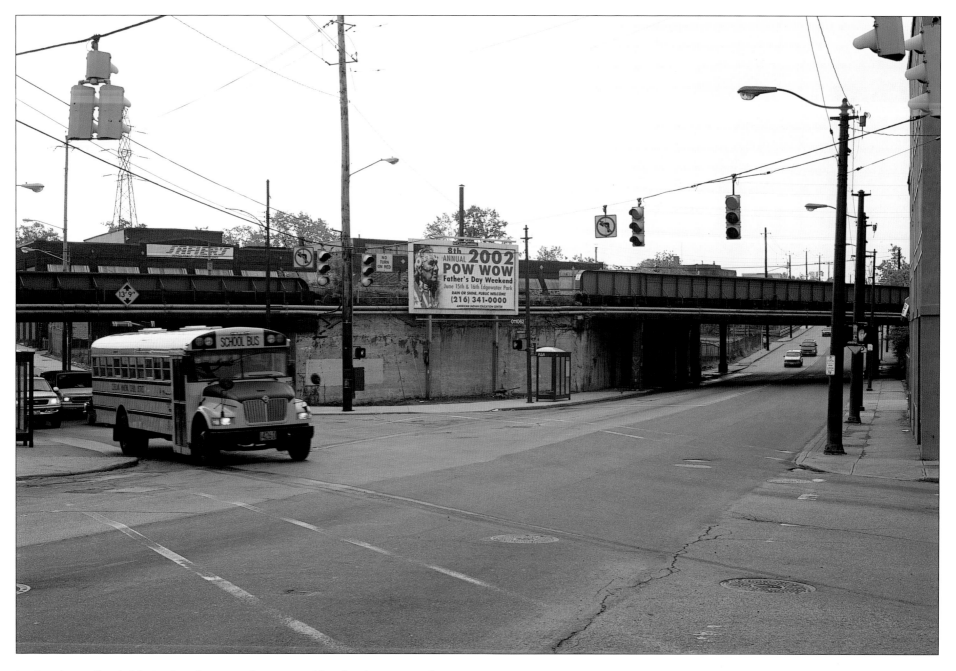

Today the mills of old Newburgh—once known as Cleveland's iron ward—are only a memory. The railroad and intersection remain, although automobiles no longer compete with electric streetcars and horse-drawn conveyances. The billboard announcing a powwow sponsored by the Native American Education Center evokes a still older past: Broadway follows the route of a Native American trail.

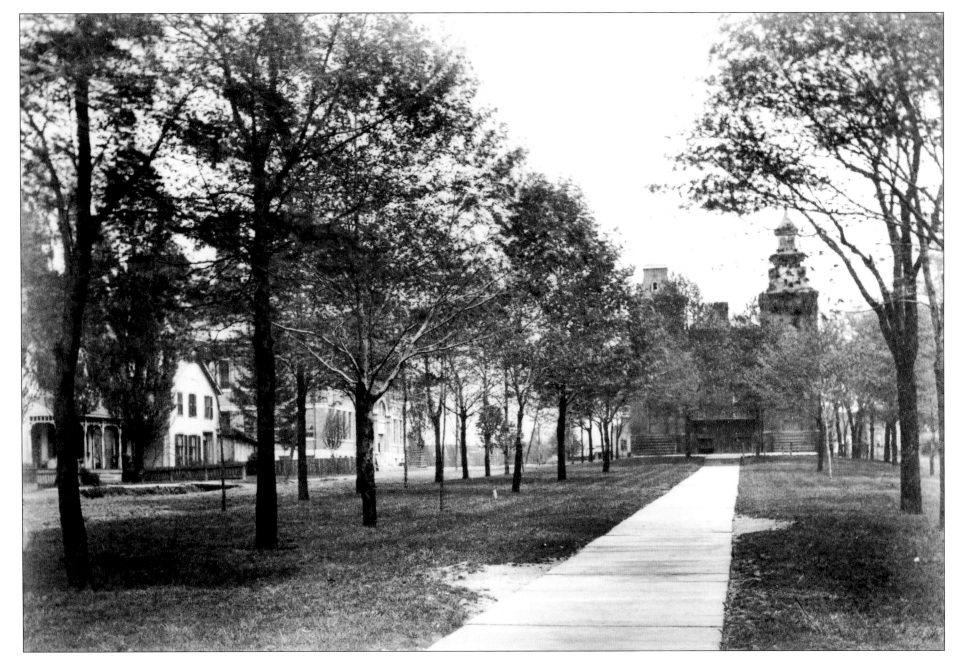

In the early nineteenth century, Newburgh grew faster than Cleveland, thanks to a healthier climate and its development as a grain-milling center. Like Cleveland, it had a town square and town hall. Water-powered mills eventually gave way to coal-fired iron and steel plants, and in 1873, Cleveland annexed part of the township, including the mills and the town square, depicted here shortly after the annexation.

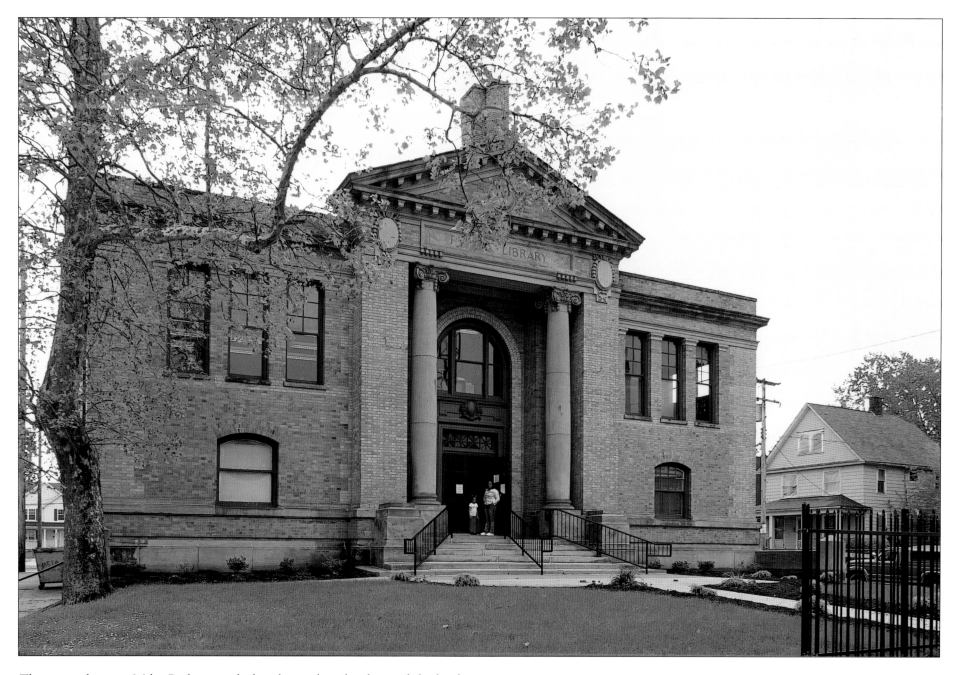

The square became Miles Park, named after the settler who donated the land to the village in 1850. The town hall became a library and was eventually replaced by a new library building in 1907. The 1907 building served as the Cleveland Public Library's Miles Park Branch for many years. Recently renovated, today it houses the Union-Miles Development Corporation, a child-care center, a police station, and a reading room.

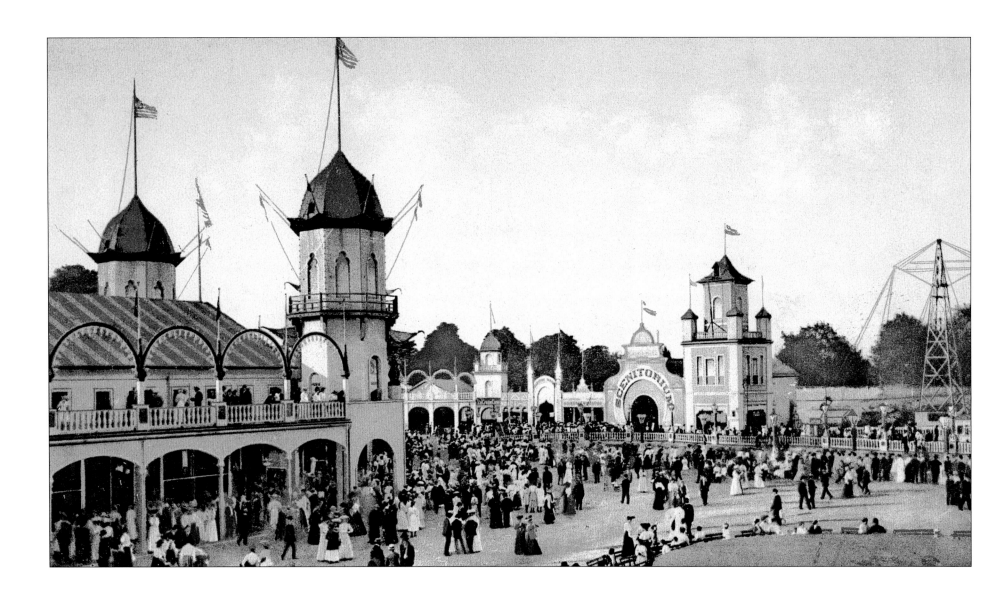

Luna Park, Cleveland's "fairyland of pleasure," opened in 1905 and immediately began attracting large numbers of visitors, many of them from nearby Hungarian, Italian, and Slovak neighborhoods. A typical urban amusement park, it featured rides, a decorative lake, a playing field used for soccer, baseball, and professional football, and a midway with make-believe pagodas, turrets, arches, and steeples lit up at night by countless electric bulbs.

Luna Park also featured freely flowing beer, which enhanced its popularity and income. After Prohibition put an end to this, it went into decline and closed during the early years of the Depression. Today the Cuyahoga Metropolitan Housing Authority's Woodhill Estates, constructed in 1940 and recently renovated, occupies much of the thirty-five-acre site, facing Woodhill Road (foreground) and Woodland Avenue (right).

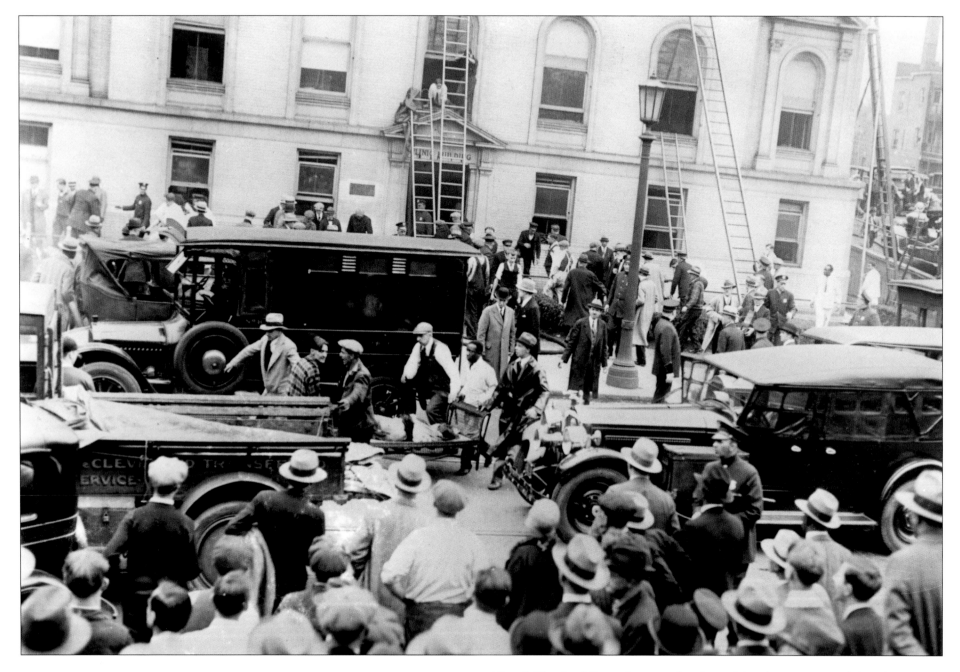

Noted *Cleveland Press* photographer Louis Van Oeyen snapped this shot on May 15, 1929, as Cleveland safety forces and citizens worked to rescue victims of what became known as "the Cleveland Clinic Disaster." Nitrocellulose X-ray film stored in the basement of the clinic had begun to smolder, causing an explosion and fire. One hundred and twenty-three people died, most from inhaling poisonous gases released by the films.

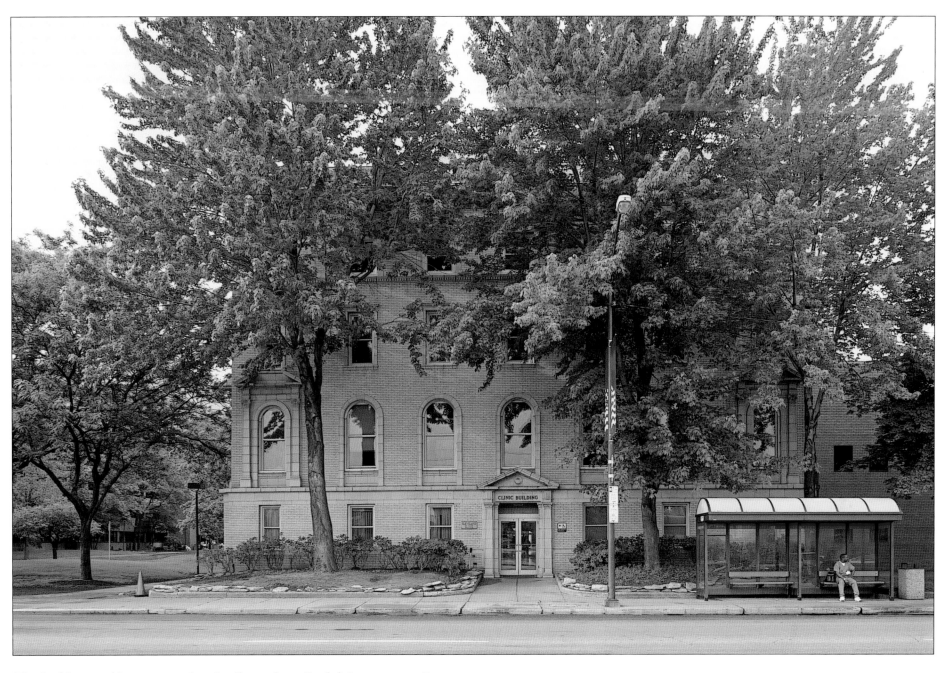

The building itself was repaired and still stands on Euclid Avenue near East Ninety-third Street. The Cleveland Clinic Foundation grew to become an internationally renowned medical center, Cleveland's largest health care institution, and one of the city's largest employers. The original four-story building, dating from 1921, is all but lost among gleaming modern edifices that house acres of hospital, clinic, research, and educational facilities.

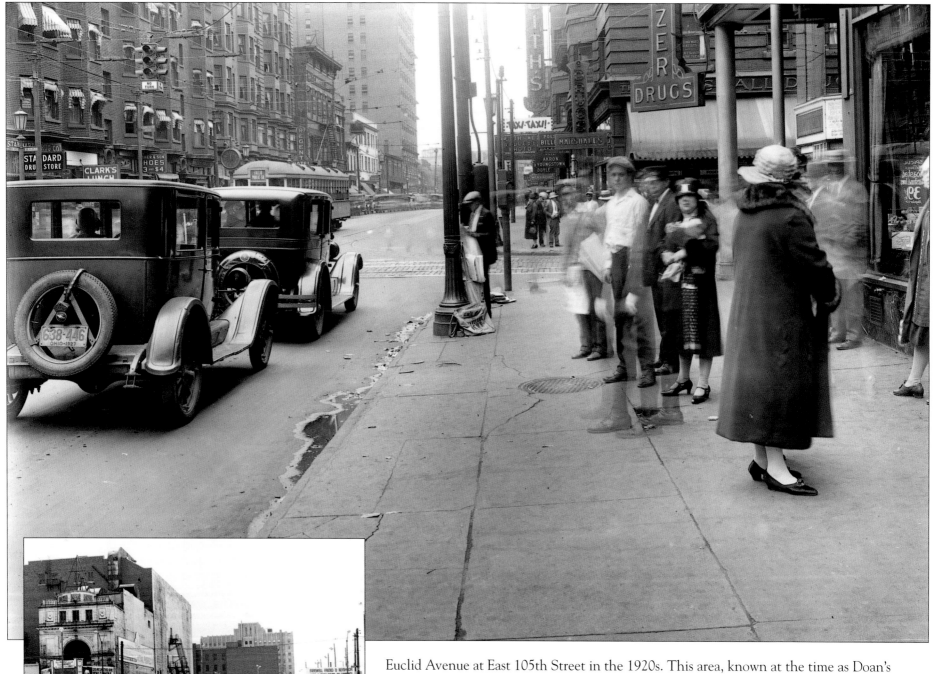

Euclid Avenue at East 105th Street in the 1920s. This area, known at the time as Doan's Corners, served as Cleveland's second downtown for several decades. At its peak in the 1920s to 1940s, it had shops, banks, and hotels, plus theaters rivaling those on Playhouse Square. The sign and marquee of Keith's East 105th Street Theater appear on the right. Negatively affected by suburbanization, the shopping district went downhill in the 1960s, and by the 1980s the East 105th area was the scene of abandoned buildings and vacant lots, as seen in the inset photograph. The Keith's Building, however, was still standing.

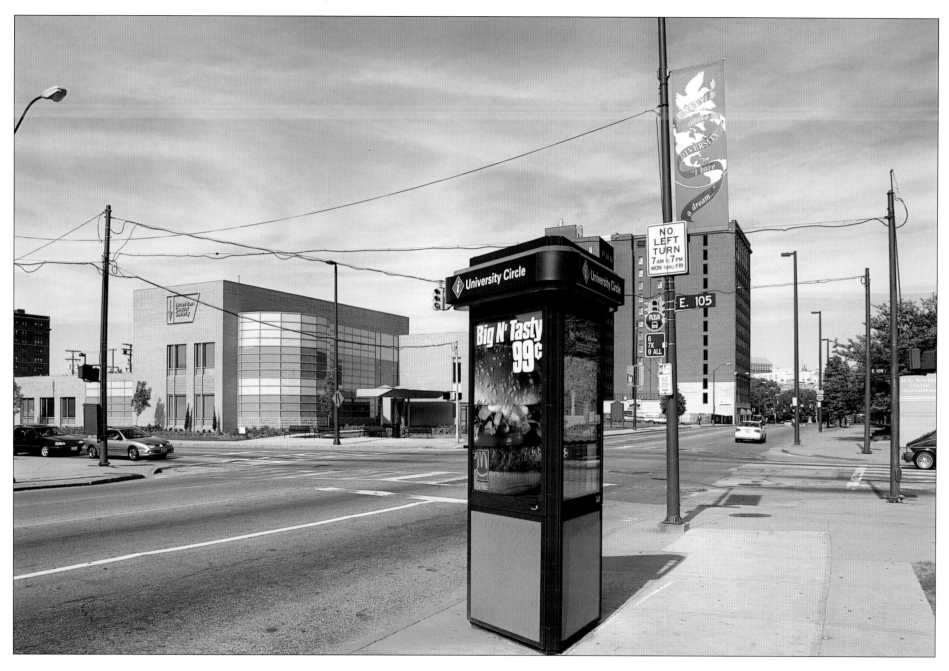

The area is experiencing a renaissance due to its location between the city's two premier medical centers, the Cleveland Clinic to the west, and University Hospitals of Cleveland to the east in University Circle. The American Cancer Society's local headquarters are in one of the new buildings at the intersection. The Fenway Hotel (left background in the 1920s photo; behind the signpost in the current view) now houses the Hospice of Greater Cleveland's offices on its ground floor.

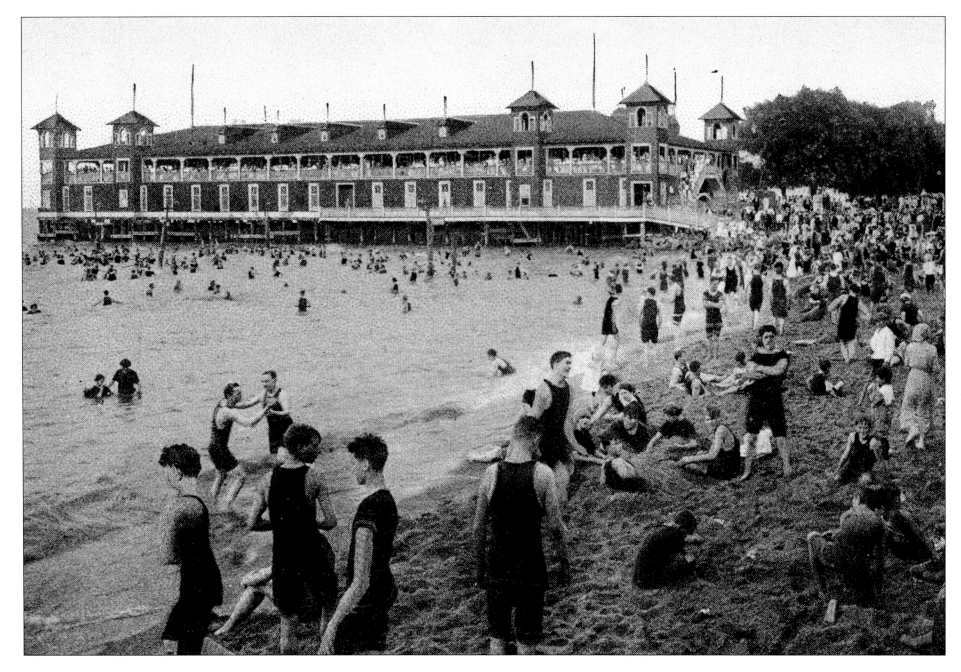

East side Clevelanders, such as these 1910s bathers, once flocked to the lakeside in Gordon Park on hot summer days. The park was the legacy of wholesale grocer and iron ore investor William J. Gordon, who had purchased 122 acres of land around the mouth of Doan Brook on Lake Erie and landscaped it as a private park. Upon his death in 1892, the land was deeded to the city for use as a public park.

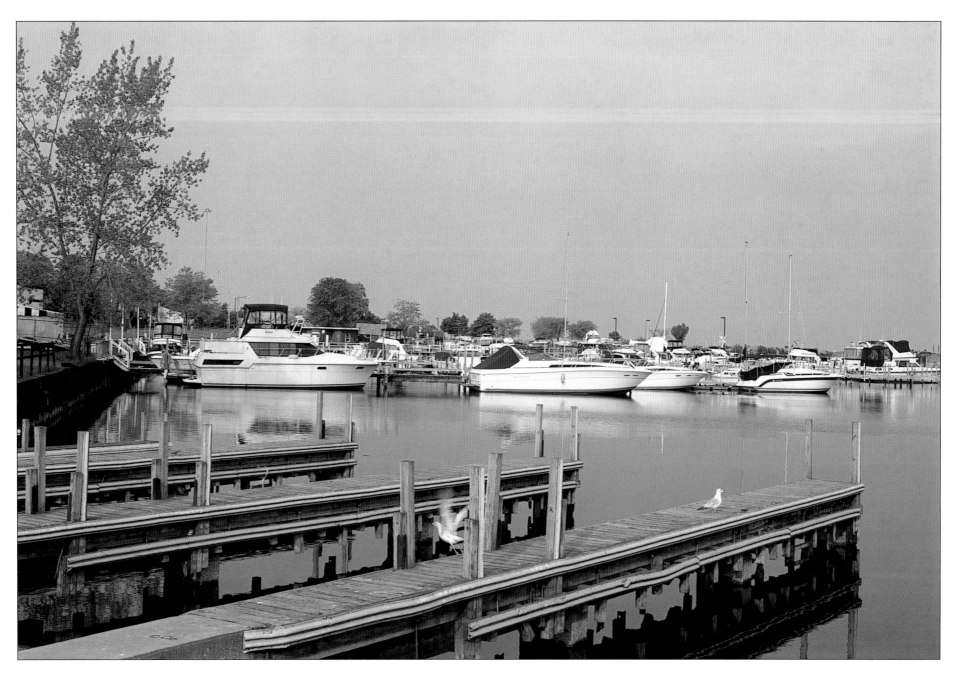

Construction of a freeway along the lakeshore cut the park in two in the 1950s. In 1978 the Ohio Department of Natural Resources came to the rescue of the deteriorating facility, restoring the lakefront portion as part of the Cleveland Lakefront State Park. The park is once again a popular recreation spot, primarily for boating and fishing, with a pier and marina in place of the old bathing beach and pavilion.

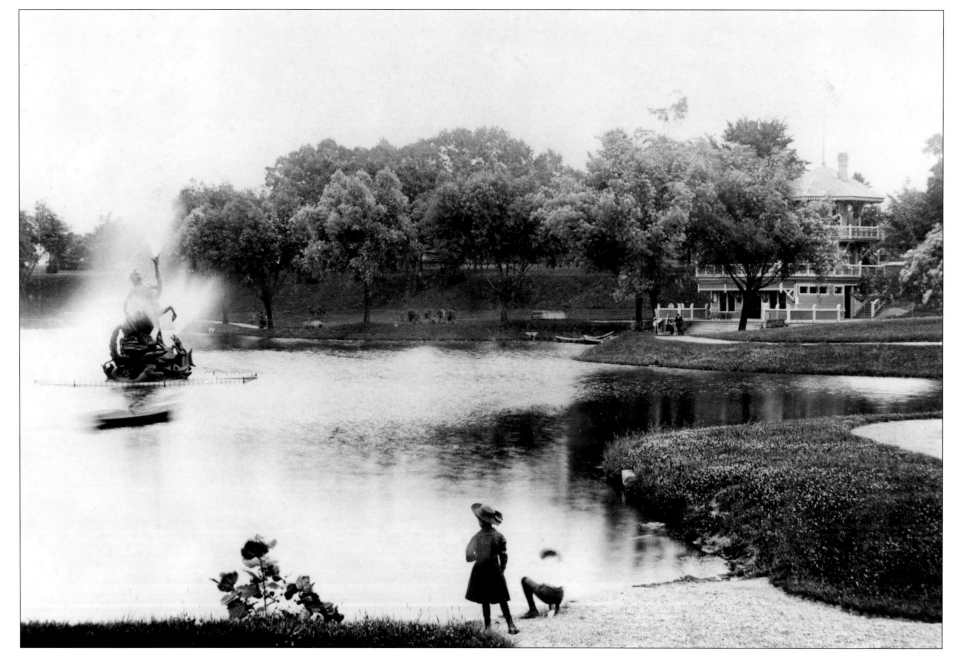

Following Doan Brook to the south, one finds another park with a similar story. Wade Park, the gift of Western Union tycoon Jeptha Homer Wade, had been donated to the city in 1882. This view shows the lagoon and boathouse in 1888. Wade and Gordon Parks became part of a chain of parks along Doan Brook with the creation of Rockefeller Park on land donated by John D. Rockefeller and his wife in 1897.

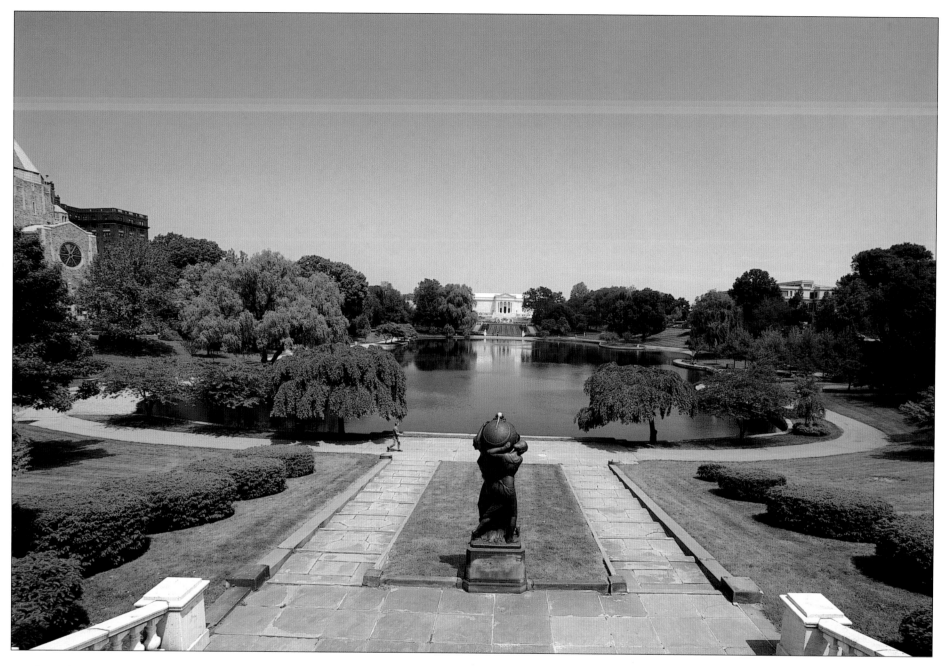

Wade Park, as part of University Circle, serves as the perfect setting for a number of cultural institutions. In its early years the park was the first home of the Cleveland Zoo (now on the city's west side). Today a reconfigured lagoon and garden create a stunning setting for the Cleveland Museum of Art, opened in 1916. A legacy of Cleveland's industrial wealth, it is widely recognized as one of the world's finest art museums.

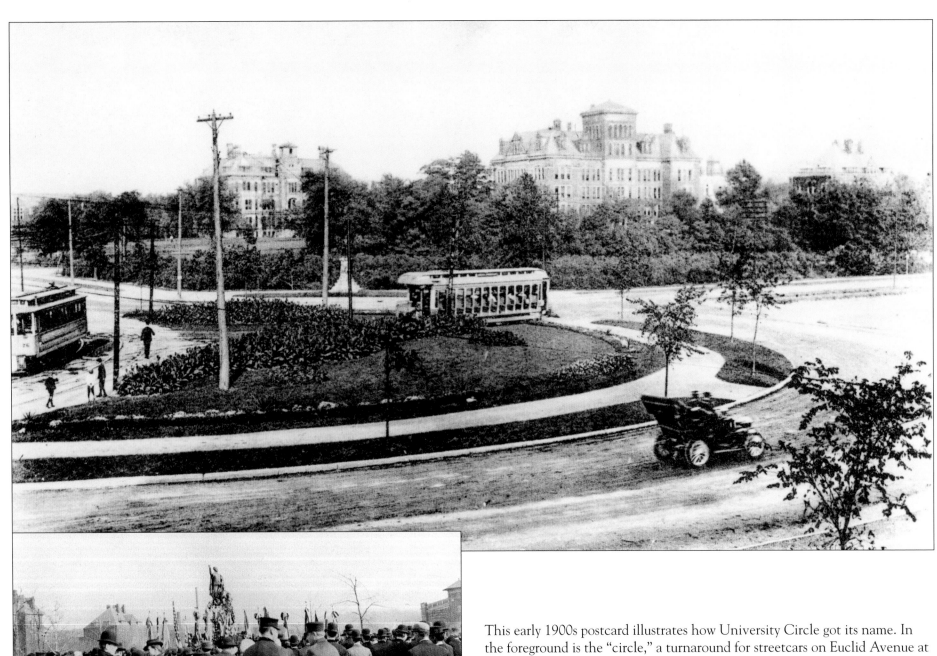

This early 1900s postcard illustrates how University Circle got its name. In the foreground is the "circle," a turnaround for streetcars on Euclid Avenue at East 107th Street. The main buildings of Western Reserve University and the Case School of Applied Science (later Case Institute of Technology) appear in the background. The inset photograph shows the dedication of a statue of Hungarian patriot Louis Kossuth at University Circle in 1902. The statue reflected the city's willingness to recognize the heritage of its ethnic groups.

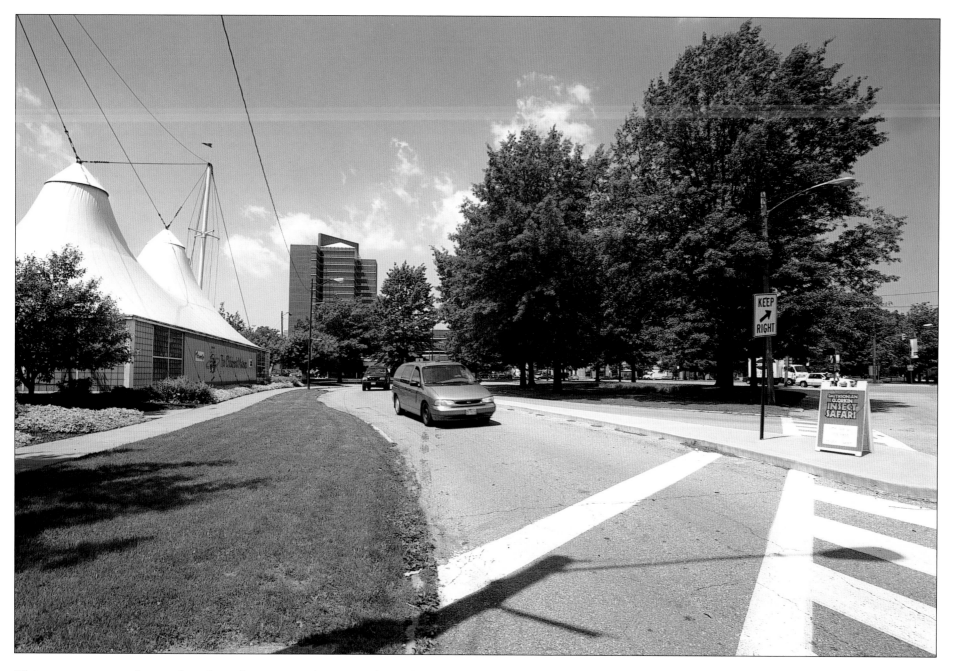

This contemporary photo, taken from the opposite direction, shows the last remaining vestige of the circle at Stearns Road, curving in front of another of the district's many museums, the Cleveland Children's Museum. In the background is the William O. Walker Center, named for a prominent local African American newspaper publisher and politician.

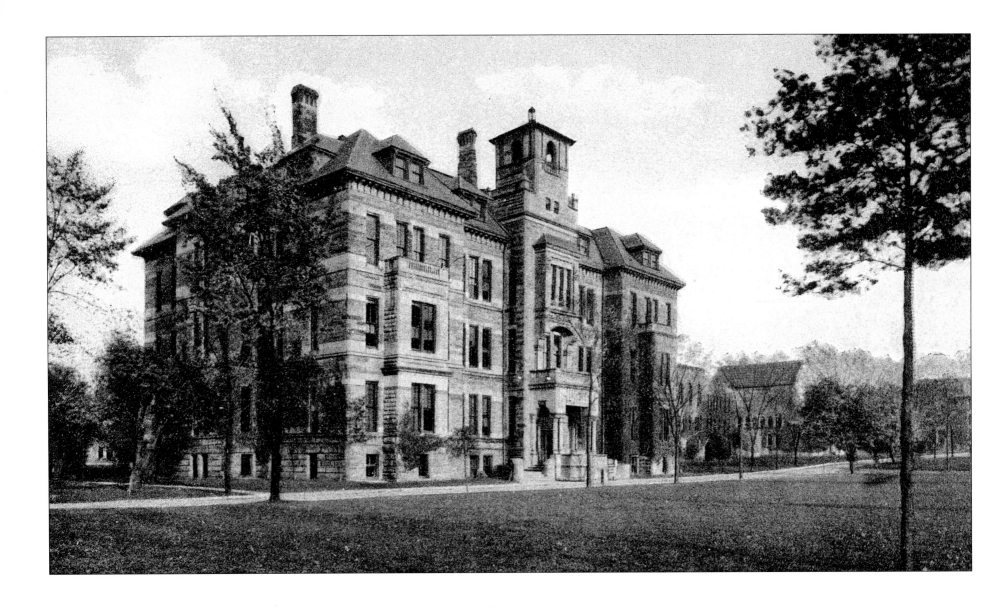

Adelbert College was Western Reserve University's undergraduate men's college. Named for the deceased son of railroad magnate and financier Amasa Stone, the college sat on land donated by the elder Stone in 1880. Stone's gift, which also included a large sum of money, allowed the university to move from rural Hudson, Ohio, to Cleveland. Both men and women attended Adelbert until 1888, when a separate women's college was created within the university.

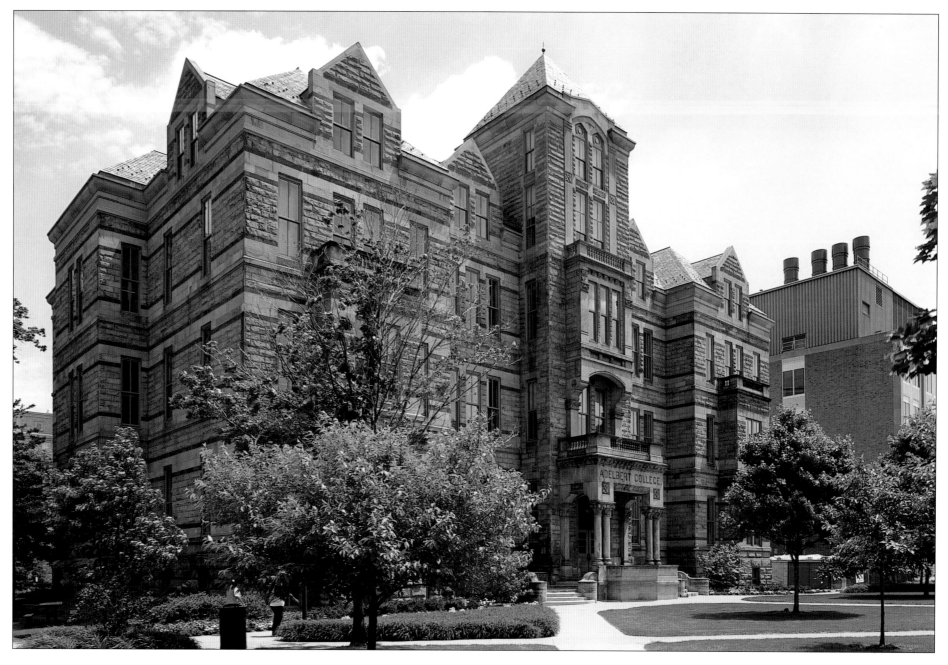

Initially, Adelbert Hall was the college's only building. As the school grew, it became primarily an administrative building. After a fire did substantial damage to its interior in 1991, Adelbert Hall was renovated. It stands today as the oldest building on the campus of one of America's finest research universities, Case Western Reserve University, the product of Western Reserve's merger with Case Institute of Technology in 1967.

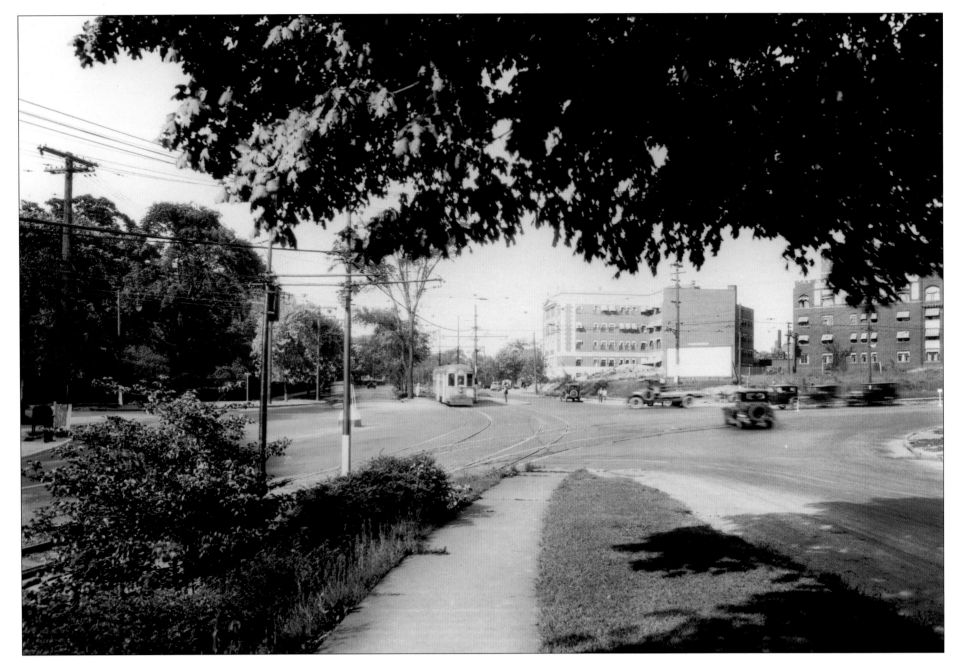

Immediately east of Cleveland, Cleveland Heights overlooks University Circle and the adjoining Little Italy neighborhood from a ridge along one of Lake Erie's ancient shorelines. Incorporated in 1903, Cleveland Heights developed as an upscale community, one of the city's first "streetcar suburbs." This view from the intersection of Cedar and Harcourt Roads in the 1920s shows a streetcar on Euclid Heights Boulevard ready to descend Cedar Road hill into Cleveland.

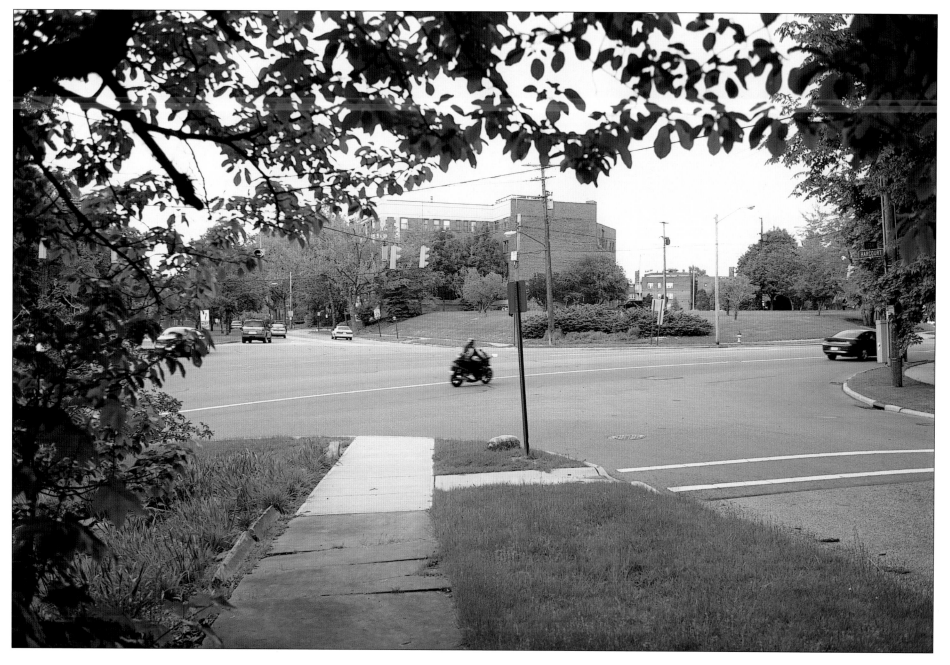

Today the view remains essentially unchanged. Although today's commuters travel by automobile or bus rather than by streetcar, Cedar Road remains one of the primary access routes to the city from the eastern suburbs. Cleveland Heights continues to be a stable residential community, with varied housing options and a diverse and well-educated population that has been attracted by the area's proximity to University Circle and the city's two major medical centers.

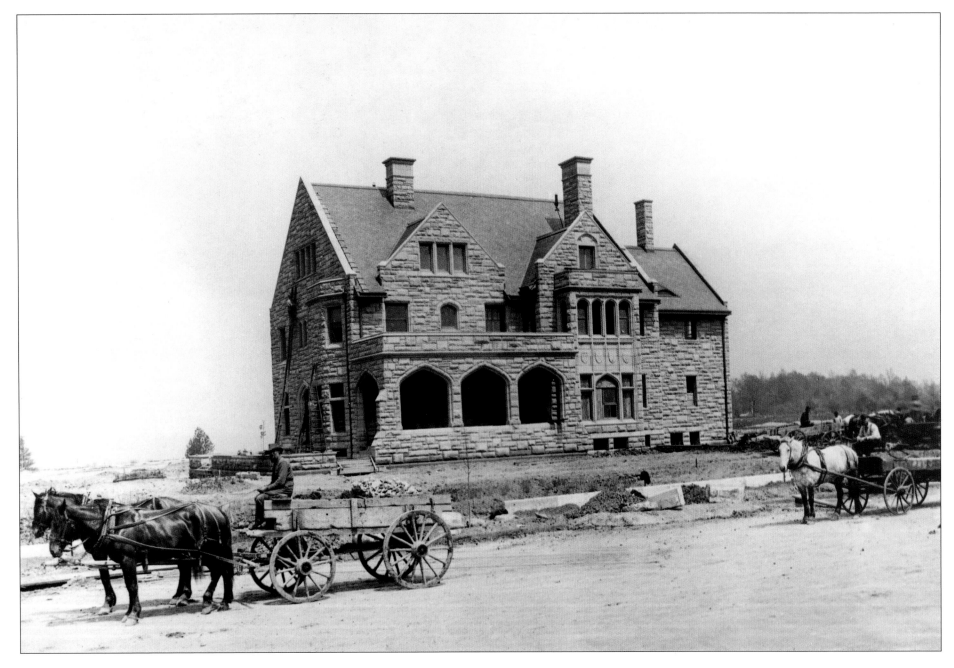

Developers Patrick Calhoun and John Hartness Brown, who came up with the idea for the East 107th streetcar traffic circle, also built the streetcar line up Cedar Road hill in the mid-1890s. They hired landscape architect Ernest W. Bowditch to plan their Euclid Heights development as a suburban "village" with curving streets and spacious houses. In 1895–96, Brown built his own baronial home at the intersection of Edgehill and Overlook Roads, a sandstone structure designed by Alfred Hoyt Granger.

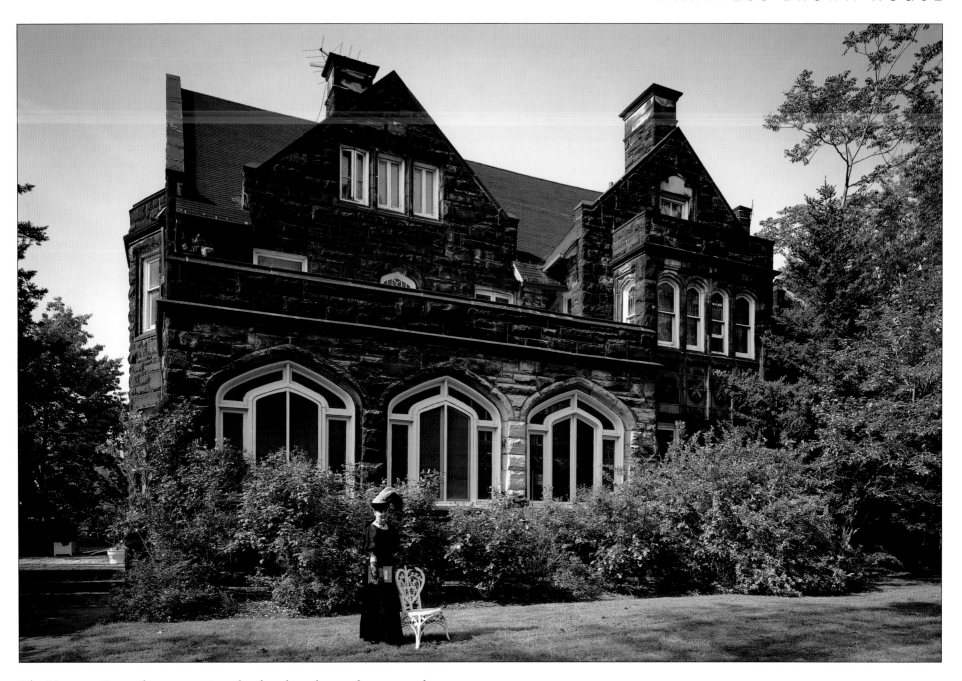

The Hartness Brown house remains a landmark at the southwestern edge of Cleveland Heights. Its current owners (one of whom stands on the lawn in period costume) undertook restoration of the old home after it had seen many years of use as a multiresidential structure. Euclid Heights, along with the adjoining Ambler Heights and Euclid Golf developments, which featured residences even larger than Brown's, became the western part of Cleveland Heights.

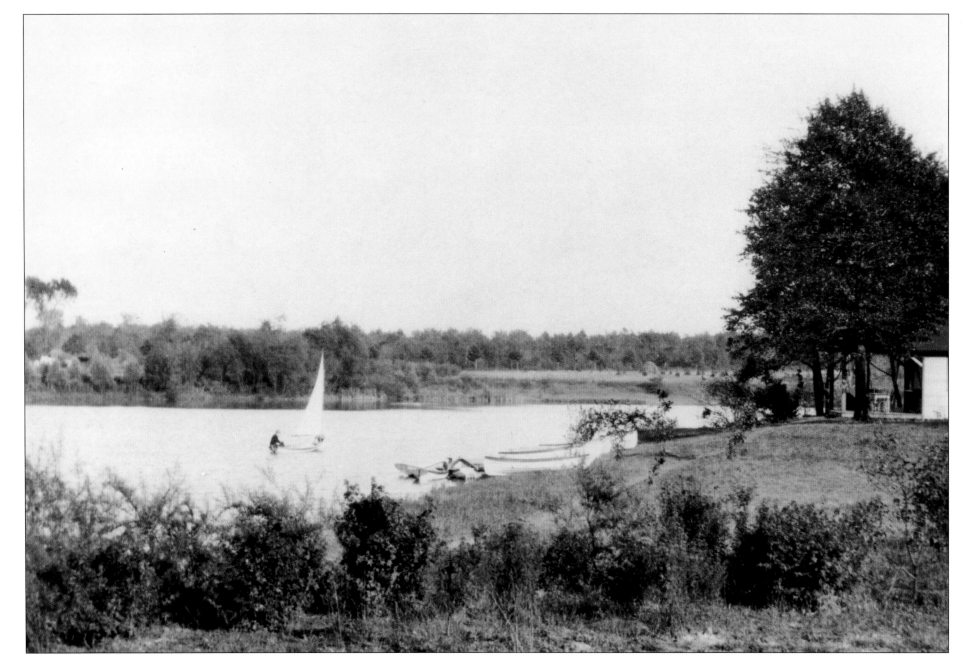

In 1822 members of the Shaker religious sect (the United Society of Believers in the Second Appearing of Christ) created one of their nineteen American communities on Doan Brook, a little over six miles southeast of the tiny Cleveland settlement. The Shakers dammed the brook to power their mills, creating millponds later known as Upper, or Horseshoe, and Lower Lakes. Here, early twentieth century boaters enjoy a day on Horseshoe Lake.

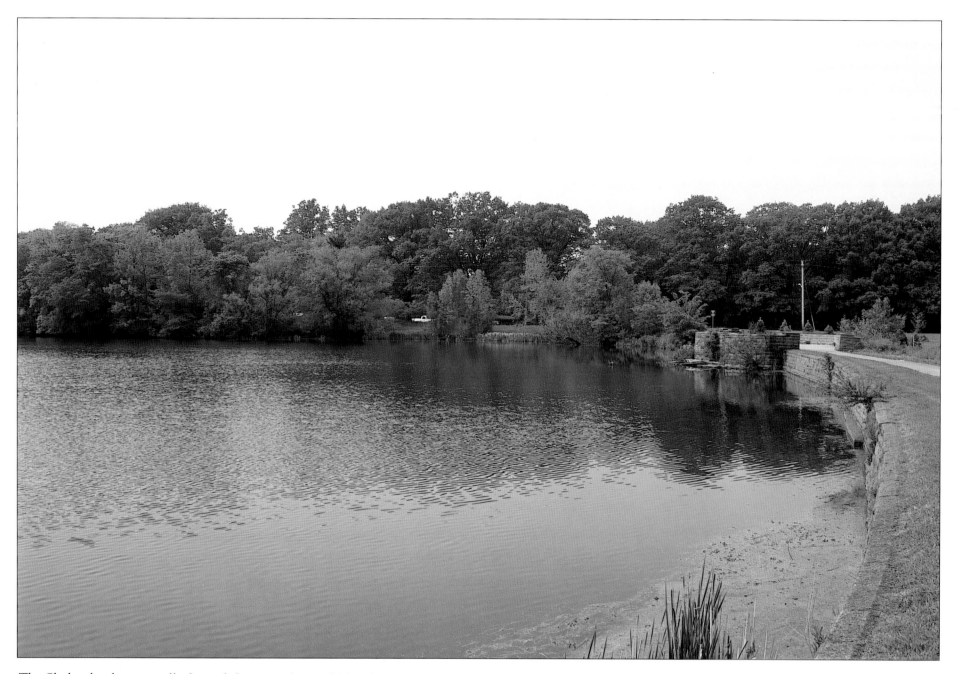

The Shaker lands eventually formed the core of one of Cleveland's
most prestigious suburbs, Shaker Heights. Its development, begun in 1905,
like that of Cleveland Heights depended on the extension of streetcar lines
to the area. The old Shaker Lakes today provide an ideal setting for jogging,
biking, walking, and enjoying nature in the middle of Cleveland's
best-known suburb.

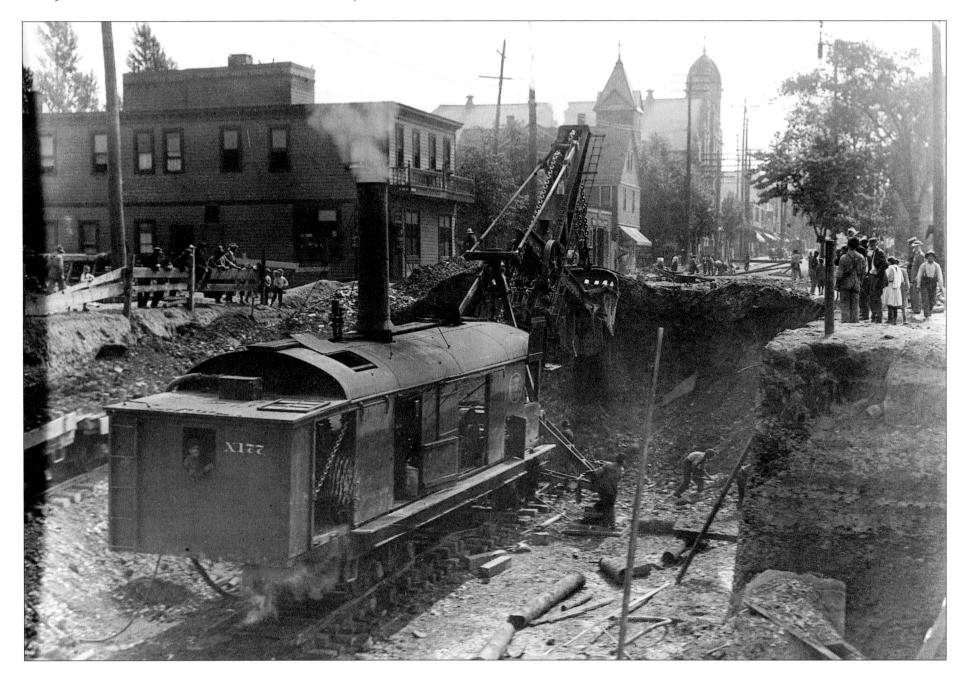

Adjacent to University Circle and Cleveland Heights is Cleveland's Little Italy neighborhood, settled in the late nineteenth century by stonecutters who produced monuments for nearby Lake View Cemetery. When this photograph was taken in the early 1910s, over ninety percent of the residents were Italian, mostly from southern Italy and Sicily. Here an underpass for the new Cleveland Belt Line Railroad is being built on Mayfield Road, the neighborhood's main street.

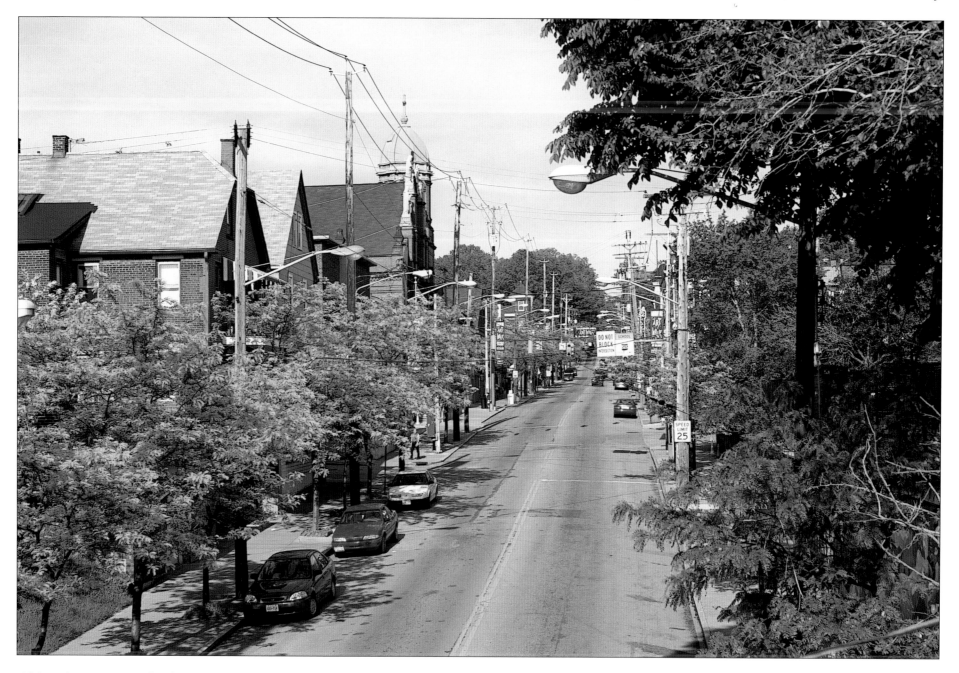

Although a major conduit between Cleveland and its eastern suburbs, Mayfield remains effectively a two-lane road here, due to narrow frontages and on-street parking. This and a high density of small, multifamily dwellings give Little Italy a truly urban atmosphere almost unique among Cleveland neighborhoods. Although fewer of today's residents are Italian, the district has maintained its identity. Along with artists' studios, numerous Italian restaurants line the streets, attracting throngs to the area on weekend evenings.

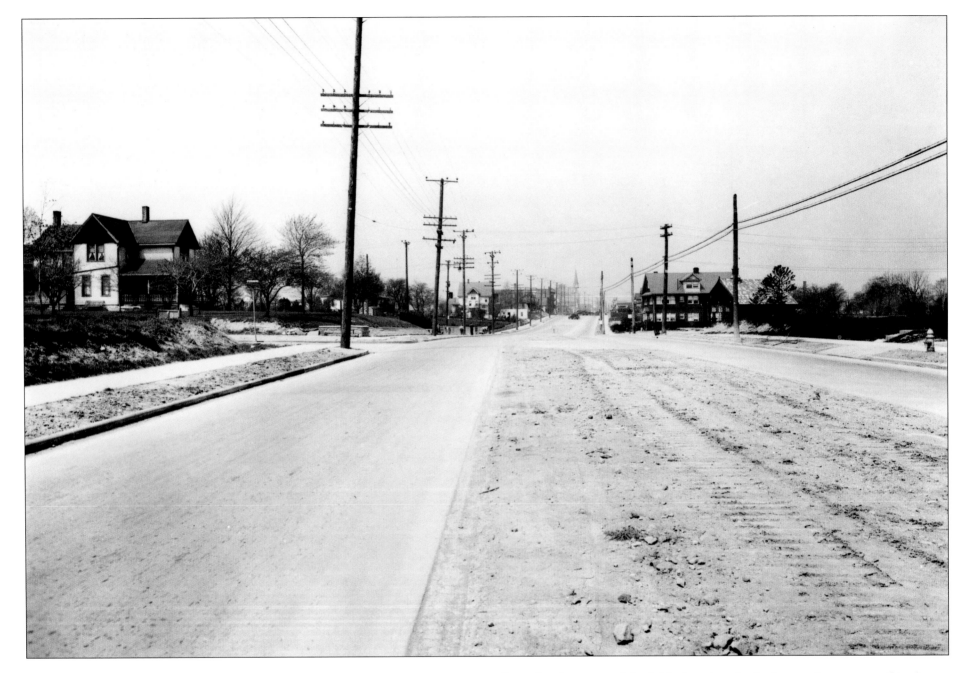

Several miles east on Mayfield, the views both then and now are strikingly different from those along the same road in Little Italy. By the late 1920s, as more people came to own cars, they began to move farther away from Cleveland. This photograph, taken in 1928 near the Green Road intersection in South Euclid looking west, shows Mayfield being widened and improved to accommodate the increased traffic.

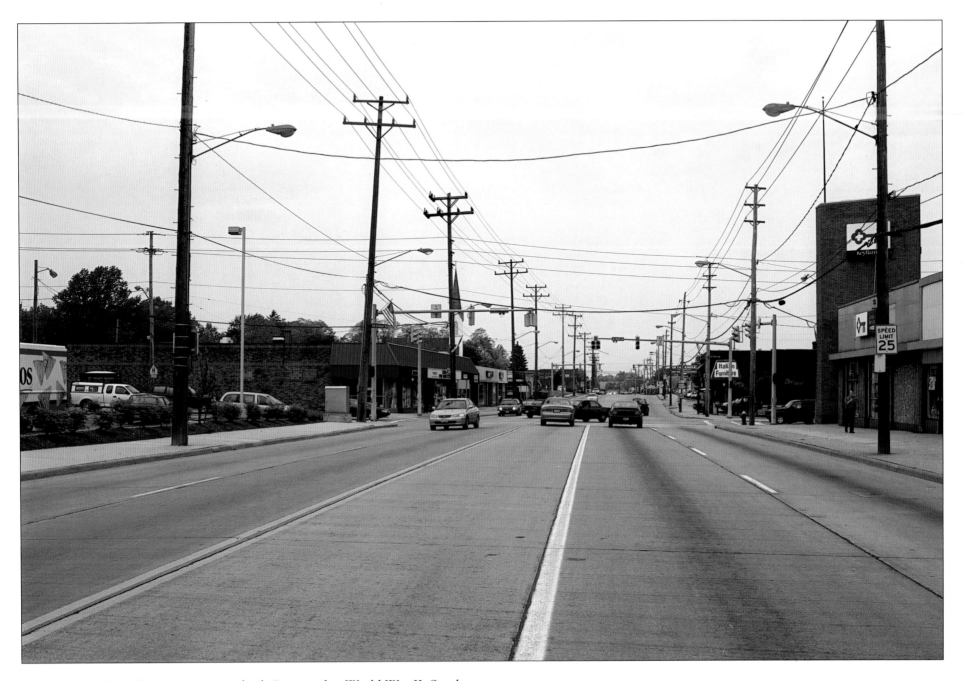

The real growth of the "automotive suburbs" came after World War II. South Euclid gained a substantial number of second- and third-generation Italian-American residents who moved east from Little Italy. Today Mayfield Road is a business district along much of its length in South Euclid, with stores and banks replacing the houses in the earlier photograph. The steeple of St. John Lutheran Church appears in both views.

Across town immediately to the west of Cleveland, Lakewood was the first major suburb to develop, its growth also spurred by streetcars and the automobile. One of its principal streets, Detroit Avenue, followed the route of the Native American Lake Shore Trail. This view eastward along Detroit from the intersection at Elmwood Avenue shows "downtown" Lakewood in the 1920s.

This section of Detroit Avenue is still an active neighborhood business district. Modern buildings have replaced many of the old structures on the south side of the street. However, the large business block on the northeast corner of the Elmwood intersection remains standing. Although it has been given a new facade, the roofline remains the same.

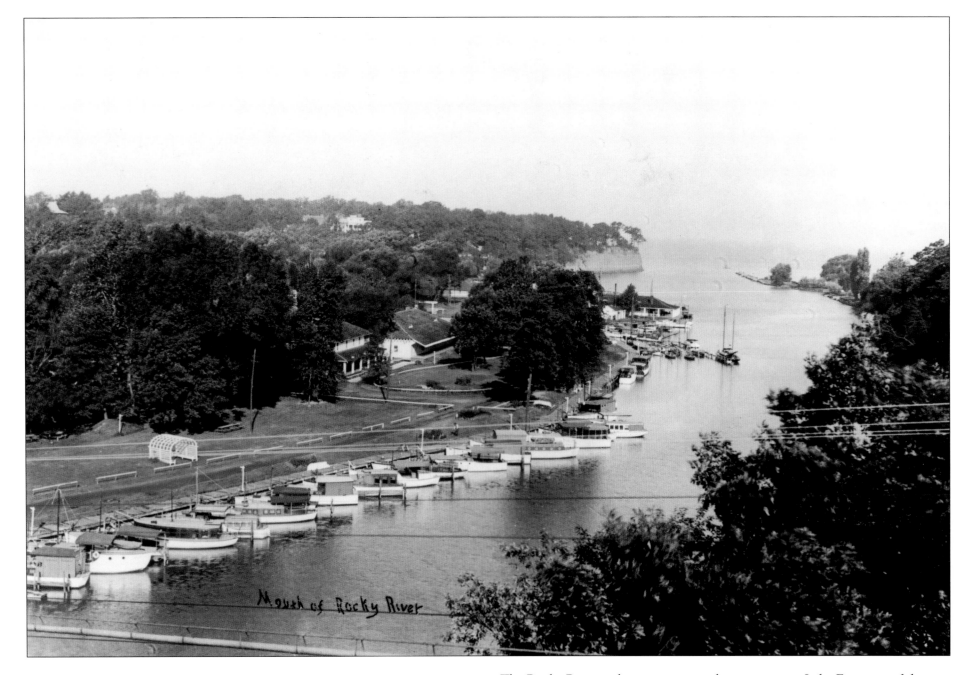

Mouth of Rocky River

The Rocky River is the next major tributary to enter Lake Erie west of the Cuyahoga. By the early 1900s, it formed the boundary between Lakewood and the village of Rocky River to the west. The area became popular with the local boating set, at that time mostly well-to-do Clevelanders, who frequented the small marina seen here and tied up their private craft along the river.

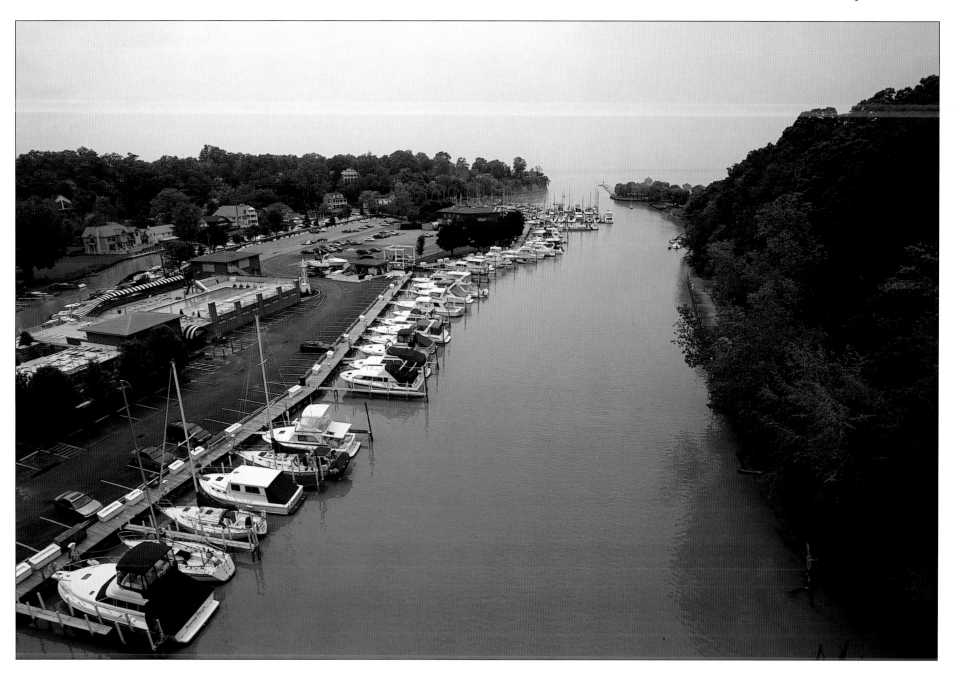

Today the mouth of the river looks amazingly similar to the early twentieth century view, with its wooded shores, placid waters, and tidy row of small boats. The primary difference is a substantial increase in the number of boats and the extent of the dockside facilities. Boating, no longer restricted to the old elite, has become popular with Clevelanders taking advantage of their town's location on the shores of Lake Erie.

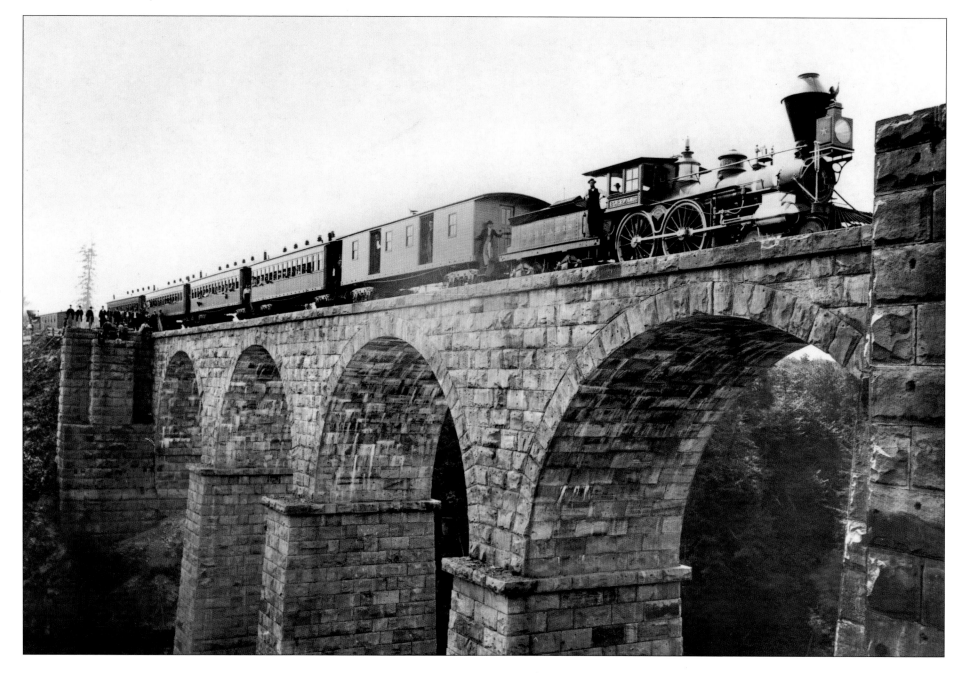

In 1865 engineer Benjamin McLane stopped his locomotive, the *Borealis*, and the train it pulled on the new stone viaduct of the Cleveland and Pittsburgh Railroad over Tinkers Creek in Bedford, then a small country town southeast of Cleveland. Photographer Thomas Sweeney captured this image with a cumbersome wet plate camera, most likely to preserve a record of the spectacular new bridge.

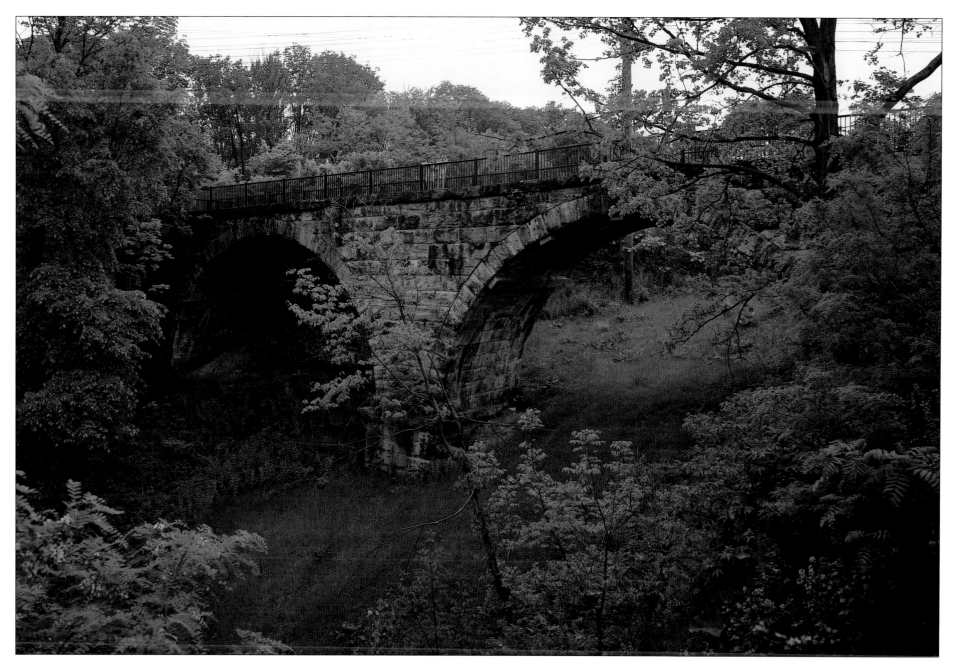

Today Bedford is a suburb of Cleveland but has managed to retain much of its small-town atmosphere. A town square, historic buildings, and the viaduct remain. The latter no longer carries trains, which now cross the valley on a newer line. The old bridge is instead preserved as a picturesque feature in a local park, where visitors can pose on the spot where Benjamin McLane stopped his train for a photo opportunity so many years ago.

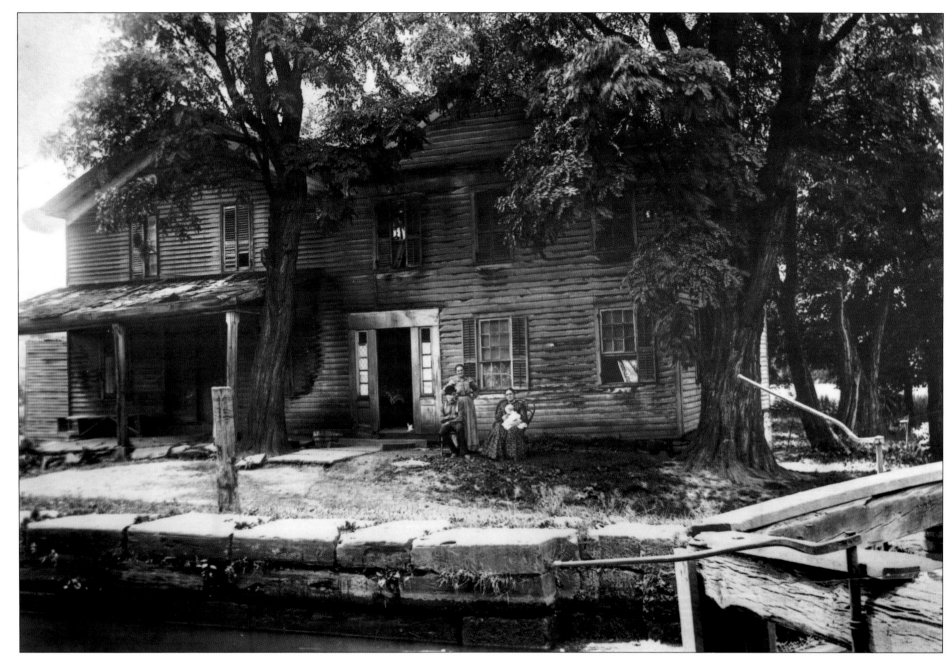

By the 1890s, what was known locally as the locktender's house at Lock 38 of the Ohio & Erie Canal seemed a decaying relic of the past. In the half-century since the canal's heyday, Cleveland had come to rely on new technology—railroads—for speedy transport of its people and goods. Very little traffic flowed through the canal; its days were numbered, and it would close after a disastrous flood in 1913.

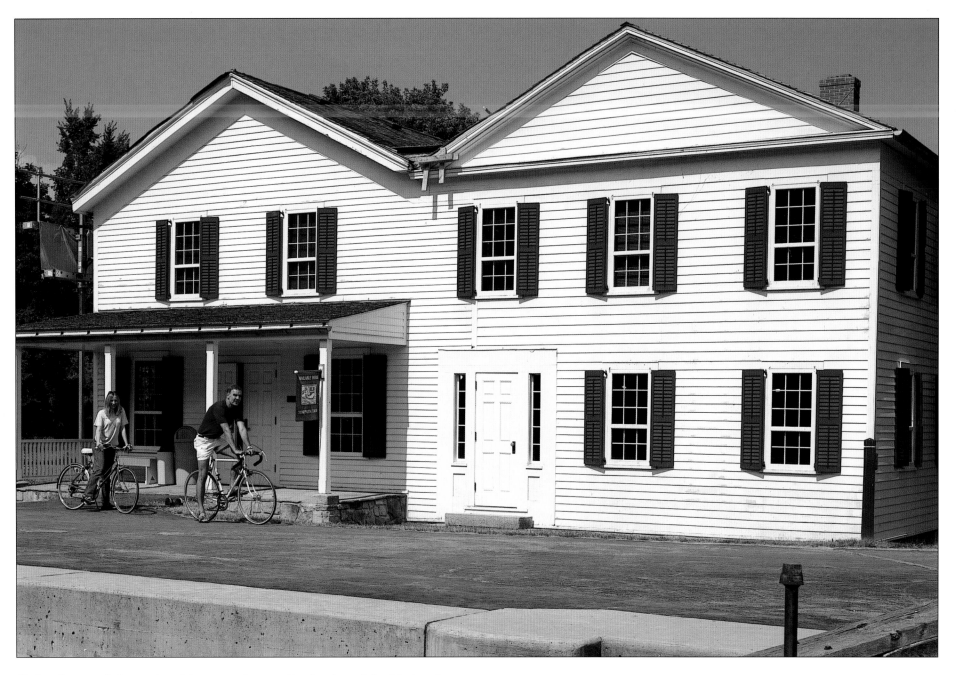

Today the canal channel and its towpath are a focal point of the National
Park Service's Cuyahoga Valley National Park, and part of the much longer
Ohio & Erie Canal Towpath Trail. Lock 38 has been restored, and the old
locktender's house at Hillside and Canal Roads has been turned into a
visitor center. Thousands of tourists and local residents come to hike,
bike, jog, and view the canal, one of northeastern Ohio's most important
historic landmarks.

INDEX